Making Paradise: Art, Modernity, and the Myth of the French Riviera

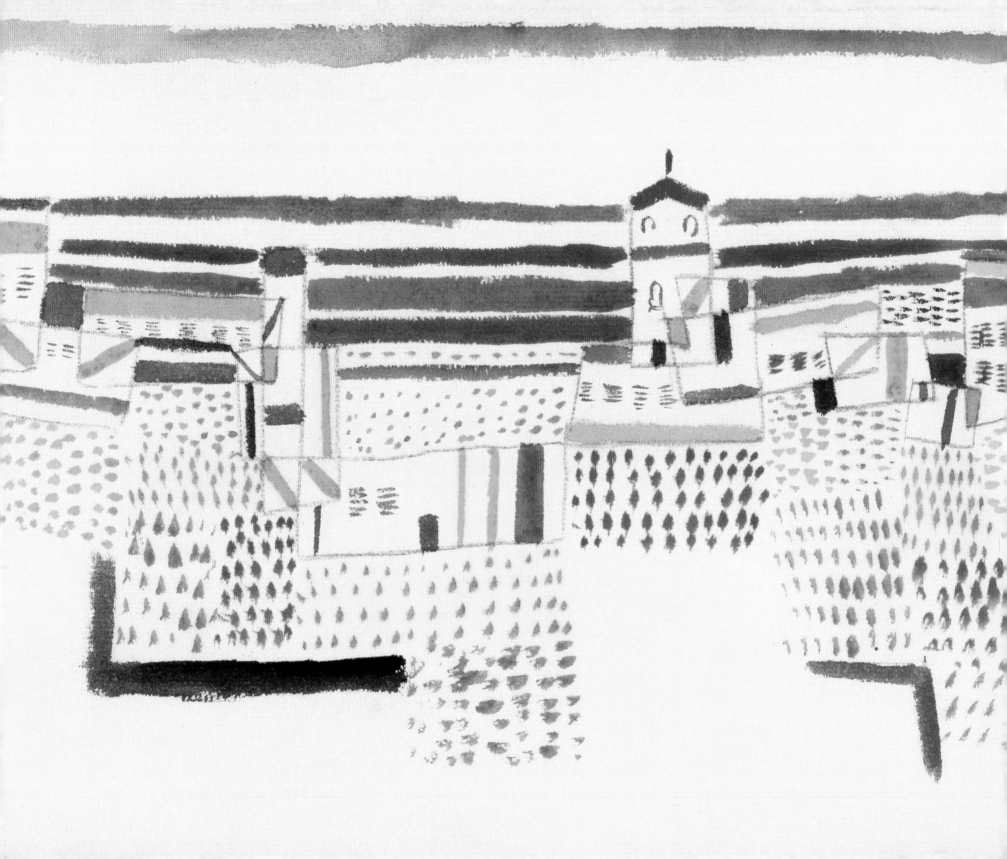

Making Paradise

Art, Modernity, and the Myth of the French Riviera

KENNETH E. SILVER

The MIT Press
Cambridge, Massachusetts
London, England

Frontispiece: Paul Klee,
Seascape, South of France,
Porquerolles, 1927.
Watercolor on paper.
Tate Gallery, London

Making Paradise:
Art, Modernity, and the Myth
of the French Riviera
by Kenneth E. Silver
© 2001 AXA Gallery

Essay texts
© Kenneth E. Silver

A list of illustration credits
can be found on page 191.

The MIT Press
5 Cambridge Center
Cambridge, MA 02142

AXA Gallery
787 Seventh Avenue
New York, NY 10019

Library of Congress
Control Number: 2001087308

ISBN 0-262-19458-9

Copyedited by Anna Jardine

Designed by Anthony McCall Associates,
New York

This book was set in Fairfield and
Futura by Anthony McCall Associates,
and was printed and bound in Italy by
Sfera International Srl.

CONTENTS

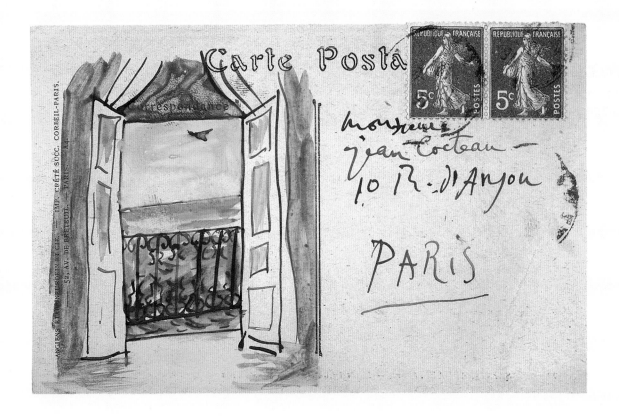

Pablo Picasso, postcard to
Jean Cocteau, St.-Raphaël, 1919.
Ink and watercolor on card.
Carlton Lake Collection,
Harry Ransom Humanities
Research Center, The University
of Texas at Austin

DIRECTOR'S FOREWORD

This publication represents the culmination of several years' research by Dr. Kenneth E. Silver, a noted art historian and professor at New York University. It accompanies the exhibition *Côte d'Azur: Art, Modernity, and the Myth of the French Riviera*, curated by Dr. Silver, which will be presented at the AXA Gallery from April 27 through July 14, 2001. Both the book and the exhibition consider the influence of a place—a sublimely beautiful place—on the imagination of modernist artists, and the effect of leisure, light, and an azure sea on the creative mind and its freedom to invent new ways of envisioning the world.

The AXA Gallery is sponsored by AXA Financial, a member of the AXA Group, one of the world's largest international insurance and related financial services companies. Since 1992, the gallery (formerly known as the Equitable Gallery) has presented scholarly exhibitions that otherwise might not find a venue in New York. We have had the honor and pleasure of collaborating with museums, university art galleries, private collectors, independent curators, and artists themselves on exhibits involving a wide variety of cultural traditions, historical periods, and media. It is our hope that these exhibitions, which are made possible by our corporate sponsorship, have brought enjoyment and enlightenment to the public.

Pari Stave
Director, AXA Gallery

ACKNOWLEDGMENTS

In the course of organizing an international loan exhibition and its accompanying catalogue, we have relied on the generosity and expertise of numerous colleagues, collectors, curators, directors, and friends.

No exhibition would be possible without the significant contribution of lenders. Our thanks go to the following individuals and institutions for their support in this regard: Maxwell Anderson, Whitney Museum of American Art; Eugénie Anglès, Anne Dopffer, and Marielle Worth, Musée National de la Coopération Franco-Américaine, Château de Blérancourt; Corice Canton Arman and Arman; Matthew Armstrong, Collection PaineWebber Group, Inc.; Linda Ashton, Sally Leach, and Dr. Thomas F. Staley, Harry Ransom Humanities Research Center, The University of Texas at Austin; Ida Balboul, Philippe de Montebello, and William S. Lieberman, The Metropolitan Museum of Art; Timothy Baum; Dorian Bergen, ACA Galleries; Grace Borgenicht Brandt; Gabriel Catone; Dr. William Chiego, Marion Koogler McNay Art Museum; Elaine Lustig Cohen; Caroline Constant; Catherine Cozzano; Martine d'Astier, Association des Amis de Jacques-Henri Lartigue; Lisa Dennison and Thomas Krens, The Solomon R. Guggenheim Museum; Anne d'Harnoncourt, Michael Taylor, and Ann Temkin, Philadelphia Museum of Art; John Donnelly and Laura Donnelly, children of the late Honoria Murphy Donnelly; Virginia Dwan; Richard L. Feigen; Gail Feigenbaum and E. John Bullard, New Orleans Museum of Art; Peter and Lilian Grosz; Willis Hartshorn and Christopher Phillips, International Center of Photography; Jessie Otto Hite, Jack S. Blanton Museum of Art, The University of Texas at Austin; Carroll Janis; Jane Kaplowitz; Elizabeth Mankin Kornhauser and Carol Dean Krute, Wadsworth Atheneum; Glenn Lowry, Avril Peck, Cora Rosevear, and Kirk Varnedoe, The Museum of Modern Art; Isabelle Monod-Fontaine, Alfred Pacquement, and Didier Schulmann, Musée National d'Art Moderne, Centre Georges Pompidou; John O'Donnell and Steven Wozencraft; David A. Ross, San Francisco Museum of Modern Art; Jorge Santis, Museum of Art, Fort Lauderdale; Donald Sultan; Joyce and George Wein; and Karl Willers, Norton Museum of Art.

For assistance with photographic materials we are indebted to Jean-Louis Andral and Jacqueline Munck, Musée d'Art Moderne de la Ville de Paris; Mrs. Philip Berman; Beverly Calté, Comité Francis Picabia; Anna Chave; Mary Corliss, The Museum of Modern Art Film

Stills Archive; Delphine Dannaud, The Museum of Modern Art; Sidney Geist; Margery King, The Andy Warhol Museum; Jean Kisling; Billy Klüver and Julie Martin; Karen Kuhlman, David Hockney Studio; Guitte Masson; Martica Sawin; David Strettell, Magnum Photos; Geneviève Taillade; André Villers; and Brigitte Vincens, Musée National d'Art Moderne, Centre Georges Pompidou.

This project has benefited immeasurably from the advice and help offered by friends and colleagues: Allen and Sue Allcock, Jeffrey Aronoff, Joseph Baillo, Anne Baldessare, Armand Bartos, Dr. Frances F. L. Beatty, Jean-Pierre Blanc, Camille Bondy, Adam Boxer, Ariella Budick, David Bull, Dr. Robert Calle, William Chambers, Judi Freeman, John Gibson, Anne Grieve, Guy Kisling, Norman Kleeblatt, Elizabeth Kley, Eric Kohler, Carol Krinsky, Rudolf Kundera, Cammie MacAtee, Yona Zeldis McDonough, Mary McLeod, Jean-Paul Monery, Jean Moreau, Rosemary O'Neill, Judith Ornstein, Olga Mohler Picabia, Faith Ringgold, Robert Rosenblum, Matthew Ruttenberg, Catherine Ryan and Mary Ryan, Julie Saul, Jack Shear, Mitchell Silver, Sidra Stich, Charles Stuckey, Ultra Violet, William Valerio, Jacques and Françoise Verdeuil, Kenneth Wayne, and the students of Kenneth Silver's 1995 senior seminar, Department of Fine Arts, New York University: Alexis Adorno, Christa Bourg, Christopher Briseño, Christina Buesing, Sally Collins, Sarah Douglas, Erin Hayes, Mi Young Hur, Zarina Mak, Amy Smith, Nathalie Smith, and Barbara Stachl. We are in debt to Anna Indych, curatorial assistant to the project, for her work on behalf of this publication, and to Ed LaMance, who provided sound judgment and good advice throughout.

Thanks are due to Doug Clouse, Anthony McCall, and David Zaza of Anthony McCall Associates for the handsome design of this book. We are grateful to Roger Conover at The MIT Press for his unwavering commitment to the project, and to Anna Jardine for her meticulous and thoughtful copyediting. The entire staff of the AXA Gallery worked diligently to ensure the success of both the book and the exhibition; we extend our appreciation to Elizabeth Cacciatore, Devan Caffrey, Nancy Deihl, and Jeremy Johnston.

Kenneth E. Silver Pari Stave
Guest curator *Director, AXA Gallery*

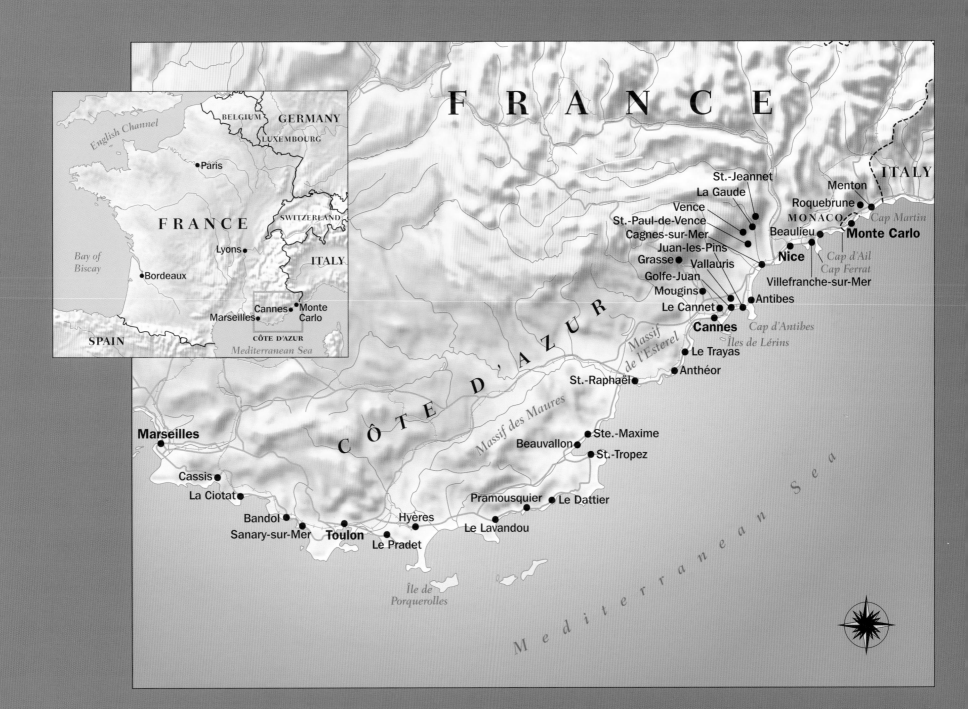

FRANCE

ITALY

St.-Jeannet
La Gaude
Vence
St.-Paul-de-Vence
Cagnes-sur-Mer
Juan-les-Pins
Grasse
Vallauris
Golfe-Juan
Mougins
Le Cannet

Menton
Roquebrune
MONACO
Beaulieu
Monte Carlo
Cap Martin
Nice
Cap d'Ail
Cap Ferrat
Villefranche-sur-Mer

Antibes

Cannes
Cap d'Antibes
Îles de Lérins

Massif
de l'Esterel
Le Trayas
Anthéor
St.-Raphaël

CÔTE D'AZUR

Massif des Maures

Ste.-Maxime
Beauvallon
St.-Tropez

Marseilles

Cassis

La Ciotat

Pramousquier • Le Dattier

Bandol
Sanary-sur-Mer
Toulon
Le Pradet

Hyères

Le Lavandou

Île de
Porquerolles

Mediterranean Sea

Inset map

English Channel

BELGIUM
GERMANY
LUXEMBOURG

Paris

FRANCE

SWITZERLAND

Lyons

ITALY

Bay of
Biscay

Bordeaux

Cannes
Monte
Carlo
Marseilles
CÔTE D'AZUR

SPAIN

Mediterranean Sea

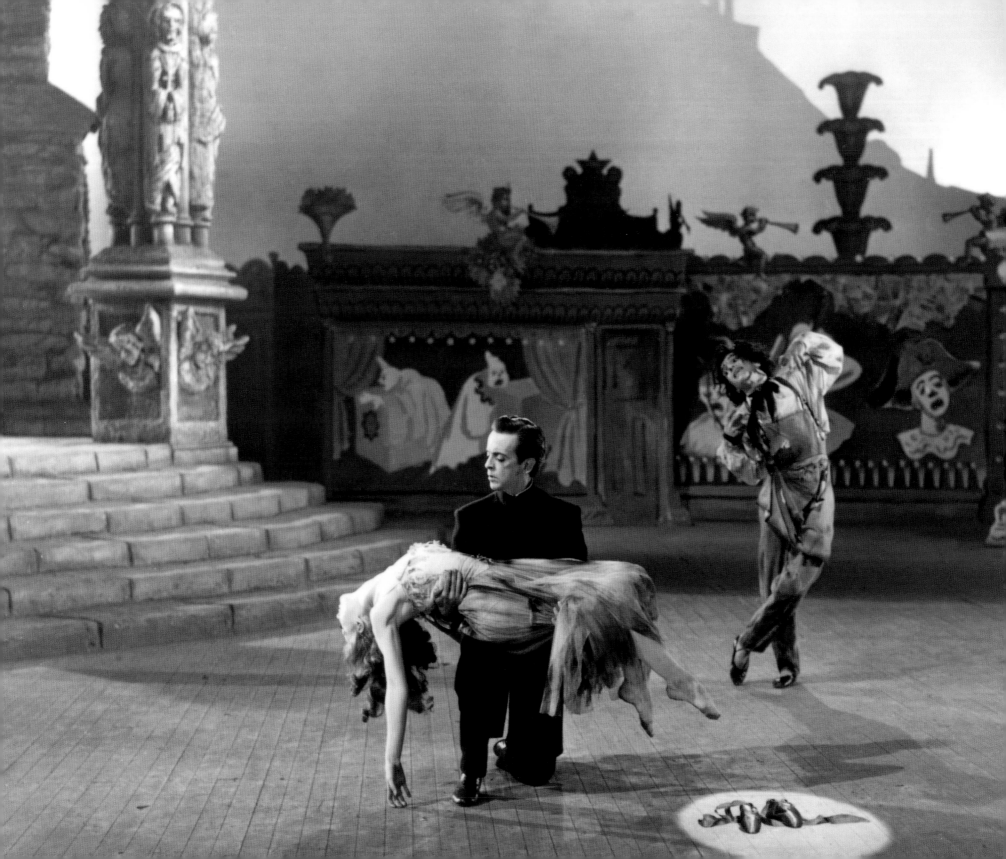

Art, Love, and Death on the Riviera, a Foreword

Although I didn't realize it when I began working on this study a number of years ago, the project had been simmering in my mind for a very long time. If I thought at all about why I had chosen to write a book and curate an exhibition about art on the French Riviera, I assumed it was because I had once almost gone to art school in Nice. When I got there—I was twenty at the time, it was 1969—I was so depressed by a city that once had been called the Queen of the Riviera but looked to me like Miami Beach, where my grandparents lived, that I took the first train out of town and joined some friends in Aix-en-Provence, where I spent a productive year at an art school there. While in Aix, I occasionally made forays to the coast (even to Nice, whose virtues I subsequently discovered). Two places, in particular, were as beautiful and unspoiled as any I'd seen: Cassis, just east of Marseilles, and the island of Porquerolles, a short boat ride from Hyères, about an hour and a half farther east. Thirty years ago both were places which, if not unknown to the tourist industry, were nonetheless uncrowded, and the residents mostly local in their worldview.

But neither of these places, nor others nearby, nor the friends I made there, had much to do with why I felt compelled to tell the story that follows. Because it was not real life as I knew it on France's Mediterranean coast but a movie I saw long before I had been there that determined my course of study. The movie was Michael Powell and Emeric Pressburger's *The Red Shoes*, made in 1947. One of the great films in the history of cinema, it was only slowly accruing its immense reputation when I first saw it in 1955. It is a "ballet movie," if it has to be assigned to a genre, but a dark and ferocious one, based on Hans Christian Andersen's tale about a girl who buys a pair of fine-looking red shoes to wear to a dance, which turn out to have a life of their own: when the girl grows weary, the shoes keep dancing, until—having danced her way through the town and out to the countryside—she dies of exhaustion. There is, in fact, a "Ballet of the Red Shoes" as a centerpiece of the film, a story within the story of Victoria Page (played by Moira

Scene from the film *The Red Shoes,* 1947. Death of the heroine in "The Ballet of the Red Shoes"

Shearer), a young English ballerina of great ambition who dances for the fictional Ballet Lermontov and is eventually cast to dance the role of the tragic heroine in the movie ballet.

The plot of the film, quite simply, revolves around Vicky's struggle between her devotion to art, as incarnated in her passionate but unphysical attachment to Boris Lermontov (played by Anton Walbrook), the company's impresario, and her love for her husband, the composer of the ballet, Julian Craster (played by Marius Goring). The climactic scene takes place in her dressing room, moments before a performance of the ballet: Boris and Julian fight for Vicky's soul, her mentor arguing for the glories of art and enduring fame, her beloved for the joys of companionship and the necessity of breaking free of Lermontov's Svengali-like hold. Seeming to have made the choice of art over love, Vicky slowly walks to the stage, where her red ballet slippers take control. She runs from the theater and down a flight of steps to a parapet overlooking nearby railroad tracks, and as a train pulls into the station, she leaps. Lying bloodied on the tracks, surrounded by onlookers, she speaks her dying words to her husband: "Julian, take off the red shoes."

Looking at the film from the present, one can readily discern the postwar social and political narratives of which it partakes: the struggle for women to choose between the work-oriented freedom they had experienced during the war and the obligations of wife-and-motherhood in the years that followed;

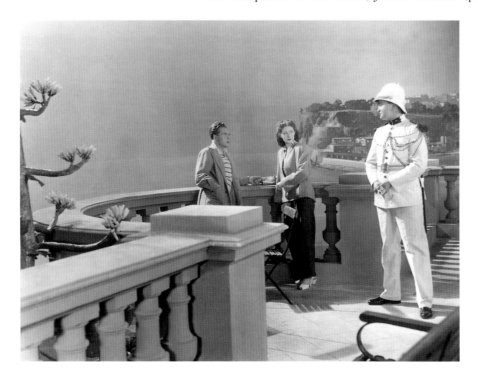

Scene from *The Red Shoes,* 1947. Julian and Vicky at Monte Carlo

and—so obviously does Lermontov, who speaks with a Germanic accent, bring to mind the Nazis—the price that fanaticism, artistic or otherwise, exacts from those who are seduced by the sublimities of commitment and discipline. But the six-year-old I was saw nothing of this, nor for that matter can I say that I took the movie at face value. As far as I was concerned, this was *my* story, and even if I hadn't the slightest idea of what adult love might be like, I already had a taste of the excitement and intensity of ballet. I was in my first dance class and had already been in a recital (I played an infantile "King of Hearts" in some concoction of my ballet teacher's), and I was dreaming of life as a dancer. The film was a warning for me: Ballet was intoxicating and dangerous, and the only thing that could result from my insistence on dancing was . . . my own death. I had, as they say, been traumatized (indeed, I dreamed my own version of the movie, on and off, for years). I quit dancing shortly afterward, never admitting to anyone but myself—and hardly even to myself—what *The Red Shoes* had done to me, and made me do.

Yet the scene of my trauma would not fade—and that scene was the French Riviera. The second half of the film, in which the Lermontov company arrives on tour in Monte Carlo, was a dazzling record of the Côte d'Azur in the late 1940s. As Michael Powell explained in his remarkable autobiography,[1] the character of Lermontov is based largely on Serge Diaghilev, impresario of the Ballets Russes, which was headquartered in Monte Carlo (and whose chief choreographer, Léonide Massine, acts and dances in *The Red Shoes*). Moreover, Powell had met many members of the Ballets Russes as the son of "Captain Powell," owner of the well-known Voile d'Or hotel in St.-Jean-Cap-Ferrat, which he eventually inherited (and sold shortly thereafter). He knew the coastline between Cannes and the Italian border intimately, and the film is an extraordinarily loving homage to a place Powell could still describe in minute detail decades later: the unforgettable flight of steps Vicky ascends to Lermontov's house above Cap Ferrat is at the villa La Léopolda, designed by the American Ogden Codman, Jr. (probably the greatest villa

on the Côte d'Azur; it is still there, as I discovered on a moonlit drive up into the hills a few years ago); the little port where the dancers throw a birthday party one night is Villefranche-sur-Mer; the theater where "The Ballet of the Red Shoes" has its premiere is the Théâtre de Monte Carlo, behind the casino. All these sites had been fixed in my memory by Powell and Pressburger as astonishing places to which I would never have access, or so I assumed. When at twenty I took myself to Nice, and then immediately ran away, I was making my first attempt to reclaim a place that had lived in my imagination and would not let go; but slowly, as the years passed, I made my way back, incrementally reclaiming for myself a landscape—and a delirious, gorgeous, no longer dangerous dream—that I thought I'd lost before I'd even had it. The study that follows is my expression of gratitude to The Archers—as Powell and Pressburger called their production company—for having given me my first, all-too-powerful glimpse of art, love, and death on the Riviera.

Introduction:
Artists, Tourists, and the Pleasure Problem

How seriously can one take art made in a place devoted to pleasure and hedonistic pursuit? How do we reconcile the work of making art with the leisure that is the raison d'être of the French Riviera? Questions like these, usually unstated, have long impeded the writing of the history of modern art on the Côte d'Azur (as the French call their southeastern coast). Although the Riviera is among the most important centers for twentieth-century creative endeavor, its role in the real and imaginative lives of many of the century's most significant visual artists has long been ignored by critics and historians. The exponential increase in studies of tourism by sociologists, anthropologists, and cultural historians over the last decade has, however, helped rectify the situation: a place that had hitherto been considered no more than a recurring detour on the itinerary of modern art has begun to acquire a cultural profile.[3]

> "It seems like a paradise which one does not have the right to analyze, and yet one is a painter, for God's sake . . . !"
>
> **Henri Matisse** to Charles Camoin, Nice, May 1918[2]

The neglect of the Côte d'Azur is nonetheless understandable. The role of pleasure in modern art has itself been a contested subject, especially of late—exactly whose pleasure does art represent, and for what audience? But even if we leave more politicized considerations aside, there remains the question of whether pleasure of any kind is commensurate with art's sterner demands. We may well appreciate seventeenth-century Dutch "Merry Company" images, or Antoine Watteau's paintings of *fêtes galantes*, or even, much further back, Etruscan bronzes of male divers or Roman wall paintings of bikini-clad young women—all these works have gained in stature as the pleasures they convey have lost their contemporary charge. But our own, modern pleasures are another matter. Just as Matisse wrote his friend the painter Camoin that he felt guilty about "analyzing" the paradise he had found on the Riviera, we too are uncertain about offering an analysis of that which is so pleasurable, and about the morality of pleasure itself.

In *Exile's Return*, discussing the exodus of American writers to Europe in the late 1920s, Malcolm Cowley noted that all along the shores of the Mediterranean, but especially in the Balearic Islands and on the French Riviera, colonies of expatriates were springing up: "In those days almost everyone seemed to be looking for an island, and escape from the mass was becoming a mass movement. There is danger in using the word 'escape.' It carries with it an overtone of moral disapproval; it suggests evasion and cowardice and flight from something that ought to be faced." What he was talking about, of course, was what we call puritanism, the word "escape" implying the pleasurable avoidance of our moral and social obligations ("escapism" constituting the epidemiological form of a too intense devotion to pleasurable pursuit). But puritanism, which is often mistaken for an ethnic, religious, and historical phenomenon, is, as we usually mean it, nothing of the kind. It is a socioeconomic phenomenon, an expression of the work ethic of the aspiring middle class—or of the proletariat, in the old Soviet Union—in which productivity is valued over consumption, and labor over leisure. Our discomfort with questions of pleasure is in large part discomfort with questions of class. If we prefer the analysis of art made in Paris, or New York, or Berlin, it is because we recognize them as sites of serious work; the idea that an artist might produce great art at a beach resort can result only in what has lately been called cognitive dissonance.

"The sun is really paradisiacal here. . . . Leave all your concerns and the rain in a corner and come down."

Marcel Duchamp to Constantin Brancusi, Villefranche, September 1931

One way to cope with the pleasure problem is to deny it, a venerable tactic in art criticism. The Goncourt brothers did precisely this, for instance, with the art of Watteau, claiming that his work was essentially melancholy. Such an interpretation, as Donald Posner has pointed out, would have astonished both the artist and his contemporary critics, who considered the paintings to be, without exception, gay and cheerful. But this was not an asset for the Goncourts, or for

subsequent commentators, for whom Watteau's supposed melancholy "allowed one to attribute a quality of seriousness, of profundity, to images that appear on the surface trivial or pointless in subject," and justified their seeing the artist as a philosopher rather than a mere limner of pleasure.[4] In similar fashion, the paintings Matisse made in his hotel rooms and apartments in Nice, so obviously filled with the joys of escape and the pleasures of a quiet, orderly Riviera existence, have been found "anguished" by more recent critics, who, like the Goncourts, must be worried that their artist will not be taken seriously. "We hope to have given an image of Matisse in the years 1917 to 1930 that is truer to reality than the comfortable and deceptive cliché generally admitted," wrote, in 1986, one of the curators of an exhibition devoted to Matisse's Nice oeuvre: "We think that the figure emerging from an attentive examination of his work is diametrically opposed to *'le peintre du bonheur'* that he in fact never was. . . . Obsessions filter through and anguish emanates from the succession of images these fifteen years of painting offer us. The depicted world is one of waiting and sadness; a world of heavy eroticism, almost a world of the voyeur. A distant world, in which communication seems impossible, or futile."[5] It would seem that any Matisse—even a complete neurotic, miserable for nearly a decade and a half on the Côte d'Azur—is deemed preferable to a "painter of happiness."

"It was a paradise!"

Olga Mohler Picabia to the author, Paris, June 1995

Class aspiration—or perhaps it is class denial—has also been a factor in art historians' neglect of the Riviera, in an almost antithetical manner. Here what gets in the way of clear thinking is not the work ethic, but the word "tourist," which sticks in the craw of many commentators. For it is one thing to retreat to one's house in the country or at the seaside, and quite another to go on holiday for a week or two (the former signifies privileged relaxation, the latter middle-class paid-vacation time). The idea that an artist might also be a tourist is cause for epistemological scandal: from an elite perspective,

the phenomenon of tourism is a debased form of leisure, so to enunciate the words "tourist" and "artist" in the same breath is to wreak havoc with carefully delineated cultural distinctions. "He did not think of himself as a tourist, he was a traveler," says the narrator of Paul Bowles's *The Sheltering Sky*: "The difference is partly one of time, he would explain. Whereas the tourist generally hurries back home at the end of a few weeks or months, the traveler, belonging no more to one place than to the next, moves slowly, over periods of years, from one part of the earth to another." Indeed, the short-term and superficial response to distant places and unfamiliar people that we usually associate with tourism would appear to be the opposite of the profound reckoning we associate with art worthy of the name.

How long must an artist, whether we call him tourist or traveler, remain in one place in order to make a work of art? Do we discount Dürer's watercolors of the Alps because they were made on his way back from Italy, or ignore his Venetian pictures altogether because they were made while he took a break from his cold northern home? The immensely cultivated city of Venice and the modern resorts of the French Riviera hardly represent the same kind of "escape," of course. The Côte d'Azur offers any number of inducements to leisure and impediments to concentrated endeavor that sixteenth-century Venice did not. To work in a place where others had come to play —in particular, for modern artists, to work while their collectors were amusing themselves in close proximity—required a good deal of self-discipline, which many of the remarkable talents who worked on the Riviera possessed in abundance. What's more, artists such as Francis Picabia and Kees van Dongen, both of whom produced vast bodies of work on the Côte d'Azur, often played as hard as their patrons, and sometimes alongside them. Play—the unfettered, imaginative return to a childlike state of creativity, art's ludic

"This sickening Côte d'Azur—I've had my fill of this pajama-blue, fake-blue . . . song and dance."

Fernand Léger to Simone Herman, just after leaving Nice, August 1933

aspect—has been a crucial idea in the modernist project since at least the time of Jean-Jacques Rousseau, manifesting itself in many forms of modern primitivism. This is not to deny that both work and play take time, no matter how brief. For many artists who traveled to the Riviera, working vacations were only a matter of a week or two—Georges Braque, Hans Hofmann, George Grosz, Paul Klee, and Lisette Model all managed to make significant work as short-term visitors. For others—including Matisse, Picasso, Jacques-Henri Lartigue, and Eileen Gray—ever longer visits tended to be the norm, until the Côte d'Azur became a second residence, or even a primary one. The work they produced there was thus subject to the same laws of development and refinement as work made anywhere else, even if their styles and themes had specific resonance in the context of coastal life.

Certainly, vacations, of whatever duration, and the resorts developed for them are haunted by a peculiar, heightened relationship to time. A friend of mine becomes anxious in anticipation of the end of her vacation at the moment she begins to make her plans; for an artist such as Pierre Bonnard—who owned a house on the Riviera, where he spent months at a stretch—it was the calendar that gave shape to his sojourns. If we look at an appointment book he used for making pencil sketches and notes for visual ideas [see page 22], we find, for the last day of October and the first three days of November 1934, drawings of two great Riviera themes, landscape and bather. Across the top half of the two-page spread (October 31 and November 2) is a detailed view from his terrace at Le Cannet, including foreground foliage, the roofs of Cannes in the middle distance, and the Esterel mountain range beyond; across the bottom half (November 1 and 3) is a second horizontal composition, one of his classic bathtub images, in which we catch a glimpse of a torso and two legs stretched out toward the clearly delineated hardware of the faucets in the upper right. It is remarkable to see how quickly and completely these two images are brought to life with such limited means, yet it is also noteworthy that these paired,

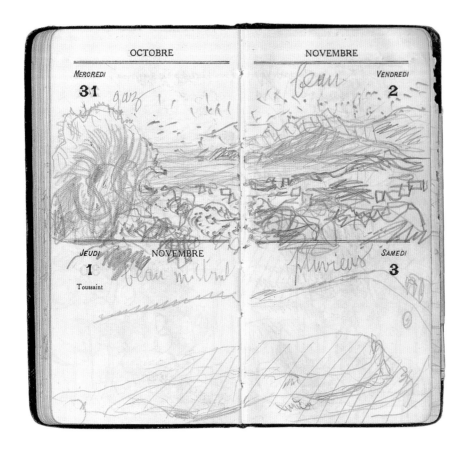

OCTOBRE NOVEMBRE

MERCREDI VENDREDI
31 **2**

JEUDI NOVEMBRE SAMEDI
1 **3**
Toussaint

Pierre Bonnard, pages
from appointment book,
Le Cannet, 1934.
Bibliothèque Nationale, Paris

timeless subjects are realized on a temporal and meteorological template: scattered among the two compositions are these notations: *"Jeudi, 1 (Toussaint): beau/mistral"* (Thursday, 1 [All Saints' Day]: fair/mistral); *"Vendredi, 2: beau"* (Friday, 2: fair); *"Samedi, 3: pluvieux"* (Saturday, 3: rainy). Time and the weather, the twin phantoms of resort life—which can spell the difference between a wonderful vacation and a ruined one—haunt the waking consciousness of the artist as surely as they do that of the typical tourist.

And there is another way in which time is of the essence for resorts. If there is a decidedly melancholy aspect to a resort off-season (which can be quite pleasurable), there is nothing quite so depressing as a resort past its prime. Brighton, Biarritz, the Catskills, even Coney Island, were once teeming with life, filled to overflowing with the promise of relaxation and joy which now has abandoned them (although it is also true that a resort can be revived, with enough effort and some good luck; Miami Beach is a striking example). Obviously, when we invoke the notion of the life and death of resorts, we are talking about economic forces: if there are too few tourists, a resort never catches on; if there are too many, it can be overwhelmed by its popularity, which results in, among other problems, the depredation of local landscape, the setting that is usually one of the reasons a vacation spot becomes attractive in the first place. But for whatever reasons—economic spoliation, the whims of fashion,

a shift in the types of leisure-time activities that are currently popular—almost all resorts, eventually, lose their vitality and become melancholy. Unlike major cities, whose economies depend only incidentally on tourism, resorts are inherently fragile entities. Is this, perhaps, part of the "melancholy" that has been misattributed to Watteau's party-goers and the lounging inhabitants of Matisse's Riviera rooms—the inherent sadness that we as viewers feel looking back at yesterday's pleasures?

The French Riviera exemplifies this life cycle of the modern resort, and at the same time, because it was the single most celebrated resort area of the twentieth century, it is a special case. The Côte d'Azur is hardly in its prime: rampant development since World War II has spoiled the scenic beauty of much of the coastline (although as early as the 1920s, as we shall see, there were those who were mourning the demise of a once unspoiled Riviera). Two things make the Côte d'Azur special, and both are related to scale. First there is the sheer size: almost 150 miles of inhabitable coastline, from Marseilles at its western end to Menton at the Italian border. Among the various settlements along this coast are large cities, Marseilles and Nice, roughly at either end; several medium-size towns, including Toulon, Hyères, Cannes, and Menton; and a vast assortment of smaller communes. There are different kinds of ports: commercial, such as Marseilles, La Ciotat, and Golfe-Juan; navy, such as Toulon and Villefranche; fishing, such as Cassis, Sanary-sur-Mer, St.-Tropez, Anthéor, and Antibes (and most ports do double or triple duty, facilitating commercial, military, and pleasure-craft functions). And there are several capes and peninsulas, which provide especially scenic residential areas—including St.-Tropez, Cap d'Antibes, Cap Ferrat, Cap d'Ail—and hill towns farther inland—Le Cannet, behind Cannes; Cagnes, Vence, and St.-Paul-de-Vence between Nice and Cannes. This remarkable variety of sites is a boon for the tourist (and for the artist); one may lie on the beach or work in the morning, visit a fishing port for lunch, work or play again in the afternoon, go up into the hills for dinner in the evening, or over to Monte Carlo for gambling. Boredom

is easily overcome by a mere change of venue, although it also has resulted, from fairly early on, in a congested road system. Still, even with its postwar development, the Côte d'Azur is large enough to have remained relatively bucolic at any number of points.[6]

But the French Riviera is special in another way that relates to scale: its mythic dimension. Not since classical antiquity, when the development of the Bay of Naples resulted in a vast and fabled seaside resort, has there been anything like the Côte d'Azur.[7] Although France's southeast coast was no more than a rarely visited place on the map before the middle of the nineteenth century, it rapidly gained in reputation, and mythic

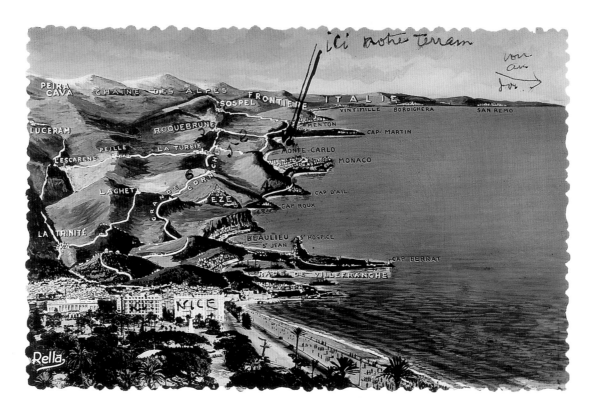

Postcard "La Côte d'Azur: Panorama Aérien de Nice à la Côte Italienne," c. 1953. Photomontage, with Le Corbusier's annotations for Marguerite Tjader-Harris in black and red ink. Collection Centre Canadien d'Architecture / Canadian Centre for Architecture, Montréal

allure, thereafter. "Once the playground of Europe, the Riviera has now become the Playground of the World," wrote one Captain Leslie Richardson in 1923. "In addition to trains de luxe from all over the continent of Europe, vast ocean greyhounds now call at Monaco direct from New York, while Toulon and Marseille receive liners from India, China, Japan, and Australia. . . . Why do they come? What is it that attracts men and women from all over the world, white, black, and yellow, to the narrow strip of coast between Marseille and Genoa?"[8]

Why, indeed? Scenic beauty and (mostly) good weather were the area's natural gifts, but these would have been insufficient unto themselves to account for what would be the Riviera's unique standing among the world's "pleasure zones." The presence of celebrities, the extent of organized entertainments, and numerous highly effective publicity campaigns all played their parts in the creation of this legendary resort.[9] Yet even these factors alone would have been powerless to make of the Côte d'Azur "a realm invisible, a state not of the mind so much as of the heart," which, according to two observers in the late 1930s, "lies anywhere around the corner on the Riviera, in mountainous eastern Provence and in the ancient County of Nice."[10] Rather, it was the status conferred on the coast by art—the tremendous quantity of works, made by scores of artists, well known and not— that transformed the Riviera from a physical place into a site of the imagination. Painters first and foremost, but also sculptors, photographers, and architects over the course of decades turned geography into myth. This, then, is my subject: How, out of 150 miles of Mediterranean coastline, modern artists created a dream space for the twentieth century.

Elsewhere

Modern art on the southeast coast of France begins, we might say, where Paul Cézanne leaves off. If we look east across the Gulf of Marseilles from L'Estaque, as we do in Cézanne's painting [figure 1]—above the chimneys and commercial structures in the foreground, past the expanse of blue sea, toward the bare hills on the far shore—we are looking at the Riviera, and the future of modern art.[11] The coastline from Marseilles eastward, all the way to Menton, became easily accessible by the early 1860s after the completion of the east-west railroad line. With its connection at Marseilles to the north-south line, the PLM (Paris-Lyon-Méditerranée railroad), a rail journey from Paris could be made to almost anywhere on the Riviera. What had previously been the far-off south was now open to commerce and tourism. *La France méridionale* began to appear, as well, on the map of artistic displacement from Paris: Vincent van Gogh dreamed that his friend Paul Gauguin would join him in Provence as the leader of a collectivist *atelier du Midi,* to be established in Arles; a Provençal by birth and upbringing, Cézanne was spending more time at his family's home in Aix-en-Provence and painting in the surrounding countryside. But although their art flourished in the Midi (French shorthand for the south of the country), neither van Gogh nor Cézanne ever ventured east, beyond the outskirts of Marseilles, to work on the Riviera.

This was probably because nothing in particular drew them in that direction. The southeast coast was still little-known, and in some ways, not especially hospitable to an ordinary visitor; tourists there were more likely to be foreign than French, and more apt to be aristocratic than bourgeois. The British had established a small but important community in Nice in the late eighteenth century, and in 1834, Henry Brougham, former lord chancellor of England, arrived in Cannes. He eventually built himself a house there, the Villa Eléanore, and encouraged his compatriots to do likewise. Upper-class Americans, Germans, Russians, Belgians, and French gradually established themselves along the coast. Queen Victoria, Empress Eugénie of France, Léopold II of Belgium, and assorted

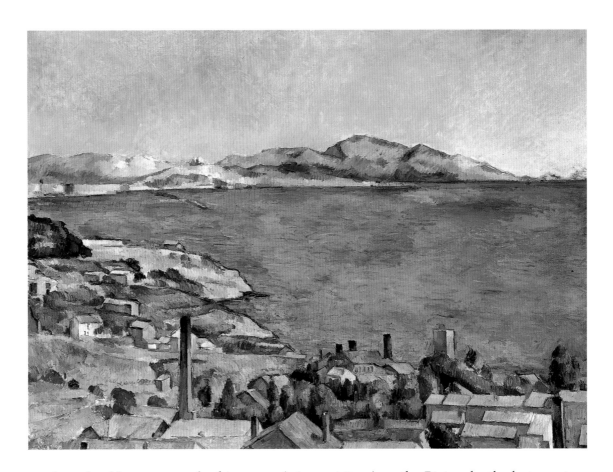

1. Paul Cézanne, *The Gulf of Marseilles Seen from L'Estaque,* c. 1884. Oil on canvas. The Metropolitan Museum of Art, New York. H. O. Havemeyer Collection. Bequest of Mrs. H. O. Havemeyer, 1929

royals and nobles were regular *hivernants* (winter visitors) on the Riviera by the last quarter of the nineteenth century. This situation—of a small, native population of peasants catering to the needs and desires of rich foreign visitors—made the Riviera a peculiar and peculiarly modern place, the model of cosmopolitan resorts that now proliferate worldwide.

While there were important native painters in the region, including Émile Loubon, director of the École des Beaux-Arts in Marseilles, there was little in the way of contemporary

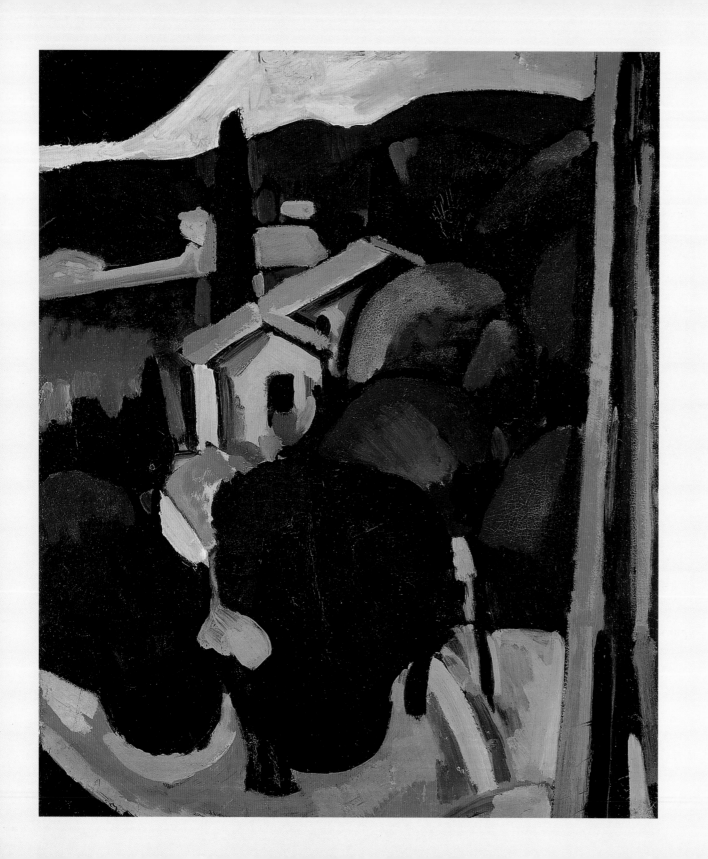

art to attract a visiting painter farther east along the coast.[12] Moreover, while western Provence—especially the area around Arles, Nîmes, Avignon, Aix, and Marseilles—possessed a powerful mythic dimension shaped by historians and poets (from the Greeks, Romans, and early Christians, to medieval troubadours, to Frédéric Mistral in the nineteenth century), the eastern Mediterranean coast of France had been relatively ignored. It did not begin to acquire a literary profile, or even a name of its own, until the publication in 1887 of Stephen Liégeard's *La Côte d'Azur*, a comprehensive ode to the charms of this hitherto exclusive enclave. Guidebooks to the coastal region did exist, but no one had "packaged" it, as Mary Blume has said, with the panache of Liégeard. "Not only does he know all these daughters of the sun," wrote the reviewer for *Le Figaro*, in reference to the author's purplish descriptions of Menton, Nice, and Cannes, "but he loves them and makes *us* love them."[13] The Académie Française awarded *La Côte d'Azur* its Prix Bordin, thus helping establish both a minor literary figure and a new destination for a larger, less strictly aristocratic group of tourists than the one already encamped there. When, the next year, Guy de Maupassant published *Sur l'Eau*, an account of a sailing trip along the same coastline, in which he introduced his readers to charming fishing ports such as St.-Tropez, the Azure Coast's long obscurity came to an end.[14]

Because it had for such a long time been terra incognita—geographically, socially, and poetically—the Côte d'Azur was useful to artists in a way the rest of France was not. Especially if one stayed away from the cities and larger towns and concentrated instead on the villages and fishing ports, the Riviera was ripe for artistic "discovery." The Fauve painter André Derain wrote to his friend Maurice de Vlaminck in May 1907 from Cassis, a small fishing port east of Marseilles [see figure 2], that he found the landscapes splendid, "certainly more beautiful than those at Collioure," the town on the southwest coast where he had previously worked alongside Matisse. Derain commented on the motifs he would like to undertake—including a pine tree outlined against the sky, and a woman carrying

2. André Derain, *Landscape at Cassis*, 1907. Oil on canvas. New Orleans Museum of Art. Gift of William E. Campbell

a basket on her head in the middle of a field—and on the wonderful weather; there was about the place "a sweetness of tone, of odor, an atmosphere of strangeness," the last word, *"étrangeté,"* conveying in French a sense of both the unusual and the foreign.[15] In the same period, Georges Braque and Othon Friesz, two other young recruits to Fauvism, had been painting at La Ciotat, a port east of Cassis. [See figure 3.] Reflecting on his initial trip to the south, Braque remarked on his excitement as well as his inability to sustain interest in a new place, as if disappointment were the inevitable finale to touristic novelty: "That first year, it was pure enthusiasm, the surprise of the Parisian who discovers the Midi. The next year, it was already different. I would have had to go as far as Senegal [for the same thrill]. One can't count on more than ten months of enthusiasm."[16]

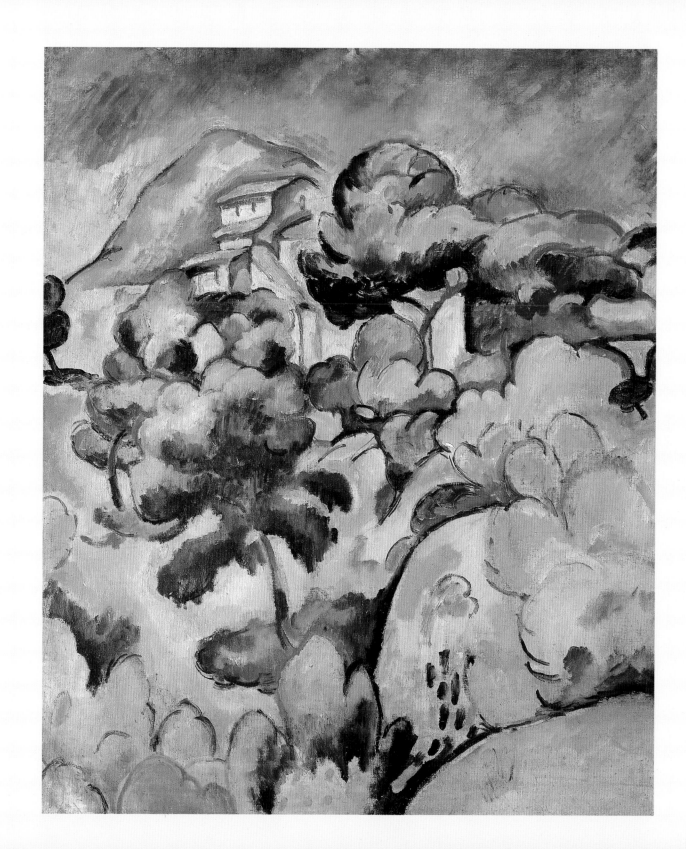

3. Georges Braque, *Landscape at La Ciotat*, 1907. Oil on canvas. The Museum of Modern Art, New York. Acquired through the Katherine S. Dreier and Adele R. Levy Bequests

Pioneers

It was actually two members of an earlier generation, Pierre-Auguste Renoir and Claude Monet, who were the pioneers of artistic tourism on the Riviera. There is nothing surprising in this, inasmuch as the Impressionists had already pioneered painting on France's northern coast. Along the English Channel, from the 1860s through the early 1880s, the two painters and their friends had contrived to make an art out of the new leisure-time pursuits of the French bourgeois, as they observed them at Ste.-Adresse, Trouville, and other resorts. But the northern coastal playground had rapidly passed through the usual cycle of discovery-to-spoliation, so that by 1884, Maupassant could write that "Normandy is trodden by as many pedestrians as the Boulevard des Italiens [in Paris]" and "Brittany hides . . . an odious tourist behind every menhir."[17] A new place was needed for inspiration, a place both Maupassant and the Impressionists were in the process of discovering. In 1883, four years before Liégeard coined the term "Côte d'Azur," Renoir and Monet made their first, whirlwind tour of the coast—Marseilles, Hyères, St.-Raphaël, Monte Carlo, Menton, and a few Italian towns, all in two weeks. Renoir would return to the Riviera numerous times in succeeding years, eventually buying property and building a house on a hillside overlooking the sea at Cagnes, outside Nice. Monet, who never settled in the south, was characteristically more businesslike in exploiting what he had glimpsed on that first trip. He returned the next year to paint on the Italian Riviera and briefly at Menton, and in 1888 spent almost four months in Antibes, bringing thirty-nine paintings nearly to completion.

Working on the coast was not without its difficulties for either artist; they had to accustom themselves to the unfamiliar environment. Renoir was frustrated in his efforts to capture the special qualities of the local vegetation: "The olive tree, what a brute!" he told René Gimpel. "If you realized how much trouble it has caused me. A tree full of colors . . . Its little leaves, how they've made me sweat!"[18] For Monet, a complainer by nature, it was the clarity of the light that posed a challenge: "How beautiful it is here,

but how difficult to paint! It's so clear in its pinks and blues that the slightest misjudged stroke looks like a smear of dirt."[19] Time and the weather exerted continual pressure: "I do not know whether what I did is any good," Monet wrote his dealer, Durand-Ruel, during his first extended stay. "If I could afford the time, I would erase all this, and would start all over again, for you have to live in a country for a certain while in order to paint it; and you [have] to have worked there painstakingly before you can render it with any degree of certainty."[20] And toward the end of his second working trip, Monet commented: "A curse follows me to the end: there is a splendid sun, but the mistral wind is so strong that it is impossible to stand up in it."[21] More than anything else, though, it was the unexpected luminosity of the Riviera that challenged him. On a day when he felt over-whelmed by the light in Antibes, he wrote a friend: "I am digging and I am plagued by every devil. I am very worried about what I am doing. It is so beautiful here, so bright, so luminous.

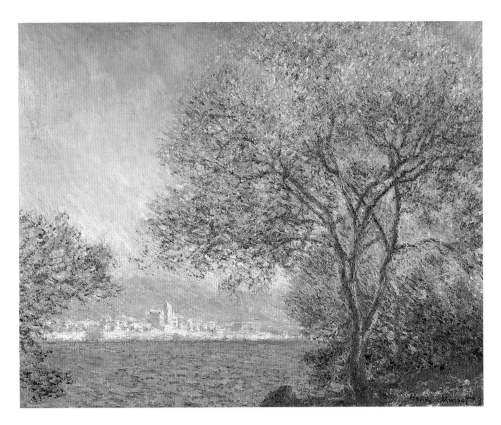

4. Claude Monet, *Morning at Antibes*, 1888. Oil on canvas. Philadelphia Museum of Art. Bequest of Charlotte Dorrance Wright

One swims in blue air and it is frightening."[22] On another day, feeling confident and accomplished, he wrote to his companion, Alice Hoschedé: "What I will bring back from here will be sweetness itself, white, pink, blue, all of it enveloped in this fairytale-like air."[23]

As it happened, Theo van Gogh bought ten of the Antibes pictures for the Boussod-Valadon gallery, which exhibited them in Paris hardly a month after Monet's return to

the capital. [See figure 4.] The response of friends and critics was mostly enthusiastic, although one critic, Eaque (the pseudonym of Paul Robert), accused the artist of forcing on the public a "garish originality" in the paintings,[24] and Félix Fénéon, a friend of Georges Seurat, claimed that they demonstrated Monet's lack of "contemplative and analytical" depth, as well as his excessive "bravura execution" and "improvisational" skills, in short, his "brilliant vulgarity."[25] The pinks, violets, yellows, and aquamarines of Monet's southern palette must have come as a shock, even to those accustomed to the brilliantly colored works the Impressionists had painted in the north. But one wonders to what extent the reputation of the Côte d'Azur as a sybaritic resort that catered to the tastes of a moneyed clientele—and which had just been given its own showy, intensely hued name by Liégeard—figured in these reactions to Monet's Antibes paintings. It would not be the last time that words like "vulgar" and "garish" would be invoked to describe both the coast and the art produced there.

Lux

Is color, garish or otherwise, more apparent on the Côte d'Azur than in the north?
In the purely empirical sense, probably the opposite is true. As many artists have discov-
ered, the southern sun's brilliance tends to overwhelm color, to wash it out. Picasso
said that the white light of Antibes exaggerated form at color's expense.[26] Yet if we look
at works made on the Riviera by Picasso, Monet, Braque, or almost any other painter,
the colors are especially vivid. Part of the reason for this apparent contradiction is
explained by such terms as "brilliance" and "luminosity," which recur in artists' discus-
sions of their work on the coast. The abstract colorist Nicolas de Staël, writing to his
dealer, Jacques Dubourg, from Le Lavandou in 1952, said that "the light is simply daz-
zling here, much more than I'd remembered. I will make some things for you of the sea,
[and] the beach, capturing the intensity of the light if all goes well."[27] The artist who
works on the Côte d'Azur is not, then, copying color in an empirical sense, but is finding
—in Symbolist fashion—its equivalent; it is the intense luminosity of the south that
is being conveyed by the heightened palette. Pierre Bonnard felt that the difference in
luminosity between Paris and the coast was so drastic that the artist had no recourse
other than to exaggerate: "In the light experienced in the south of France, everything
sparkles and the whole painting vibrates. Take your picture to Paris: the blue turns to
gray. . . . Therefore, one thing is necessary in painting: heightening the tone."[28] As is not
the case in the highly colored north, with its dense vegetation and its ever-changing
light, when color appears in the south—in, say, the vermilion of bougainvillea—it does
so against a parched, blanched landscape that is bathed in an overall brilliance. Hue
springs forth to the eye with a singularity that the northern profusion of subtle colors
cannot match. The brilliant palette of many artworks made on the Côte d'Azur results
from an inversion of quantities: lack of coloristic variety becomes a surplus of coloristic
intensity. The highly colored art of the Riviera is, like the mask in Greek tragedy, a
lie that tells the truth.

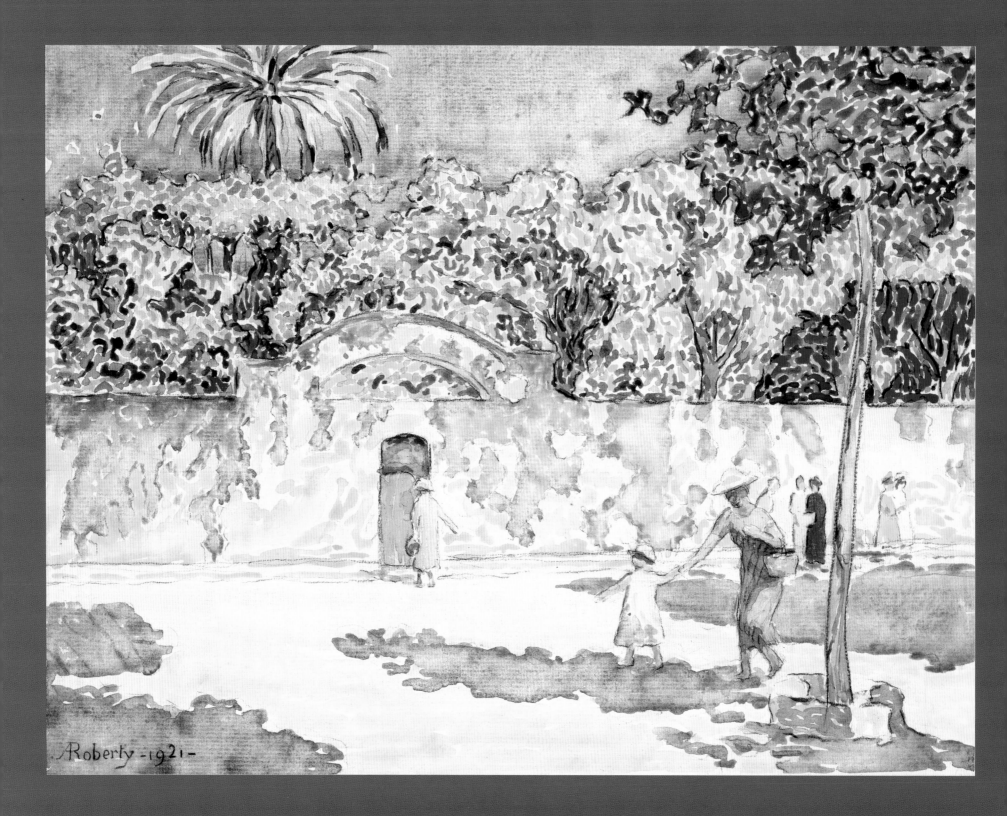

Roberty -1921-

This hyperbolic use of color (or, in Bonnard's formulation, the compensatory heightening of tone) is apparent in the 1921 view of a village square in St.-Tropez by the largely forgotten practitioner André-Félix Roberty [figure 5]. Here the yellow of sunlight and the violet of shadows convey the sense of a warm, languid southern world. Complementary violet and yellow became a chromatic signature of Côte d'Azur painting, adumbrated in Monet's Antibes pictures, where we first find variations in the contrast of lavender and pink to pale yellow. Bonnard also employed violet and yellow regularly as a major color theme in many of the works he made at Le Cannet in the 1920s through the early 1940s. Is it by accident that violet and yellow were so crucial to the art Gauguin made in the South Seas? There is, if not an empirical aspect to this preference, at least one based on the visual logic of observation, that is, that violet is the shadowed contrast to the sun's yellow brilliance. "The bright blue is absolutely marvelous," de Staël wrote his friend, the poet René Char, "and suddenly the sea is red, the sky yellow, and the sand violet."[29] Moreover, whether or not one can actually see a shade of violet in the sand, of the three basic sets of color complements—the other two being red and green, and blue and orange —the combination of violet and yellow produces the greatest tonal contrast; if one wants to convey the intense luminosity of the south, this pairing of colors provides the juxtaposition of lightest and darkest. Yet the violet–yellow contrast is first and foremost rhetorical: it is the device that tells us, instantly, that we are in the south (or in the tropics), if for no other reason than that it is by far the least common set of complementary colors. As it does in Roberty's painting, violet–yellow signals that which is exotic, out of the ordinary . . . elsewhere.

5. André-Félix Roberty, *Wall at St.-Tropez*, 1921. Watercolor and chalk on paper. The Metropolitan Museum of Art, New York. Gift of Mr. and Mrs. Daniel H. Silberberg, 1969

Utopia-by-the-Sea

It was the Neo-Impressionist painter Henri-Edmond Cross who first encouraged Paul Signac, color theorist and talented follower of Seurat, to settle on the coast. Just after his arrival by sailboat in St.-Tropez in 1892, Signac wrote to his mother that he had managed to rent a terrific little *cabanon* five minutes from town, "lost in the pines and roses," near Graniers beach on Canoubiers Bay. "In the background the blue silhouette of the Maures and the Esterel [mountain ranges]—I have enough here to work for a lifetime— I've just discovered happiness."[30] He later bought a house at St.-Tropez, to which he gave the nautical name La Hune (The Topmast), where he would spend, when not in Paris, most of the next two decades.[31]

One might assume from what he wrote to his mother that Signac was a solitary man who had found a personal Eden, a place where he could lose himself in the beauty of the landscape and be left to his own devices. Nothing could be further from the truth. Although he was a prodigious worker, Signac was the most gregarious of men, an art-world *animateur.* Not only did a number of other Neo-Impressionists, including Cross, Théo Van Rysselberghe, Jeanne Selmersheim-Desgrange, and Maximilien Luce, gather around him on the Côte d'Azur, but also, slightly later, did the younger generation of Fauves— Albert Marquet, Albert Manguin, Louis Valtat, Camoin, and Matisse, a group the critic Louis Vauxcelles referred to as a "flock of migratory birds . . . a valiant little colony of artists painting and conversing in this enchanted land."[32] Signac's presence in St.-Tropez is as significant for the people whom he attracted there, and to whom he introduced the pleasures of the coast and its way of life, as it is for the utopian ideas with which he imbued his work. An anarchist-socialist, as were many of the Neo-Impressionists, Signac saw in the relatively untrodden landscape of the Riviera the future site of an improved society. In a letter to Cross in 1893, Signac quoted a phrase of the writer Charles Malato, recently published in the *Revue Anarchiste*, "The Golden Age is not in the past, it is in the future!"[33] and he said that it might make a good subtitle for a painting he was working on.

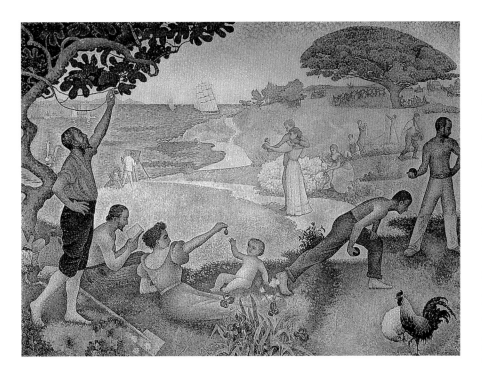

6. Paul Signac, *Au Temps d'Harmonie,* 1894–1895, oil on canvas. Town Hall, Montreuil, France

This was *Au Temps d'Harmonie,* or *In the Era of Harmony,* of 1894–1895 [figure 6], Signac's largest and most important painting. While it now dominates a monumental staircase in the town hall of Montreuil, on the edge of Paris, it shows the bluffs of St.-Tropez's Graniers beach. Rendered in the classic pointillist system of divisionist color, Signac's future Golden Age on the Riviera is structured around the violet–yellow complements; the foreground figures, in classic *contre-jour,* or backlighting, are cast into purplish shadow, and form a filigree screen through which we view the bright yellow shoreline, with its incidents of wholesome human endeavor. Here, artists and farm laborers work in tandem, parents educate their children *en plein air,* and leisure—dancing, swimming, playing *boules,* and generally lounging about—forms an integral part of the better life to come. Signac, in effect, has turned tourism (a bourgeois and "colonizing" enterprise, if ever there was one) on its head: transient visitors like him are rendered as utopia's permanent residents, and "escape" (from work and responsibility) reappears as unalienated labor and productive relaxation.

It was this image, among others, that Henri Matisse had in mind when he painted *Luxe, Calme et Volupté* [figure 7]. In the summer of 1904, the artist, his wife, and their son went to stay with Signac at St.-Tropez.[34] Matisse had just been made a *secrétaire adjoint* of the Salon des Indépendants, of which Signac was vice-president. But in contrast to the Neo-Impressionist's huge Côte d'Azur painting, the visit was not entirely

harmonious: the two painters, one up-and-coming, the other a seasoned professional, apparently argued a good deal about Neo-Impressionist theory. Nonetheless, out of genuine curiosity about Signac's method and perhaps as an homage to him, Matisse upon his return to Paris made this pointillist work of his own, based on studies he had made in St.-Tropez [see figure 8]. Matisse's painting, unlike Signac's idealized image of the coast's future, makes no reference to utopian politics. *Luxe, Calme et Volupté* is a hybrid, a picture both more old-fashioned and newer-looking than its predecessor. Within a group of arcadian (read: timeless) bathers, of the kind we might find in a work by Puvis de Chavannes, Matisse has inserted at the left a large seated woman, dressed in elaborate contemporary street clothes; what appears to be a child wrapped in a blanket stands behind a reclining bather. Topographically, Matisse has turned us about ninety degrees west of Signac's view, so that we look toward the mainland (St.-Tropez is on a peninsula) and the Maures mountains. With the primitive single-sailed boat (called,

7. Henri Matisse, *Luxe, Calme et Volupté*, 1904. Oil on canvas. Musée d'Orsay, Paris

locally, a *tartane*), moored at the water's edge and the austere lone pine at the right, this could be—were it not for the intervention of the modern woman—a scene of mankind's origins on the shores of *mare nostrum*.

"Even as they open time out into the temporal expanse of natural myth," writes James Herbert, "Matisse's pastoral paintings also made reference to the contemporary moment, specifically to the new practices of tourism developing in the south."[35] In *Luxe, Calme et Volupté* and other works, Herbert identifies these practices iconographically—

8. Henri Matisse, study for *Luxe, Calme et Volupté*, 1904. Oil on canvas. The Museum of Modern Art, New York. Mrs. John Hay Whitney Bequest

the incongruous modern woman is, then, a touristic interloper—and formally as well. Matisse's intentionally rough, almost casual refashioning of Signac's meticulous technique, whereby precise dots of color become cruder strokes of paint, and color harmonies are replaced by discordances, is the artistic corollary of a new, turn-of-the century, "naturalized" tourism. Traveling off the beaten track, attempting to mix with the locals, walking, hiking, swimming (in the open sea), and even sunbathing—in short, "roughing it"—were recommended by commentators as the new, healthful, more authentic ways for urbanites to experience unknown places. Matisse's painting—awkward, intensely colored, jarring in its thematic and stylistic incongruities—expresses both a yearning for mythic innocence and the modern reality of effortful travel on the Côte d'Azur. That, despite its deviations from orthodox divisionism, Paul Signac bought the finished painting to hang in his dining room at La Hune, testifies to his generosity of spirit and to Matisse's talent. For its title, Matisse chose the last six syllables of the two-line refrain from Charles Baudelaire's poem "L'Invitation au Voyage," which succinctly express, in essentially untranslatable French, the promise of modern resort life:

> Là, tout n'est qu'ordre et beauté,
> Luxe, calme et volupté.

Chambre Claire

"Nice is still Nice!" a local newspaper proclaimed in October 1914. "The charm of the Riviera, even during the war, has not been lost."[36] Indeed, the allure of the Côte d'Azur only increased after the outbreak of the Grande Guerre. At least for artists—but also for a section of the vast upper middle class that would now start to visit, and an even larger general public that would come to know the coast secondhand—World War I marked the beginning of the Riviera's heyday. Although the Impressionists, Neo-Impressionists, and Fauves had contributed significantly to an evolving aesthetic profile of the coast, its mythic status remained, through the first fifteen years of the twentieth century, a marginal one. The war changed that, forever.

A beach resort coming into its own in the midst of war is perhaps less anomalous than may at first sound. The very qualities that mark the Riviera as an escapist destination were, after August 1914, suddenly real rather than metaphorical. Wounded soldiers were sent to convalesce in Cannes, Nice, and Menton, as far from the front as possible, the change of scenery and the mild climate understood as beneficial to recovery (of no avail, however, to the sculptor Raymond Duchamp-Villon, who died in a military hospital at Cannes in October 1918). For civilians, the distant coast was a way to leave the war behind, to find a bit of paradise far from Paris, without actually fleeing the country, an act that could be interpreted as unpatriotic.[37] For several noncombatant foreign artists, Nice had the added attraction of having been, since the previous century, a place to which (wealthy) Russians fled when the winters in Moscow and St. Petersburg became unbearable. Until the 1917 Revolution, as one American commentator noted, the Russians were "in high favor in Nice. They were powerful allies of France, brothers-in-arms, who fought for the common cause."[38] Léopold Survage, a Finn born and raised in Moscow, Alexander Archipenko, from Ukraine, and Eugène Zak, a Pole, made their way to Nice shortly after war was declared. In a 1915 issue of the *Petit Messager des Arts et des Industries d'Art*, Guillaume Apollinaire told his readers that Zak, "whose native city is

still in the hands of the Prussians, is languishing, in ill health, in the sunshine of Nice," and that Archipenko was there as well, his wife keeping herself busy by sending "sweaters to their friends in the French army."[39]

Perhaps the long-standing Russian presence in Nice had something to do with Matisse's decision to set himself up there in December 1917. Two of his most important prewar patrons, Ivan Morosov and Sergey Shchukhin, after all, were Russian. While he must have been happy to escape the wartime atmosphere of the capital, Matisse did not find the superb weather he had expected. He complained that it rained the entire first month he was there, and just when he had made up his mind to decamp, the mistral arrived, "chased the clouds away," and "it was beautiful. I decided not to leave Nice."[40] Sometime that winter Matisse painted a representation of his room at the Beau-Rivage hotel, located at the eastern end of Nice's shoreline drive, the Promenade des Anglais (a section renamed the Quai des États-Unis, in honor of the American contribution to the war effort). *Ma Chambre au Beau-Rivage* (*My Room at the Beau Rivage*; figure 9) is as introverted a picture of the Côte d'Azur as *Luxe, Calme et Volupté* is exhibitionist. From arcadian landscape to domestic interior, from an almost overcrowded group scene to one without figures, from self-consciously avant-garde pointillist technique to thinly painted, neo-naturalist facture—the trajectory between the works is backward, as if Matisse had withdrawn from his earlier, youthful exuberance at the edge of modernism. Although the paintings share a lushness of tone, we no longer feel that Matisse is experimenting with color, as he was in 1904, when strong contrasts dominate. In 1917–1918, the complementaries are rendered in secondary and tertiary hues: on the reddish-pink floor sits a greenish-brown chair; the ocher walls are contrasted with the bit of mauve floral decoration on the ceiling; the hint of blue sea visible through the window is countered by the burnt-sienna triangle of a drape or shadow which is contiguous with the brown leather of the artist's suitcase, on the table (or bed) at the lower right. Both works do, however,

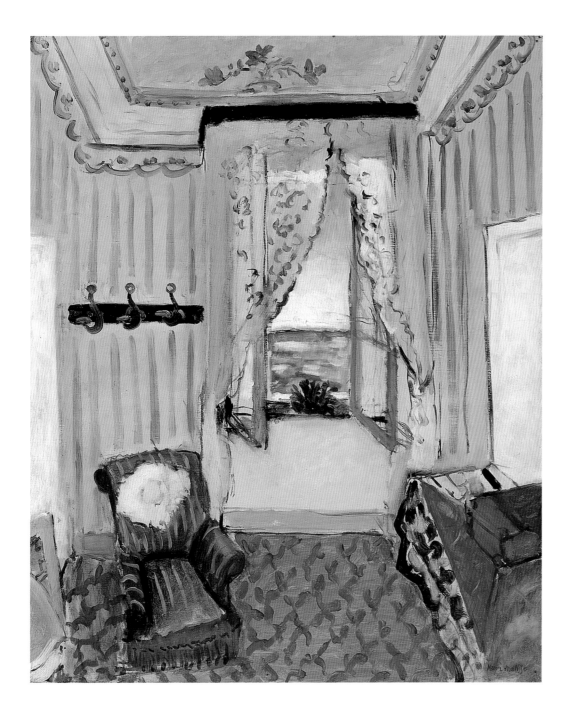

eschew many of the traditional signs of perspectival construction, and the result in both is a flattened space that asserts the modernist "truth" of the two-dimensional canvas. But because *Ma Chambre au Beau-Rivage* is the picture of a room, its more normative, illusionistic ancestry—alluding to the camera obscura of Renaissance perspective, as well as the *chambre claire* of photographic realism—is implicit.

Among the first paintings Matisse made upon his arrival, it forecasts his major preoccupation of the next decade in Nice: rooms, like this one empty of inhabitants, or as a setting in which to pose models. Rarely in the Nice interiors do we feel we are looking at an artist's "studio"; Matisse usually provides just enough domestic detail to let us know he is painting in a hotel room, or in an apartment, as if insisting on his status as a vacationer (perhaps as a way of putting distance between himself and the overprofessionalized, overheated Paris art world).

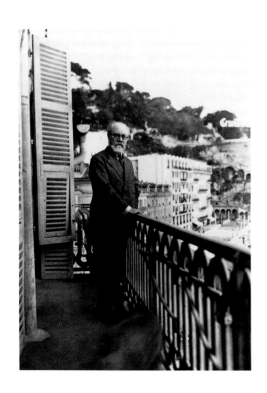

10. Henri Matisse on balcony at 1 Place Charles-Félix, Nice, early 1930s. Photograph by Albert Eugene Gallatin

Ma Chambre au Beau-Rivage is, in fact, the "portrait" of a Riviera hotel room: its two main features are the armchair, with antimacassar spread across its back, and the curtained open window, with the Mediterranean and just the top of a palm tree visible at the window's lower edge. Three empty coat hooks on the wall next to the window, a painting turned to the wall at the lower left, and the suitcase at the right elaborate on this story of a transient artist's temporary lodgings. The work also tells us something about the economic reality of renting a room by the sea in Nice, at least for mid-range accommodations: one got merely enough space for a bed, a chair, and a good-size window, and almost no storage.

Matisse had been painting pictures of rooms with open windows for many years by now, and the theme of the open window had been a staple of European painting since at least the early nineteenth century. As Lorenz Eitner said, it is in this Romantic theme par excellence that "elements of middle-class realism blend with an essentially unheroic, idyllic view of the world";[41] further, he cited Novalis's statement that "everything at a distance turns into poetry: distant mountains, distant people, distant events; all become romantic." It is hardly coincidental that the window view in art and the artist-as-tourist are both late-eighteenth-, early-nineteenth-century Romantic phenomena: not only did the view from one's window, at an inn or a hotel, become crucial to the experience of travel —safely containing, framing, and keeping at a distance the unusual or foreign—but the experience of travel (for the artist, as for others) was itself shaped by a history of pre-existent images and preconceptions. Touristic viewpoints, whether at the Grand Canal or the Grand Canyon, provide a means of measuring that which is strange, allowing for a stable, "middle-class," "unheroic" sense of the normal in unfamiliar places. And while the view from one's hotel room window in such resorts as the Côte d'Azur establishes class distinctions—do you look at the sea, the garden, or the parking lot?—the shared experience of looking at the same things most of the time creates an undeniable bond among

the nomadic tribe of tourists. When an interviewer asked him later in his life why he kept coming back to Nice, Matisse replied: "Because in order to paint my pictures I need to remain for several days in the same state of mind, and I do not find this in any atmosphere but that of the Côte d'Azur. The northern lands, Paris in particular . . . offer too unstable an atmosphere for work as I understand it."[42] If life back in Paris is unstable, life on the Riviera is reassuringly predictable.

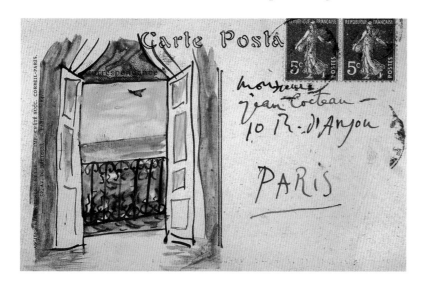

11. Pablo Picasso, postcard to Jean Cocteau, St.-Raphaël, 1919. Ink and watercolor on card. Carlton Lake Collection, Harry Ransom Humanities Research Center, The University of Texas at Austin

When Picasso and his wife of one year, the ballerina Olga Koklova, went to the Riviera in July 1919, a Matisse-like window of their hotel room at St.-Raphaël became the theme of a series of more than ten small-scale works.[43] On a postcard he sent to Jean Cocteau back in Paris [figure 11], Picasso drew an ink-and-watercolor picture of the open window, through which is glimpsed the sea behind the grillwork of an iron balustrade, a small airplane flying overhead. It is probably no accident that Picasso's little sketch, and others in the series that resemble it, remind us of Matisse's Beau-Rivage picture; several of his hotel room paintings, with their prominent windows open to the Mediterranean, were exhibited in the first Paris show of Matisse's Nice work, at Bernheim-Jeune, in May 1919, just before Picasso left for the coast.[44]

Nor can we doubt the influence of Matisse's Riviera pictures on Raoul Dufy, who considered *Luxe, Calme et Volupté* a revelation: "At the sight of this picture I understood the raison d'être of painting, and Impressionist realism lost its charm for me as I beheld this miracle of creative imagination at play, in color and drawing."[45] Dufy, who spent many years painting, drawing, and making prints of the Côte d'Azur, went on to create an extensive series of windows overlooking the sea at Nice, comparable in their ambition

to those of his predecessor. In his 1938 *Window on the Promenade des Anglais* [figure 12], Dufy actually looks out on the beach where Matisse moored his rowboat. Ensconced in the Hôtel Suisse, where the Promenade des Anglais turns abruptly seaward, Dufy affords us a view over the Baie des Anges and back onto the Quai des États-Unis. Although his vantage point was no more than a few hundred meters east along the shore from Matisse's, the result was entirely different. Instead of the straight horizontal of the Mediterranean, a stable referent beyond the window—such as we see in the views of Matisse and Picasso —the Promenade des Anglais and the city behind it form part of a dynamic, arching shape that Dufy contrasts to the foreground, with its rectilinear closed window, and the series of repeated verticals of the balustrade, exactly parallel to the picture plane. A study in abstract geometry, *Window on the Promenade des Anglais* remains nonetheless a touristic work, in which the lively yellows and oranges of the city, and the aquamarine of the sea and sky, beckon the visitor beyond the ghostlike vagueness of the (implied) hotel room in the foreground.

The hotel room window, or the window of any room with a good view, became a visual trope of the Côte d'Azur in the 1920s. Neither precisely a landscape image nor a domestic genre scene, but partaking of both, the window view represented the comfortable no-man's-land of tourism—looking at the scenic wonders but not belonging to them, living on the coast but domiciled elsewhere. In Juan Gris's *The Open Window*, painted in 1920 at Bandol, the *persiennes* (the exotic French name for shutters) are flung open to reveal a brilliantly lit Mediterranean landscape, in front of which the artist has arranged a Cubist still-life of bottle, cup, guitar, fruit bowl, and sheet music, as the clouds hovering over the hills on the distant shore float ever so slightly into the darkened foreground. The Cubist painter Louis Marcoussis, perhaps cognizant of Gris's work, also placed a still-life arrangement in front of a window opening onto a view of mountains and sea, in a picture he made at Hyères in 1928. His *Blue Fish* [figure 13] is even more

12. Raoul Dufy, *Window on the Promenade des Anglais,* Nice, 1938. Oil on canvas. Philadelphia Museum of Art. The Samuel S. White III and Vera White Collection

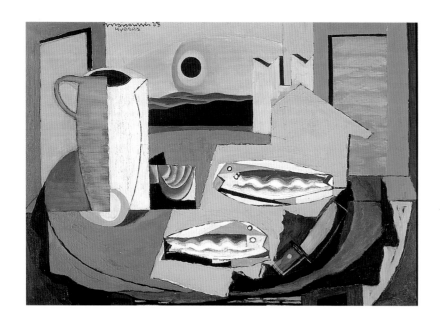

13. Louis Marcoussis, *Blue Fish*, Hyères, 1928. Oil on canvas. Musée d'Art Moderne de la Ville de Paris

pointedly a regional image than Gris's: now it is not just the area's topography, but also the local catch—the blue fish of the title—that places us firmly on the coast. The contents of still-life arrangements with local fare became a joke in the family of the painter Moïse Kisling, who, before he built his own house at Sanary, rented one there in the late 1920s. The writer Carlo Rim, who was a houseguest, told of a meal with the Kislings at which the two sons, Jean and Guy, complained that they were tired of eating fish. Their father, who was in the midst of painting a series of still-lifes that featured the ingredients for bouillabaisse, gave them a quick lesson in the relationship between art and local life: "Yesterday I painted it, today we eat it!"[46]

So great was the allure of these ready-made Côte d'Azur vistas, available to the artist without having to leave his room, that even as unlikely a practitioner as George Grosz, the German Dadaist, succumbed. He spent much of the spring and early summer of 1927 at Pointe Rouge, a suburb on Marseilles's southern shore. From there he wrote a friend that although ordinarily he was "not a particular friend of motifs" (meaning, we may infer, that he usually found them too conventionally picturesque), he had found "plenty" to his liking on the Riviera. "A house, a few trees, a piece of sky, the sea are sufficient. There are enough difficulties composing these few things."[47] In his *Landscape at Pointe Rouge, Marseilles* [figure 14], we find nothing of the social critique that was his specialty in Berlin. Instead, Grosz creates the most anodyne of images, the most postcardlike of coastal views: looking toward the Îles du Frioul, in front of which passes a small boat (perhaps on its way to Corsica, for this is the standard sea route from Marseilles), we observe the scene from behind the ubiquitous iron balustrade, with red-tiled roofs, pink- and ocher-colored houses, and pine, eucalyptus, and mimosa before us.

14. George Grosz, *Landscape
at Pointe Rouge, Marseilles,*
1927. Oil on canvas. Collection
Peter and Lilian Grosz,
Princeton, New Jersey

Arcadia

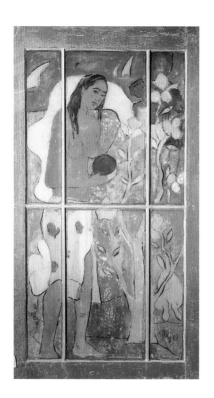

15. Paul Gauguin, *Bare-Breasted Tahitian Woman Holding a Breadfruit*, c. 1892 (window installed at W. Somerset Maugham's Villa Mauresque, St.-Jean-Cap-Ferrat). Oil on glass. Private collection

Somerset Maugham described the Côte d'Azur as "a sunny place for shady people," referring to its reputation, by the late 1930s, as a site of decadent pleasures.[48] But Maugham himself had come to the coast, so he said, for the same reason that many other artists had, in search of the simple life, not the high one. At his Villa Mauresque, at Cap Ferrat—where at one time he employed a dozen servants, including gardeners—he invoked the spirit of that most celebrated nineteenth-century seeker of radical simplicity, Paul Gauguin. As if in emulation of artists who had created views from their windows on the sea, Maugham devised an artistic view of his own: in his writing room, he installed (on a hinge) a window from Gauguin's house in Tahiti, which he had purchased there in 1916, while researching his novel based on the artist's life, *The Moon and Sixpence*. [See figure 15.] Approximating the look of stained glass by means of oil paint applied to the pane, it shows a bare-chested native woman holding a breadfruit, standing alongside a small tree and a rabbit, a seascape with three sailboats in the background.[49] As he worked, and if the window was closed, Maugham could see Gauguin's image of simple, sensual Tahitian life in place of his view of Cap Ferrat.

The superimposition and the interchangeability of arcadian visions—representing the panoply of fin-de-siècle escapist fantasies—characterize many modern images created on the Riviera. Gauguin's primitivist concoctions, Puvis de Chavannes's timeless classical Mediterranean paradigms, and the utopian works made on the coast by Signac and his friends were key points of reference for anyone who might imagine novel, idyllic Côte d'Azur imagery. Matisse, as we know, created the first picture in this revivalist mode in the new century, in *Luxe, Calme et Volupté*, a hybrid of Seurat and Puvis; Renoir, in his last fifteen years at Cagnes, painted scores of female nudes as water nymphs and a few boys as antique shepherds. But the projection of a Golden Age onto the shores of France's southeast coast required the suppression of the all-too-real local inhabitants. Writing to Théo Van Rysselberghe from the Riviera in 1905, Henri-Edmond Cross said that he had long before recognized his "insensitivity towards the peasant":

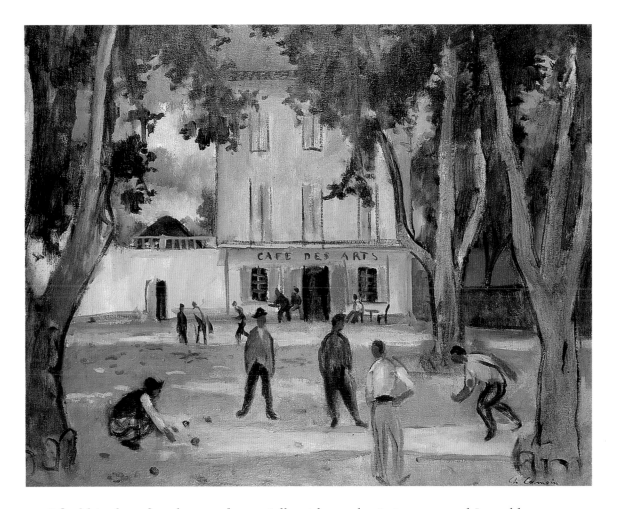

16. Charles Camoin,
St.-Tropez, Place des Lices and Café des Arts, c. 1925. Oil on canvas. Musée de l'Annonciade, St.-Tropez

I find him here [on the coast] especially without plastic interest, and I would not know how to paint him. He only moves me as a spot, and he seems small and far away. On the rocks, on the sand of the beaches, under the clumps of pine, nymphs and naiads appear to me, a whole world born of beautiful light.[50]

Cross's lack of interest in the locals and his corresponding preference for imaginary beings—what we might call the triumph of mythic place over real geography—would typify modern artists on the Riviera. There were occasional glances in the direction of the local working people—Amedeo Modigliani painted a portrait of the girl who worked

in the bakery at Cagnes, Charles Camoin painted local men playing *boules* in the Place des Lices at St.-Tropez [figure 16], and Picasso fixed for eternity the image of Antibes fishermen at night—but these were exceptions. For the most part, when modern artists on the coast painted humankind, it was either themselves and their friends whom they represented, or a generic, mythic race.

The subject usually referred to as "bather" has been a standard in Western art since the Renaissance. It is a vaguely classical, trumped-up category, devised as an excuse for depicting naked women, and occasionally, naked men. On the coast, naturally, there were real bathers, or swimmers, the designation depending to a certain extent on how strenuous, that is, how athletic, the exertions were. At first mostly in tubs and pools (in warm salt water or fresh), and progressively more often in the open sea, swimming became a routine Riviera pastime.[51] When the Cubist sculptor Alexander Archipenko went south during the war, he lacked the proper facilities for making major three-dimensional works; he turned to what he called "sculpto-painting," a collage medium in relief. One such work, inscribed "Nice, 1915," and made of paper, wood, and metal with oil paint and pencil drawing, depicts a bather [figure 17]. Undoubtedly inspired by real-life swimmers he saw, Archipenko elevated the figure in the direction of the generic. With one arm artfully raised above her head, she dries herself with a towel (the fan-shaped form near the center) held in her other hand. Although this pose is intricate enough to win her an Olympic medal in gymnastics, its rationale is provided by the work's Cubist stylization. The palette—blue-violet and various shades of yellow and orange, and a touch of red and green—is made up of the complementary colors we recognize from other images created on the coast; the free-standing column drawn in pencil at the left adds a classical note, whereby Archipenko's bather steps into the long line of related figures in post-Renaissance art.[52]

In its classical reference and as a soigné variant of Cubism, Archipenko's 1915 *Bather* was prescient in the context of contemporary French art. For at this time—in the midst

of the war—Picasso was introducing elements of a new traditionalism, and a new classicism, into the vocabulary of the Parisian avant-garde.[53] These included self-conscious emulation of Ingres's draftsmanship, references to the commedia dell'arte, and the invocation of Golden Age imagery. Although he had restricted himself to views from his hotel room window at St.-Raphaël in 1919, when Picasso returned to the Côte d'Azur the next year, to Juan-les-Pins, a world of Mediterranean legend took shape before his eyes. For one thing, the topography of the coast confirmed an idea that already existed in his head—"I don't claim to be clairvoyant, but I was astounded. There it was, exactly as I had painted it in Paris. At that moment I realized that this landscape was mine."[54]

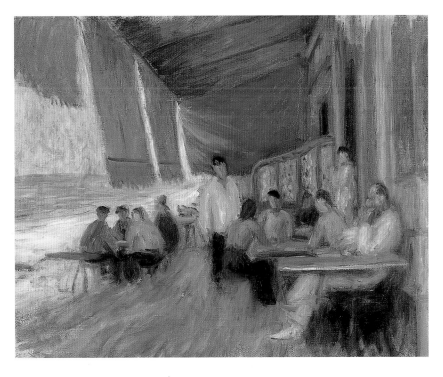

18. William Glackens, *Outdoor Café*, c. 1932. Oil on canvas. Museum of Art, Fort Lauderdale, Florida. Ira Glackens Bequest

On August 19 (the date is clearly visible in the upper right), Picasso created his own landscape: rocky outcroppings frame three bathers in a cove [figure 20]—two lounging on the blanket in the foreground, one swimming nearby—whose ample forms are set off against the vivid aquamarine of the water and a patch of blue in the sky. Here, fully realized on the French Riviera, is a timeless world of arcadian *décontraction*; but for the beachgoers' accoutrements—the blanket and the book, which the supine figure reads with great concentration—this could be the generic Mediterranean setting that has captivated Western painters since the time of Raphael. Picasso is intent on breathing new life into a classicizing genre that by the time of Puvis de Chavannes

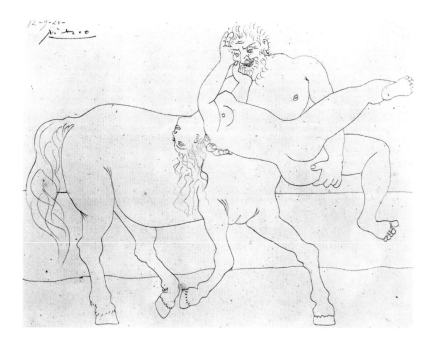

19. Pablo Picasso, *Nessus and Deianira*, Juan-les-Pins, 1920. Pencil on paper. The Museum of Modern Art, New York. Acquired through the Lillie P. Bliss Bequest

OPPOSITE
20. Pablo Picasso, *Three Bathers*, Juan-les-Pins, 1920. Pastel with oil and pencil on laid paper. The Solomon R. Guggenheim Museum, New York. Thannhauser Collection, Gift, Justin K. Thannhauser, 1978

had become anemic. Now the colors are intense, the anatomy exaggerated, and the facture varied: some passages, the rocks for instance, are thickly worked up, and others, such as the water, are flat and unmodulated; the result is a subtle, collage-like dissonance. But if *Three Bathers* is classical in a languid and pointedly modern way, only a few weeks later, while still at Juan-les-Pins, Picasso made a series of drawings and a watercolor that were specifically ancient in their violence, based as they were on a story from Ovid's *Metamorphoses*. They depict the rape (or abduction) of Hercules' bride, Deianira, by the centaur Nessus. [See figure 19.] Like Henri-Edmond Cross before him, Picasso said, years later while living in Cannes, that the Riviera was haunted by the ghosts of its ancient myths: "It's strange, in Paris I never draw fauns, centaurs or mythical heroes. . . . They always seem to live in these parts."[55]

The idea that one might glimpse on the Côte d'Azur an otherwise vanished world of fantastic creatures—of nymphs and naiads, fauns and centaurs—may be difficult to reconcile with the overdevelopment of the coastline now. But the notion recurred, until fairly recently, in much of the literature and art devoted to the Riviera. Perhaps this mythic past was compensation for the neglected real history of the coast; if considered a conveniently vacant, discursive site, the Côte d'Azur could be reinvented for modern use. As recently as World War II, when the painter and designer Christian Bérard and Boris Kochno, writer and former secretary to Serge Diaghilev, rented a house in a tiny fishing town, it was still possible to imagine oneself transported to a mythic realm. "The village lies beyond the last turn on the road from Marseilles, where suddenly all of Les Goudes comes into view," Kochno explained. "Seeing it, I felt as if I had stepped into the world of legend, the background for a Rape of Europa or a Fall of Icarus. The little beach houses

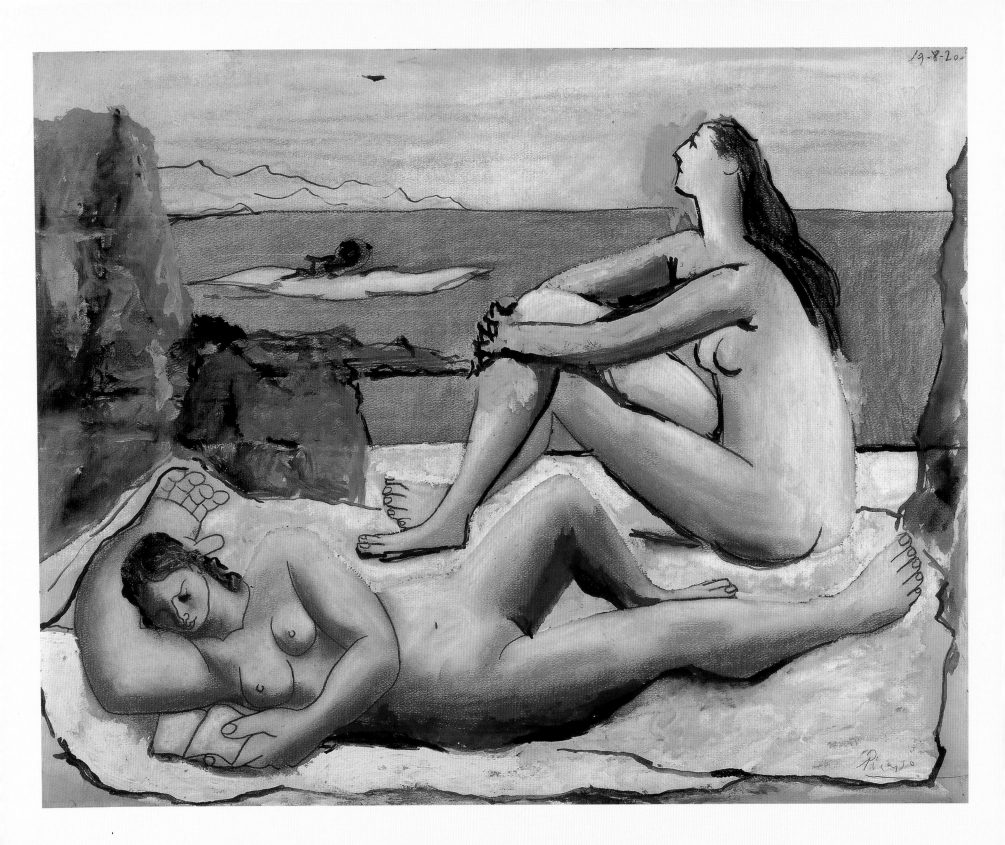

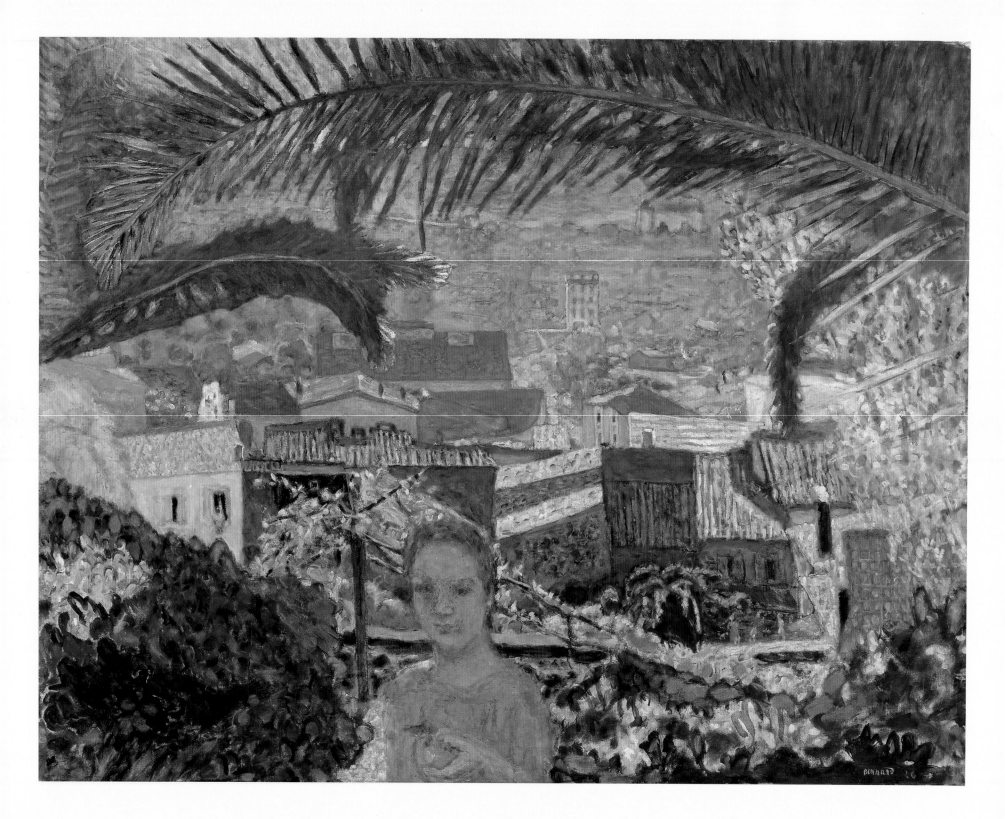

in vivid colors perched on chalk-white rocks facing the sea seemed to me a vision of antiquity. . . . I have always been troubled by the mystery, even in daylight, of that cut-off landscape, lost at the ends of the world."[56] It is worth pointing out that the coastline around Les Goudes, which strikingly resembles that of a Greek island, remains relatively untouched to this day.

Such was not to be the fate of Le Cannet, located in the hills above Cannes. Now a crowded suburb, it was still a small village, blessed with views back over the city and out to the Îles de Lérins when Bonnard bought a modest speculator's house there in 1926.[57] Bonnard named his house Le Bosquet (The Grove), and it is the setting for one of his greatest paintings, *The Palm* [figure 21], an ode to the coast and its mythic aura. At first glance, this is the most uncomplicated of pictures. A young woman stands in a garden, a piece of fruit in her hand, behind which we see the red-tiled roofs of Le Cannet in the middle ground and the hotels and apartment houses of Cannes in shades of violet and yellow in the distance. After a moment, the painting's intricate structure begins to assert itself. We stand in an arbor created by the overhanging palm fronds that reach out across the picture's upper edge and by the effulgent greenery that brackets the image at lower left and right. This organic curvilinear enclosure is subtly countered by the geometry of the buildings in the immediate vicinity, their overlapping elements woven into a complicated pattern of verticals, horizontals, and sharp angles. Even the vines just beyond the woman's head grow on a triangular wooden support that introduces, in skeletal version, the solid geometry beyond the garden wall. Strong greens and oranges dominate the work, but are relieved by a subsidiary palette of violets, blues, pinks, mauves, and yellows.

This elaborate, empirical picture-making encloses a mystery, as pointed out by Sasha Newman, who has written most eloquently on the painting. Reduced as the woman in the painting is to a "chalky, blue-violet shadow," she is virtually "a dream amidst material reality," a mythic figure, a ghost, who harks back to "the pantheistic celebrations of the

21. Pierre Bonnard, *The Palm*, Le Cannet, 1926. Oil on canvas. The Phillips Collection, Washington, D.C.

seasons," or evokes a modern Eve, holding the fruit that will lead to our fall.[58] We might say that three great myths—pagan, Old Testament, and modern—are superimposed here, and become indistinguishable on the Côte d'Azur. Bonnard does not insist on a single reading of his painting; as a good late Symbolist, he does not want his picture "read" so much as felt, or its meanings explained so much as suggested. That the Garden of Eden comes to mind is inevitable; that the young woman might also be thought of as Pomona, Roman goddess of fruit trees, is perhaps more arcane a reference, although it is true that Aristide Maillol and Ossip Zadkine, two sculptors Bonnard probably knew personally, had created Pomona figures (the former in 1910, the latter in 1926, the same year Bonnard painted *The Palm*).[59] The modernity of the phantom figure is, at any rate, her most important feature, and Bonnard intimates it through the concatenation of her blue-violet presence in the immediate foreground and the blue-violet of the modern city in the distance. This, after all, is where the painting's charge must be located: even in the most worldly of modern resorts, Bonnard seems to be saying, here on the outskirts of the real city of Cannes—in the present moment, 1926—myth asserts itself, under dazzling light and deep in splendid foliage. Pleasure and sin; dream and reality; life, death, and regeneration— we sense all of this, palpably, in *The Palm*.

Palm Trees and Sandy Beaches: From Icon to Index

The palm tree—either represented in its entirety or metonymically suggested by its fanning fronds, as in Bonnard's great painting—is an icon, the classic botanical symbol of the French Riviera. "Its power, of course, resides in the fact that it is instantly recognizable," writes Jean-Bernard Pouy. "Invariably virile, sleek and manicured, its plume an explosion," the palm remains "at the same time unknown. Everyone confuses the date palm with the coconut palm, the royal palm with the carnauba." For Westerners, according to Pouy, the palm tree is part of the "sign system of luxury, even if the tourist eats fewer and fewer dates, even if coconut milk gives him indigestion."[60] Recognizable and yet unknown— *étrange*—the iconic palm tree, for every modern artist who worked on the coast, has a distinct evocative valence. For Bonnard, as we have seen, it can signal at once the modern resort and the biblical (or mythic) garden; for Matisse, who often depicts palm trees lining the Promenade des Anglais, it can seem like one of many fancily dressed if odd urban characters; for Dufy, the palm tree is often a ceremonial framing element —an immensely tall, vertical, highly decorative form that relieves the monotony of the horizontal line of sea and shore (although he is not averse to using, on rare occasions, other trees as formal devices, as in the pine that rises straight through the middle of his view of Golfe-Juan, figure 23). In the case of the German Expressionist Max Beckmann, who visited the Riviera often in the 1930s and 1940s—staying in Marseilles, Cannes, Nice, Beaulieu, and Monte Carlo, from one end of the coast to the other—the palm tree evokes an altogether

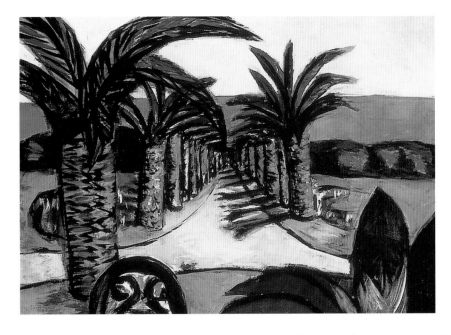

22. Max Beckmann,
Landscape, Cannes, 1934.
Oil on canvas. San Francisco
Museum of Modern Art.
Gift of Louise S. Ackerman

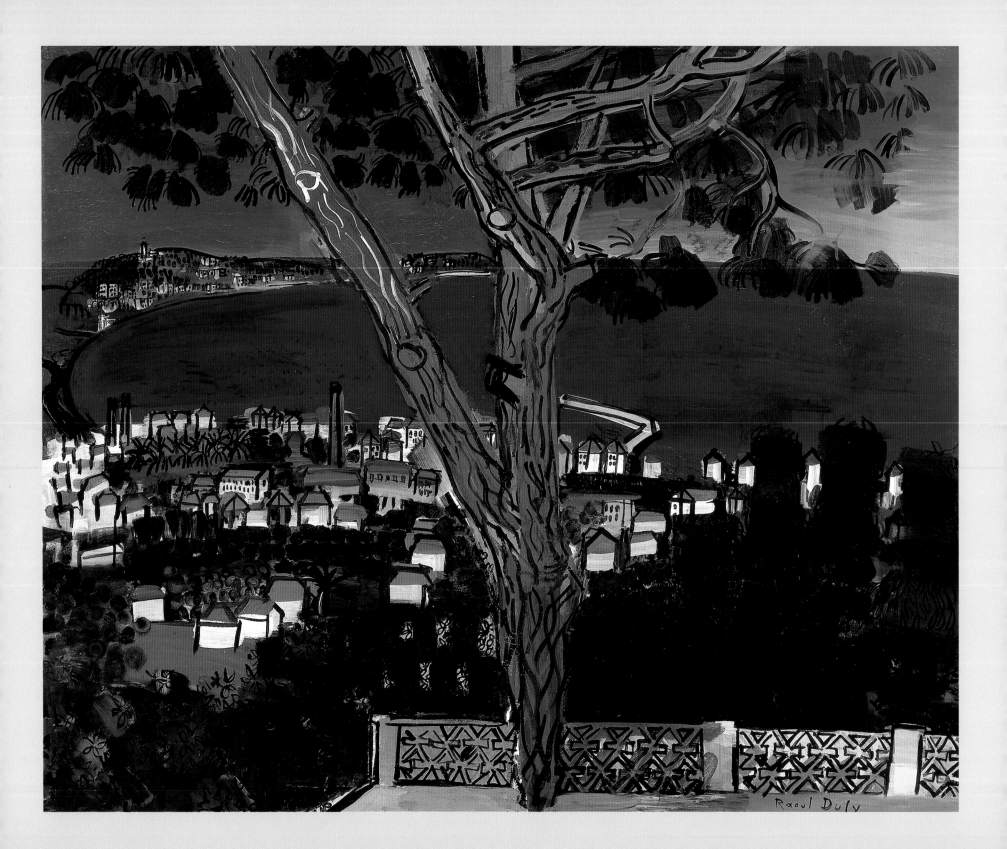

different world. [See figure 22.] With their thick trunks and spiky, tumescent fronds, his palms look primordial, survivors of a prehistoric moment. These hulking forms, which cast long, black shadows, are at the other extreme of the aesthetic spectrum from the artificed specimens in the art of his French contemporaries.

In reality, the presence of the palm on the Riviera is part of its make-believe: the tree is not native to the region, but was imported in the nineteenth century from the Canary Islands and the Americas. The cultivation of the exotic—transforming the foreign palm into a kitschy icon of the Côte d'Azur—is the joke behind Francis Picabia's *Promenade des Anglais* [figure 24]. Dada to its core, the construction makes reference to the kinds of tourist objects that flourish in coastal resorts—seashell-covered cigarette boxes, lizard-skin pencil cases, pebble-encrusted mirrors. The palm trees along Picabia's boulevard are

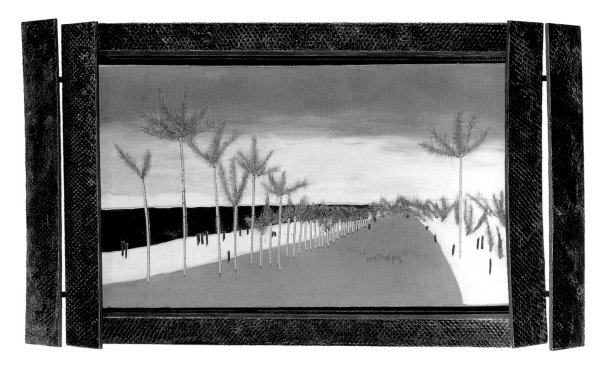

24. Francis Picabia, *Promenade des Anglais*, Nice, c. 1923–1926. Oil, feathers, macaroni, and leather on canvas, in a snakeskin frame by Pierre Legrain. Collection Société Anonyme, Yale University Art Gallery, New Haven, Connecticut

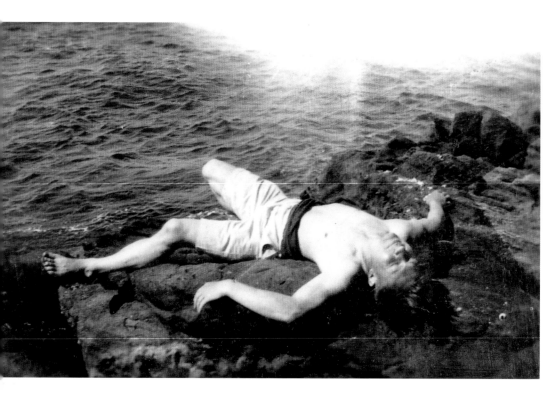

rendered in macaroni (the trunks) and green feathers (the fronds), and surrounded by a snake-skin frame created specially by Pierre Legrain.[61]

This Dada spirit—the freedom to create art out of unexpected materials, which has its origin in Cubist collage—is also responsible for a very different kind of Riviera image, neither iconic nor symbolic, but indexical (through trace, or physical imprint of the site). For those who left their hotel room from time to time, daily life on the Côte d'Azur could be a powerfully visceral experience, in which the body was continuously engaged with the environment. The ability to spend a good deal of time out of doors (because of the mild climate) and the proximity of the beach

25. André Masson on the beach at Canadel, 1928

OPPOSITE

26. André Masson, *Battle of the Fishes*, Sanary, 1926. Sand, gesso, [glue,] oil, pencil, and charcoal on canvas. The Museum of Modern Art, New York. Purchase

and the sea meant, by the 1920s, that one was often in a bathing suit, with skin exposed to the elements. It was at Sanary, between May 1926 and March 1927, that André Masson created his most celebrated works, his "sand paintings." While he never said that it was specifically the manner in which sand clings to the body that inspired these Surrealist productions, there are many photographs of Masson on Riviera beaches. [See figure 25.] We know that by January 1927, the artist had written to his dealer, Daniel-Henry Kahnweiler, that he was pleased with a new group of paintings to which sand had been applied, although he was concerned about their fragility.[62]

Among these is *Battle of the Fishes* [figure 26], which includes passages of sand applied to wet glue, as well as oil paint, pencil, and charcoal on canvas. Before it is anything else—a post-Cubist collage, a Surrealist autonomist experiment, a telluric

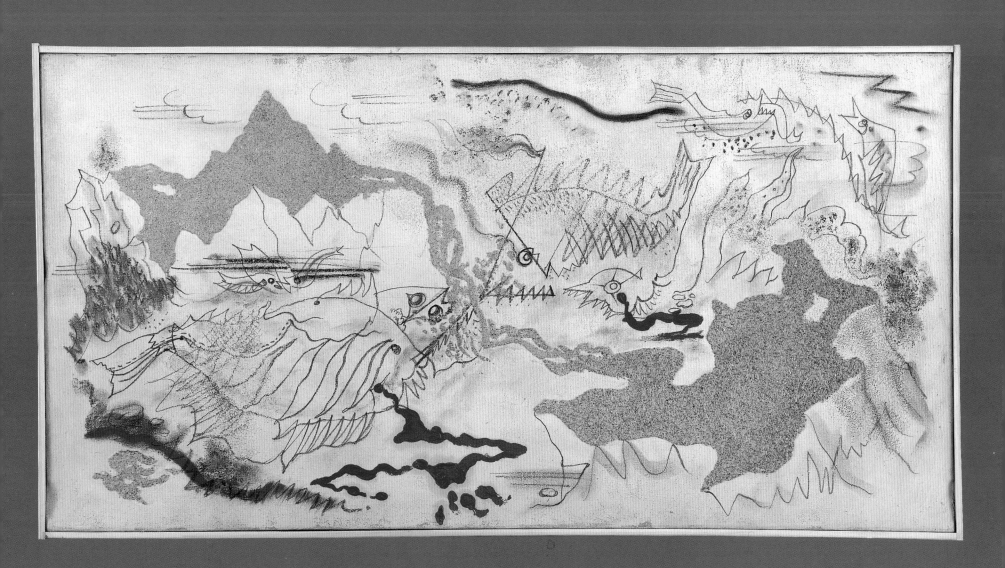

paradigm—this is an indexical beach painting, in which the place of its gestation has invaded (imprinted itself on) the canvas. Masson had many extended stays on the Riviera —at Antibes, St.-Tropez, Le Dattier, and Le Lavandou, among other towns—but the work he made at Sanary is most fully that of an artist immersed in coastal life. This is evident not only in the literal incorporation of the region's distinctive granular soil into his art, but also in the underwater iconography (the presence of what appears to be a bird's head among the fish is, in Surrealist fashion, part of the mystery). It may even be that the subaqueous battle depicted, with its rivulets of blood-red paint, was suggested to Masson by daily local ritual: who has not been struck by the shocking, pathetic corporeality of a pile of fish, many still throbbing with life, on the floor of a fisherman's boat or at a fishmonger's stall? Of course, the extreme abstraction of the image, the "automatic drawing," and the irrational juxtaposition of traditional media and new material are deployed for anything but local or folkloric effect. This is a poetic, brutal evocation of nature's forces at work, of a struggle among the species, however unconventional in form. In 1930, Georges Limbour wrote a haunting account of the genesis of Masson's sand paintings: "He put himself to a difficult task, and, his sleeves rolled up like a baker's, he scoured the sea's floor, where he broke the nails of his clenched fists, grabbing up the handful of sand of his future solitude, filled with the imponderable vestiges of human shipwrecks, and where the blood of his finger, pricked by a fish's sword, traces a mysterious writing. He thus established a magnificent Sahara where caravans will never pass."[63]

Although Picasso's much earlier use of sand in his Cubist art (circa 1914) had undoubtedly influenced Masson's use of sand as a pictorial medium, the situation had obviously reversed itself by 1930, so that now it was Masson's paintings on Picasso's mind when, between August 14 and 28, at Juan-les-Pins, he created a series of sand-encrusted constructions. [See figure 27.] Picasso's use of sand in these works is less pictorial than sculptural: even more forcefully than Masson's, they make us think of bodies coated with

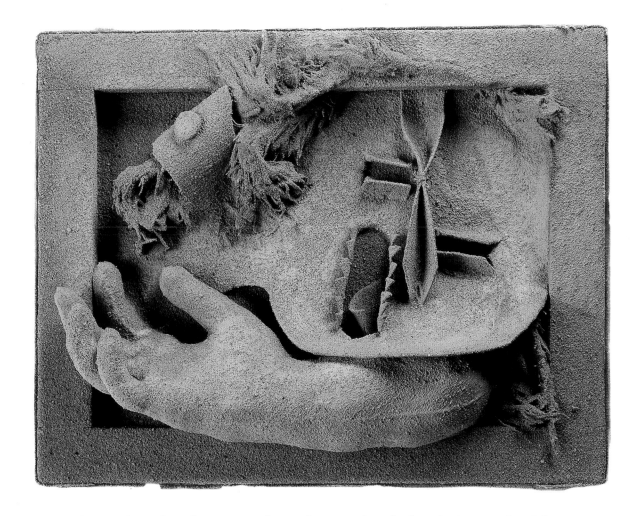

27. Pablo Picasso, *Composition with Glove*, Juan-les-Pins, 1930. Construction with sand and found objects. Musée Picasso, Paris

sand, of being buried, perhaps up to the neck, in sand at the beach. Among the eight constructions Picasso made in those two weeks are several recognizably descriptive, if rather abstract, images—three bathers and a harbor scene—and four agglomerations of objects, freely juxtaposed. Working on the backs of the canvases, so that the wooden stretchers form a container and frame for the constructions, Picasso has gathered (much of it from the beach) such diverse objects and materials as a glove, a toy boat, palm

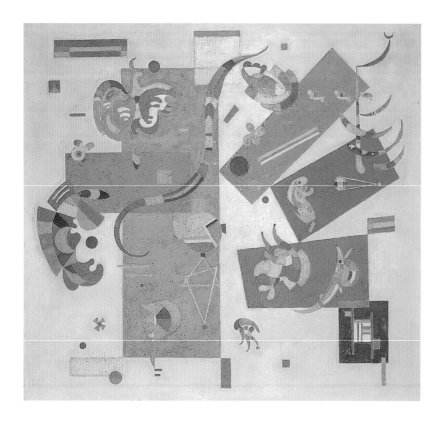

28. Wasily Kandinsky, *Blue World*, 1934. Oil with sand on canvas. The Solomon R. Guggenheim Museum, New York. Gift, Solomon R. Guggenheim, 1945

leaves, nails, cardboard, and rope, which are sewn and glued down. The whole is covered in glue and then immersed in sand, to yield monochromatic reliefs that have the unnaturally becalmed quality of the casts of Pompeii's residents, circa A.D. 81.

For two other artists as well, the Riviera seems to have suggested local, materially based variations on themes already in progress. From 1928, when he sojourned in Nice and Juan-les-Pins, Wasily Kandinsky made numerous trips to the Côte d'Azur: in 1933 to Les Sablettes, outside Toulon; in 1935 to La Napoule, near Cannes; in 1938 to Cap Ferrat; and in 1939 to La Croix–Valmer, near St.-Tropez. An abstracted harbor scene, *At Rest*, from 1928, may be Kandinsky's response to his first Mediterranean stay.[64] As early as 1931, a critic for *Cahiers d'Art* thought it possible to see a geographic dimension in certain formal properties of the recent work: "The space is clear, the superimposed and interlocking planes are of extremely reduced size; a great simplicity and a luminous clarity reign in his paintings. One is tempted to attribute the quality of this transformation to the Midi, the Mediterranean, or the ocean."[65] But it is in works, including *Blue World* [figure 28], that Kandinsky made between his stays at Les Sablettes and La Napoule where the impact of the coast is strongest. A number of these works appear to draw on biological imagery, especially marine invertebrates—these forms "swimming" through a space either indeterminate or anchored by geometric patterning—and as in the works of Masson and Picasso before him, sand is a medium, in this case mixed with colored oil pigment to produce textured zones.[66]

LEFT

29. (Left to right) Constantin
Brancusi, Marcel Duchamp,
and Mary Reynolds,
Villefranche, c. 1930

RIGHT

30. Constantin Brancusi,
The Crocodile Temple,
St.-Raphaël, 1924. Mixed media.
Photograph by the artist

For Constantin Brancusi, who stayed on the coast at least two different times, the
sand dunes of St.-Raphaël were the setting for a site-specific sculpture, extemporaneously
contrived in August 1924. Caught in a riptide, as Brancusi recounted, he barely escaped
drowning, by grabbing onto a piece of cork oak bobbing in the water. In order to com-
memorate this "miracle," he built what he called "a temple of Providence," intended as a
"token of gratitude." Brancusi's improvised shrine to the spirit of the place was fashioned
on the beach from found materials—pieces of driftwood and what look like the pilings
from a pier, with the reptile-shaped savior cork oak mounted as a cult object. Brancusi
dubbed it "The Crocodile Temple," and photographed it [figure 30], thereby inaugurating
the documentation process of earthworks that is by now commonplace. He wrote to his
friends, fancifully, that he had made it "by magic, in the desert . . . no kidding."[67] When
he returned to Paris he brought the "Crocodile" with him, and it remained in his studio as
a talisman for the rest of his life. In Brancusi's beach temple we see, as was suggested
in Masson's sand paintings, the combination of two seemingly contradictory modes of the
Côte d'Azur *imaginaire:* the triumph of mythic place over real geography and—in the
form of the indexical trace—of the real over the represented. In creating an ephemeral
work, whose brief life span echoed the rhythm of the natural clock of high and low tides,
Brancusi found a way to combine the magical and the material in a single gesture.

The Raw and the Cooked:
Vernacular and High Modernism

The local stone of the Riviera, as it had been employed in vernacular construction, would provoke a significant shift in the aesthetics of Le Corbusier. In the villa he designed for Hélène de Mandrot at Le Pradet, outside Toulon, circa 1929–1932, we find, for the first time in his work, the introduction of rubble walls.[68] [See figure 31.] Whereas his other houses of the late 1920s had smooth white or brightly colored wall surfaces— as in the Villa Stein, in the suburbs of Paris, among his best-known "machines for living"—this vacation house on the coast is characterized by its heavy, untrimmed rustication of the local Provençal stone and the unadorned modernist panels of the architect's patented prefabricated windows, doors, and walls.[69] It is a one-story pavilion raised on a *soubassement*, with a terrace facing the sea, enclosed by a single-room wing at either end; one descends a staircase to the garden, just as one mounts a flight of steps—thrillingly raised on a platform—to enter the house from the side facing land.

31. Le Corbusier,
Villa de Mandrot, Le Pradet,
c. 1929–1932

In almost every way, Le Corbusier's Mandrot house is a refutation of typical Riviera villas. In those elaborate Belle Époque confections, whereby an essentially Parisian Second Empire style had been transferred to the seaside, architectural recognition of local culture was limited to the free use of the vast reserves of local clay, in the form of glazed terra-cotta balustrades and pitched red-tiled roofs.[70] At the Villa de Mandrot, instead, the primary concept is not even touristic, at least not in the nineteenth-century sense: the house sits not at the water's edge, but back

in the landscape (although facing the Mediterranean), amid what was in the 1920s farmland. While it hardly looks like one, the villa is conceived as a fancy farmhouse, modeled on the aristocratic Palladian villa in the countryside, raised above the landscape like the Villa Rotonda but laterally echoing its environment like the Villa Barbaro. Yet the house is radically modern in its plan, its flat roof, and the severity of its uncompromising stripped-down geometry, and in its radical primitive "reversion" to local stone as a building material, which gives the structure its subtle and various tonalities and its rough texture. At once sophisticated and crude, the Villa de Mandrot is the perfect expression of a modern idea of escape, of the new, twentieth-century "authentic" tourism on the Côte d'Azur, which put a premium on the indigenous, the out-of-the-way, and the surprising.

32. Eileen Gray and Jean Badovici, "E.1027," Roquebrune–Cap Martin, c. 1926–1929

The Mandrot house was the last of three major modernist villas constructed on the coast, in quick succession, in the late 1920s. The other two were Eileen Gray and Jean Badovici's "E.1027" house,[71] built around 1926–1929 at Roquebrune–Cap Martin, not far from the Italian border, and Robert Mallet-Stevens's Parc Saint-Bernard, also known as the Villa Noailles, designed for Viscount Charles and Viscountess Marie-Laure de Noailles, and built around 1923–1933, only a few miles from Le Pradet.[72] [See figures 32 and 33.] Gray and Badovici's house, which they designed for themselves, is a starkly white rectangular box, modest in size, raised on piles and situated on rocks high above the water, commanding a spectacular view of Cap Martin and the beach below, with Monte Carlo clearly visible in the distance.[73] Mallet-Stevens's buff-colored villa is a large, meandering structure, built

in several stages, and consists of a series of juxtaposed rectangular sections perched on a hill behind the Old Town of Hyères. Its view, although quite different, is no less striking than that of "E.1027": out over the rooftops of the town to the sea, with the three nearby islands —Porquerolles, Port-Cros, and Île de Levant—completing the panorama. The two most notable aspects of the Villa Noailles relate to its garden structures and the perspectives they afford. The wall of the enclosed garden, through which one enters the main door, is pierced by six horizontal apertures (glassless windows, in effect), which by prohibiting the "dispersion of the gaze on too vast an area," as one critic wrote in 1928, intensify "the pleasure of the view rather than being an impediment."[74] The visitor becomes a moviegoer, and the surrounding landscape is viewed through a succession of large screens. Also tightly controlled are the view and the structure of the Cubistic flower garden, below the enclosed one, designed in 1928 by Gabriel Guévrékian [figure 34]. Here, the natural flourishing of plants is subjected to the discipline of a series of overlapping grids, the whole inserted into a narrow triangular plot that must be viewed from above if its design is to be appreciated. (For its farthest acute angle, the viscount and his wife commissioned *Joie de Vivre*, a Cubist sculpture by Jacques Lipchitz, which, mounted as if on the prow of a ship, rotated every four minutes on an electric turntable.[75])

Although neither house invokes the vernacular in the direct way that the Villa de Mandrot does, both "E.1027" and the Villa Noailles were conceived, in general terms, as "southern," Mediterranean, dwellings. In both cases, the Riviera sun was of paramount importance in their design. At "E.1027," as Caroline Constant has noted, "Gray devised a plan diagram depicting internal circulation routes in relationship to the sun's daily

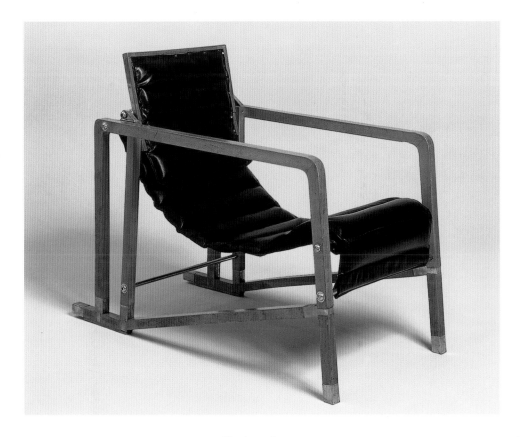

35. Eileen Gray, *transat*
chair designed for "E.1027,"
Roquebrune–Cap Martin, c. 1929.
Collections MNAM/CCI,
Centre Georges Pompidou, Paris

path, using hatched lines to represent the solar impact on the building envelope. . . . By focusing on issues of human locomotion and stasis in relation to the daily transit of the sun, Gray's plan diagram suggests the possibility for an architecture of leisure to reawaken a natural—that is to say *non-numerical*—understanding of time."[76] And Charles de Noailles, who apparently had already met with his prospective architect, wrote in his first letter to Mallet-Stevens: "I realize that I didn't think to draw your attention to a point which seems to me—and which will also, I am sure, seem to you—a necessary principle on the Côte d'Azur. I want to be certain that our plan provides for sun in the morning in the bedrooms, and sun in the afternoon in the salon, because it's for the sun that I'll go to this house."[77] Moreover, the two houses were southern—and even, arguably, vernacular—in another way as well: though to a greater extent at "E.1027" than the Villa Noailles, the model of simple white-washed Mediterranean peasant houses, stacked like boxes on the hillside, was influential on both their designs. The white unadorned flat-roofed rusticity of Greek fishing villages had early on captivated Le Corbusier too. If he did not invoke that model at Le Pradet, it was probably because he wanted to be more strictly Provençal than Greek there, and because he had already exploited so much of the potential of the Mediterranean "white box" aesthetic, paradoxically enough, in his buildings in the north, in and around Paris.

Still, despite their various relationships to local and Mediterranean practice, the trio of villas—Mandrot, "E.1027," and Noailles—were alike in their ostentatious defiance of tradition. All three fetishize, as it were, their deviation from other Riviera villas, and assert their pared-down, rectilinear, and undecorated styles as the necessary alternative to frivolous vacation architecture. Although each was designed as self-consciously contextual —taking into account, in varying degrees, siting, materials, and atmospheric conditions— all three were at the same time repudiations of common practice, rejections of a century's worth of Côte d'Azur grandiosity, and of the historicizing detail that rendered other villas hopelessly old-fashioned. Here, instead, were new houses for new people (even if two of the three sets of owners had the aristocratic partitive *de* in their names). These stylish Parisian sun-worshippers wanted to separate themselves from their neighbors and dominate the landscape; their houses were aggressively contrapuntal in their geometric difference from the organic natural environment. This approach, whereby one might arrive at a new form of aesthetic "health" by rational means, and by jettisoning the conventional (flat roofs instead of pitched; variations on shades of white, buff, and the colors of stone in place of the pink, burnt-umber, and ocher walls of the typical Riviera villa), was at the foundation of modernist architectural thinking. That even at the most celebrated site of pleasurable pursuit one could discipline oneself to forgo the obvious signs of pleasure, that one could practice a form of aesthetic abstinence at a place renowned for sybaritic excess, was the ultimate test of one's modernity. This refusal—which was the royal road to "deeper" and more "exalted" modern pleasures—was crucial to both the architects and the owners of these three remarkable houses.

Côte d'Azur Cubism

The triumphalist stance of these architects—imposing a geometric formality onto the untamed expanse of land, sea, and sky—characterized the approach of numerous painters on the Côte d'Azur as well. Usually, though, even for those artists whose approach was resolutely High Modernist, the picturesque quality of the Riviera insinuated itself into works where one would least have expected it. In one of Jean Metzinger's best Cubist paintings, *The Harbor*[78] [figure 36], a glimpse of the Vieux Port, or Old Port,

36. Jean Metzinger, *The Harbor*, 1912. Oil on canvas. Dallas Museum of Art. Sara Lee Collection

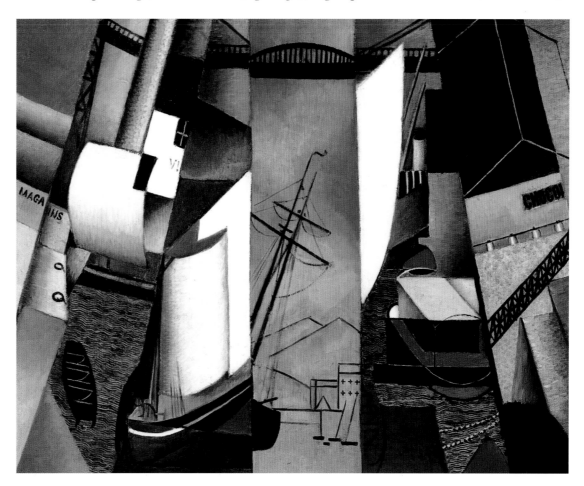

of Marseilles—with a quaint double-masted schooner silhouetted against the mountains
on the outskirts of the city—takes the form of a vertical slice, *en grisaille*, right through
the middle of the picture. Were it not for this local touch, the kaleidoscopic, overlapping,
fragmented planes of the representational field could be anywhere, even in the industrial
north, where Metzinger usually worked. Or almost: in fact, Metzinger chose a spot in
Marseilles that, more than any other place on the southeastern coast, combined familiar
aspects of industrial culture with old-fashioned Mediterranean nautical life. Marseilles's
Old Port was the home, since 1905, of the remarkable iron-and-steel Pont Transbordeur.[79]
[See figure 37.] A technological wonder, with an adjustable suspended roadbed (a form
of updated drawbridge that carried land vehicles, cargo, and people between the north
and south sides of the city), the Pont Transbordeur is clearly indicated in the black hori-
zontal form with arching span at the top of Metzinger's painting. Tourists flocked to
the structure, for the opportunity to be raised above the city as the Pont Transbordeur
performed its work, and to gain unparalleled elevated views in every direction, and not
unexpectedly, it attracted photographers too over the course of many years.[80] [See figure 38.]
Once we realize that this is the setting for Metzinger's harbor picture, we come to
understand the rationale for the radically diverse viewpoints it synthesizes, which include
a perspective looking straight down, from very high up, onto the small rowboat in the

water at lower left, and the elevated vantages of most of the painting's other Cubist fragments; only the glimpse of the Old Port, in the center, is rendered from a ground-level point of view.[81]

But Metzinger, we might say, was a begrudging tourist. If he could not completely deny the Old Port's dated charm, he was not about to give in to Côte d'Azur folklore. Hence it is Marseilles's great modern monument, sometimes referred to as the "Eiffel Tower of the South," that inspires the Cubist painter with its up-to-date mechanics and multiple perspectives. For Léopold Survage, who went to live in Nice during World War I, and who had only recently been converted to Cubism, the impact of suddenly finding himself on the Mediterranean was thoroughgoing. A series of local epiphanies were formative for his art: a sea gull flying overhead in a narrow street in Nice gave him, he said, a new sense of spatial complexity; an old peasant who lived next door to him, "so familiar with his world that he walked on the branches of his fig tree, gathering figs, as easily as if he were in his house," revealed the complicated interrelationship of man and environment.[82]

A hybrid modernity—at once urban and regional, man-made and natural—characterizes such works as a landscape made in Nice in 1915 [figure 40]. The palette is typically southern (pink, yellow, red, green, brown, and orange predominating), although the deep gray-black silhouette of a man in a derby, repeated five times, interjects a distinctly Parisian note. He is recognizable as the *flâneur*—the quintessential Baudelairean man-with-time-on-his-hands, who wanders through the modern city seeking out experiences on which to focus, and sharpen, his critical faculties. Even more precisely here, Survage's mysterious stranger is, like the artist himself, an outsider on the coast during wartime—the doubly displaced *étranger*, a cross between tourist and immigrant, who finds himself in a lush and unexpected setting. The flickering planes of apartment house walls, with their myriad curtained windows and occasional doorways, are like so many eyes or potential vantage points from which the picture's protagonist may be watched,

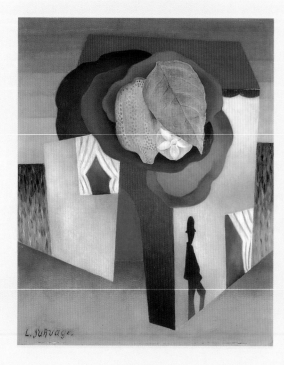

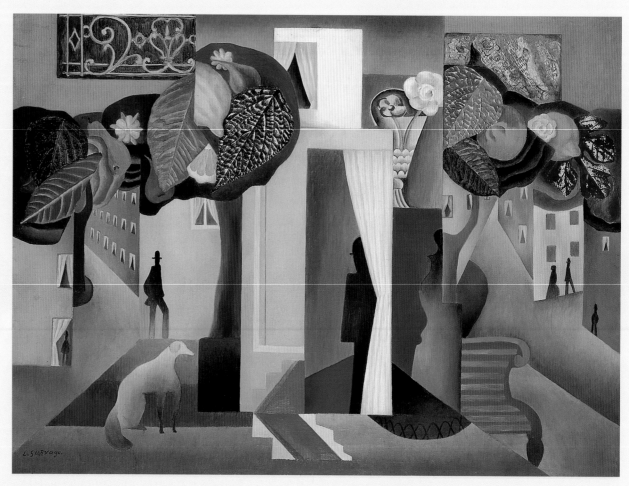

LEFT
39. Léopold Survage,
La Côte d'Azur, Nice, c. 1915.
Oil on canvas. San Francisco
Museum of Modern Art. Bequest
of Blanche C. Matthias

RIGHT
40. Léopold Survage,
Landscape, Nice, 1915. Oil on
canvas. Musée d'Art Moderne
de la Ville de Paris

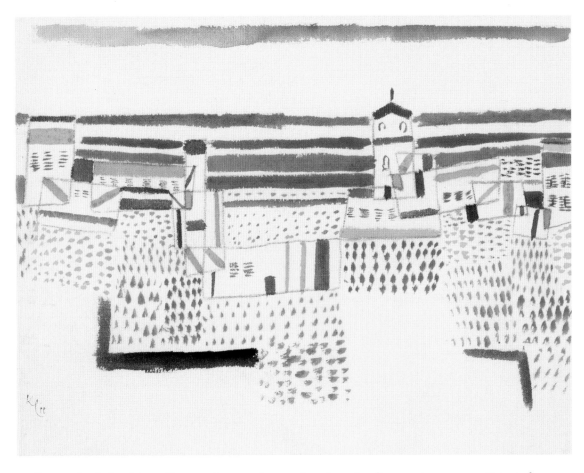

or from which he himself may observe the curiously episodic passing scene. Yet at the same time this unmistakably paranoid fantasy is lightened by high-keyed colors, and surprising details: some rococo balustrade in the upper left, a Russian wolfhound at the lower left, part of a wooden bench at the lower right, and a cut-glass vase with two flowers near the top center, the entire image crowned by a frieze of Mediterranean nature's bounty—oranges, pears, figs, and several citrons, all nestled among the leaves of their respective trees, whose brown trunks support the efflorescence from below. We might describe this as "Côte d'Azur Cubism in the shadow of war."

The Cubist grid, or a derivation, was used as an ordering element in works Paul Klee made on the island of Porquerolles, where he spent ten days in the middle of the summer

43. Hans Hofmann,
Untitled, St.-Tropez, 1928.
Ink and pencil on paper.
The Metropolitan Museum of Art,
New York. Purchase,
Mrs. Derald Ruttenberg Gift, 1999

of 1927 (he returned to the Côte d'Azur in 1933, and visited the neighboring island of Port-Cros, stopping on the way in Nice, St.-Raphaël, and Hyères).[83] Klee stayed on the island with his son Felix, at the Hôtel Sainte-Anne, just a short walk up from the port. In a watercolor done on Porquerolles [figure 42], Klee creates a unified gridded field— in shades of pink, red, ocher, green, blue, and violet—out of the buildings on the village square, patches of landscape and cultivated ground, as well as the sea and sky. In a manner not dissimilar to that in which, two years later, Le Corbusier would use Provençal stone for color and texture at the Villa de Mandrot (located across the water from Porquerolles), Klee enlivens his modernist rectilinear structural system with local detail. Rows of individual dots of color on the ground, perhaps suggested by plants and rocks on the beach, are played off against the geometry of houses, stores, and hotels (including rows of small horizontal colored lines on the buildings, shorthand for their louvered shutters). The sea is marked by a series of horizontal green and blue lines, and the sky by one long, watery violet band across the top.

Little of this delicacy, or concision, is to be found in the works Hans Hofmann made the next year, slightly farther down the coast at St.-Tropez, although they too subject the local landscape to a Cubist grid structure.[84] [See figure 43.] Rendered in black ink and pencil, these drawings look as if they could explode from the internal combustion of Hofmann's repeated marks. The supercharged quality derives from, and is meant to convey, the complex nature of the site. Standing on the Citadelle above Old St.-Tropez— a classic artist's vantage point, from which Matisse, Picabia, and André Dunoyer de Segonzac also created views—Hofmann looks down on the spit of land where the town sits, to the water of the bay, over to the far shore (toward Beauvallon and Ste.-Maxime), and beyond to the Maures mountains; there is almost no room left for any indication of sky. In order to convey all this information, Hofmann imposes a unifying, imbricated template. We feel his struggle in the number of times he traces, and retraces, the

profile of various "zones"—trees, fields, the water's edge—until some of these outlines become clotted, and the areas they demarcate autonomous shapes. Apart from the yellow tone of some of his paper supports, there is no color in these works. This seems surprising, not only because the Côte d'Azur was luminous, but also because Hofmann would become a well-known theorist of color. The exclusive linearity may itself be pedagogical, for Hofmann took along with him to St.-Tropez students from his art school in Munich (he would repeat the trip, with other students, in 1929): one can well imagine the sense of modernist mastery and high purpose that Hofmann would have conveyed to the students by insisting that they rise above the coast's obvious chromatic charms, in favor of a more demanding search for spatial essences. This was the future Abstract Expressionist, after all, for whom "space is alive; space is dynamic; space is imbued with movements expressed by forces and counter-forces."[85]

Intruders in the Landscape

Although I have described High Modernist interventions on the coast as, to some extent, intentionally contrary—imposing a new, geometric order on the ancient, God-given landscape—there is a sense in which these works were not really contrary, but expressive of the reality of coastal life. Like it or not, the Côte d'Azur was being modernized at a rapid pace, and with each step in the direction of the new, what was old, idyllic, and supposedly enduring about the Riviera faded more into the recesses of an idealized past. At almost every level, as the twentieth century progressed, the coast was becoming a place of striking contradictions. In addition to what we might think of as the inherent contrasts of the coastline—mountains and sea, separated by a tiny strip of flat land; intense luminosity creating strong shadows—there were the contradictions wrought by tourism—foreigners versus Frenchmen; (mostly rich) visitors versus (first poor, and then increasingly prosperous) locals; "guests" versus "hosts"—with the attendant distinction between those at leisure and those working in the service of that leisure (of which the relationship between working artists and their vacationing patrons on the Riviera was a highly equivocal variation). Most formidable was the contrast, and the contradiction, between the bucolic landscape that was the Riviera's initial attraction, and the signs of development that pushed nature further into the background—that turned nature *into* a background for the modern life being enacted in front of it. The objective correlative of all these contradictions was the automobile.

It was a significant cultural event when Isadora Duncan was strangled by her own long scarf, which caught in one of the wheels of the convertible she was riding in on Nice's Promenade des Anglais in 1927. This ghastly death in the heart of the pleasure zone encapsulated all of the contradictions of the automobile's gradual domination of coastal life: a fast-moving machine, exhilarating and dangerous, roaring along the shoreline of the ancient Mediterranean. The railroad, of course, was there first, bringing a hitherto unexplored piece of nature into view, and plunging the modern tourist into a new

environment. But by 1924, the discomfort of the railway journey had, according to Helena Waters, finally "induced owners of private motor cars to undertake a six days' motoring tour to reach the Riviera," rather than "face the disagreeable incidents" that might take place during a long train trip. This, in turn, meant that the automobile was available for local touring: "When comfortably settled on the Riviera the car was still in requisition to take the happy owners to enjoy the magnificent mountain scenery, which could not have been visited with the aid of horses alone."[86] Even those who did not own a car, or who had arrived by train, could rent one in almost all the major towns along the coast. Where the 1902 edition of the Baedeker guide to southern France mentions the possibility of renting only horse-drawn cabs in Nice, the 1914 edition lists no fewer than eight garages where, for about 100 francs a day, a car could be rented.[87]

44. Marsden Hartley on the beach at Cannes, 1925

According to C. N. Williamson, writing in 1911, the automobile was already indispensable at the end of the first decade of the century: "The chief pleasure of motoring on the Riviera is that it enables one to add immensely to the variety of life. At first sight, the Riviera, being little more than a narrow strip of sea-coast at the foot of high mountains, would seem to be far from ideal from the motorist's point of view. . . . One has heard motorists say, 'What is the good of taking a car to the Riviera? There is only one road. If you go west you get to Marseille; if you go east you get to Ventimiglia. When you've done it once, why do it again?' But motorists who talk like this have simply never taken the trouble to explore the many interesting and romantic valleys which cut the mountains, and open ways into scenery little less magnificent than that of Switzerland."[88]

For artists, this was a boon. Now, because of the automobile, there was a "secret" landscape-within-a-landscape available for pictorial exploitation on the coast. In one of

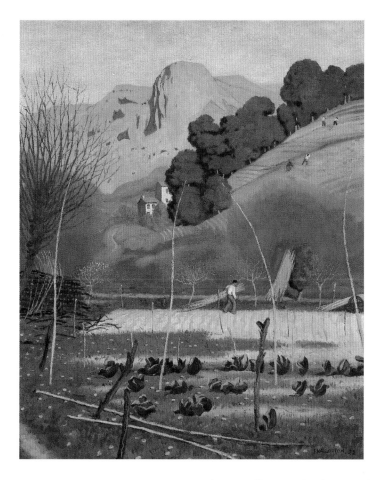

these valleys, which cuts through the mountains between Nice and Antibes, are located Cagnes, La Gaude, St.-Jeannet, Vence, and St.-Paul-de-Vence, and by the late teens the area constituted a major "art colony." Here the American Marsden Hartley lived around 1925–1926, in Vence, only a few miles inland from the heart of the Riviera. Here the Swiss Félix Vallotton painted an exceptional image of a farmer in his orchard at St.-Jeannet in 1922, and here Chaim Soutine painted a superb series of landscapes in the early 1920s. [See figures 45 and 46.] In contrast to the surprisingly touristic pictures that George Grosz painted at Pointe Rouge, Soutine's works made in and around Cagnes are what we might expect of an Expressionist. These roiling renditions of the local topography are among the greatest paintings of his career; what is surprising is that he made such good

art in a place he so disliked. "I want to leave Cagnes," he wrote his dealer in 1923, "this landscape which I can't stand. I even went to Cap Martin for a few days, where I thought I'd move. I didn't like it [either]. I had to wipe clean canvases I'd already begun. [Now] I'm back in Cagnes, against my will."[89]

Obviously, a certain degree of antipathy may not be counterproductive for an Expressionist, if emotional turmoil can be turned to good account. In Soutine's Cagnes paintings, the villages and the hills on which they stand gyrate to some weird, hitherto unsuspected music of the spheres. His exaggerated bright colors—yellows, blues, and greens, with a few touches of red—and frenetic paint handling (suggesting hopped-up versions of the works van Gogh made in Arles) seem to accuse other, more rationalized treatments of the Riviera landscape of merely skimming the topographical surface. Like the unhappy van Gogh before him, the disgruntled Soutine manages to project his intense energy and hypersensitive "northern" spirit onto a venerable southern landscape typically rendered, even by Cubists and their followers, as highly ordered. Whether the result is experienced as "anguished" or "ecstatic" depends, to a large extent, on the viewer, although one wonders whether Soutine's interpretations of the area were inspired by something other than deep feeling. Don't the looping movements of the Cagnes pictures look suspiciously like translations of the rapid shifts in terrain as experienced from a speeding car?

It was also here at Cagnes that Renoir lived, at Les Collettes, where, with the help of the automobile, many artists came to pay him homage, including Mary Cassatt, Maurice Denis, Auguste Rodin, Charles Camoin, Albert Marquet, Pierre Bonnard, and Tsugouhara Foujita. According to legend, so did Modigliani, although his meeting with the old Impressionist apparently did not go well: Renoir showed the young man some of his latest nudes, anticipating his approval, but received instead an insult—"*Je n'aime pas les belles fesses*" (I don't like beautiful asses).[90] In the case of Matisse, who went to see

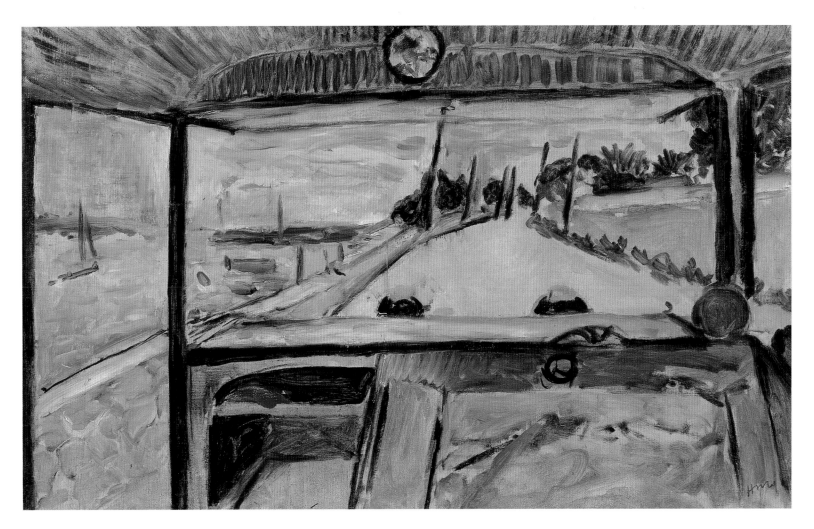

47. Henri Matisse, Antibes,
View from Inside an Automobile,
1925. Oil on canvas. Private
collection

Renoir at Cagnes almost as soon as he was settled at the Beau-Rivage, in late 1917–1918,
it was the old man who had a thing or two to say. In the celebrated encounter, Renoir told
Matisse that, frankly, he didn't like his work, except for the way he handled black: "You
put on a black and you make it stick. So even though I don't like at all what you do,
and my inclination would be to tell you you're a bad painter, I suppose you are a painter
after all."[91] Renoir was dead by the time Matisse, making free use of black, devised a sin-
gular viewpoint from which to paint the coast: through the windshield of his car. [See
figure 47.] A picture of the road that runs along the water at Antibes, this large horizontal

BELOW LEFT
48. André Derain in his Dodge,
Sanary, 1920

BELOW RIGHT
49. Moïse Kisling on the
running board of his Citroën
in front of the villa Ermitage
de Roses, Sanary, 1925

OPPOSITE AND DETAIL
50. Alfred Courmes,
Peggy Guggenheim, 1926.
Oil on canvas. Musée
National de la Coopération
Franco-Américaine, Château
de Blérancourt. Gift of the
Amis du Musée

canvas (five feet wide) looks rapidly painted; yet it is entirely consistent in approach with the window views Matisse painted from his rooms in Nice. As he did there, the artist finds here an aperture through which he can put himself at a distance from the passing scene and remain securely enclosed. We might say that the automobile here is a kind of hotel room on wheels, which allows its occupants to be "in" the landscape without going out of doors, to remain private and independent yet mobile. This was what Helena Waters meant by saying that the car saved the traveler from embarrassing moments in the public conveyance of the train, and it was also an aspect of what C. N. Williamson found so congenial about the automobile. When he wrote that the motor car added "tenfold to the variety and charm of a holiday," he was referring not solely to the gorgeous landscapes it opened up, but also to the freedom and intensified individuality it afforded. "It makes the possessor independent of the inconvenient time-tables of the P.L.M. [Paris-Lyon-Méditerranée], so that social engagements can be kept anywhere along the coast, without having to catch trains at unreasonable hours, or waste time in waiting if one arrives too early at one's destination. It enables every man to cultivate his individual tastes, whatever they may be."[92]

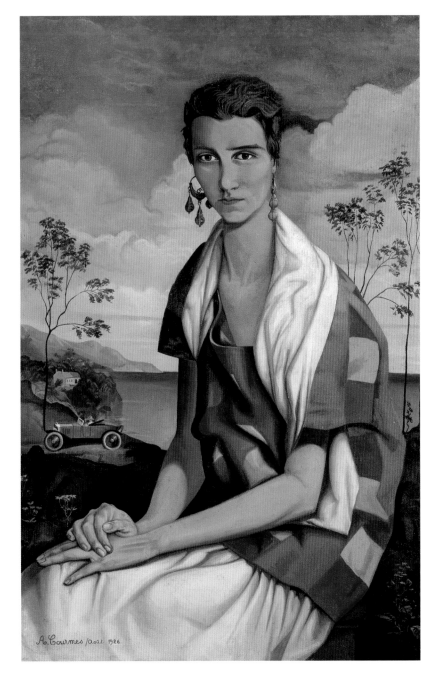

This private "cultivation of taste" was immensely appealing to artists on the coast, and not just to Matisse. We know, for example, of Paul Signac, that in October 1905 he was in Marseilles to pick up his new Peugeot, as he wrote to Albert Manguin; several days later he wrote again, saying that he was thrilled with his new car, and delighted with the ease of traveling in it from Marseilles to St.-Tropez.[93] We also have numerous photographs of artists posed proudly with their cars on the coast, including Derain and Kisling [figures 48 and 49]; posing with one's automobile became a trope of Côte d'Azur life. In a portrait by Alfred Courmes [figure 50], Peggy Guggenheim sits on a parapet

overlooking the sea at Pramousquier, near Le Lavandou, where she and Laurence Vail had a villa. Rendered in a highly finished, neotraditional style that borrows freely from Giovanni Bellini, it is nevertheless the picture of a thoroughly contemporary woman, a flapper on the Riviera. Guggenheim's short, stylish haircut permits a clear view of her large, dangling earrings; she wears a geometrically patterned blouse; and most telling, her red Dietrich-Lorraine roadster is parked under a tall mimosa in the left background—one more attribute of a rich, seriously modern visitor to the coast. (The picture was painted in August 1926; shortly thereafter the copper-mining heiress and a few of her friends bought a cottage for the anarchist Emma Goldman at St.-Tropez, where she would settle down to write her autobiography.[94])

Above and beyond its representation, the automobile helped create a new kind of resort of the Riviera, one in which ease of movement and constant short-distance travel were becoming the norm. For artists, this meant a tremendous variety of places in which to work (the "scenic advantage"), from the small fishing port to the large town, from the back country to the beach. It also allowed for a great deal of socializing—as Williamson notes—so that artists were repeatedly driving along the coast to pay visits to one another, and to see one another's work in progress. Indeed, one wonders how much the automobile, encouraging a frequent displacement and freeing artists from the boredom that might overtake them in a resort, also helped precipitate a dissatisfaction with staying put. Restlessness distinguishes the lives of artists on the coast. Picasso's various Côte d'Azur sojourns are emblematic. He was at St.-Raphaël in 1919, and at Juan-les-Pins in 1920, in 1924 and the next two years, and again in 1930 and 1936. He stayed in Cap d'Antibes in 1923 and Antibes in 1939, and in Cannes in 1927, 1933, and 1934; he bought a house in Cannes where he lived from 1955 to 1961. In 1945, 1946, and 1947, he stayed in Golfe-Juan; between 1948 and 1955, he lived in Vallauris; and he stayed in Mougins for part of 1936 and 1937, later buying a house there, where he lived for the

last years of his life, from 1961 to 1973. This pattern—of continually moving from one place to another along the coast—was repeated, in varying formulas, by Derain, Masson, Kisling, Cocteau, Lartigue, Beckmann, Eileen Gray, and many others.

The mixture of freedom and anxiety, exacerbated by the automobile, meant that the Côte d'Azur, whatever else it might be, was a distinctly modern site. It also meant that the coast was increasingly subject to the same modern cycles of economic boom-and-bust as other urban centers. We can find a trace of this fact in a work by the Viennese painter, publisher, and collector Walter Bondy, who fled from the Nazis to the Riviera in the 1930s. [See figure 51.] Painted in Sanary in 1934, the picture shows a local garage, at least one of whose eponymous signifying letters has been lost to subsequent renovation of the clay-red Provençal building, in front of which a Citroën insignia is prominently displayed. As the backdrop to a trio of agave plants growing willy-nilly in a nearly empty, half-cultivated lot, the garage is an apt symbol for the Riviera once the Great Depression had hit France, when tourism declined precipitously, and most local businesses, especially those dependent on tourism, were hard-pressed to survive.[95]

51. Walter Bondy, *Garage*, Sanary, 1934. Oil on canvas. Collection Catherine Cozzano

Yet even before it became apparent that the good times on the Côte d'Azur would not last forever, it was obvious that the area was becoming too popular. In a postcard of Juan-les-Pins from the 1930s [figure 52], the beach looks as crowded as the Champs-Élysées. In Bonnard's large unfinished St.-Tropez

52. Beach at Juan-les-Pins, early 1930s

OPPOSITE

53. Pierre Bonnard, *The Beach at St.-Tropez*, c. 1932–1934. Oil on canvas. Norton Museum of Art, West Palm Beach, Florida. Gift of Mr. Walstein C. Findlay

beach scene from around 1932–1934 [figure 53], the sense of private *luxe, calme et volupté* that distinguished Matisse's canvas of more than a quarter-century earlier has given way to busy leisure-time activity. Fernand Léger, for one, was exasperated by the congestion on the coast. In August 1933, he wrote his girlfriend about what had happened when he opened his hotel room window in Nice: "Last night I endured again that infernal noise—it took place, to be exact, on the Promenade des Anglais. . . . You can imagine what it's like—for 20 kilometers it's nothing but a racetrack where cars drive past double-file, in both directions. At 10–11 p.m. it's the most intense. . . . Only certain situations at [the Battle of] Verdun can be compared to this modern thunder—a battle of the gods."[96] Despite his vexation, Léger manages to elevate the din outside his window to mythic proportions (which, we know, was common artistic hyperbole on the coast). That same year another auditor could hear only what sounded like the aural manifestation of depredation. Recalling the Riviera's halcyon days, when everywhere were to be found "peaceful corners for working or meditating in complete tranquility," Louis Bertrand now could hardly find a place to free himself from the dissonance of modernity: "Today, even in out-of-the-way spots," he wrote, "you come to expect the almost continual blaring of all the intolerable noises of modern life: the roar of airplanes continually passing over your roof; automobiles revving up and idling, and a continual line of them, especially on 'circuit' [road race] days; sounds of the T.S.F. [radio] and phonographs in the neighboring villas; parakeets chirping, dogs barking, the invasion of all kinds of animals, with whom the nouveaux riches and bourgeois now fraternize; the tumult of dance halls, cinemas, and roadhouses, near and far."[97]

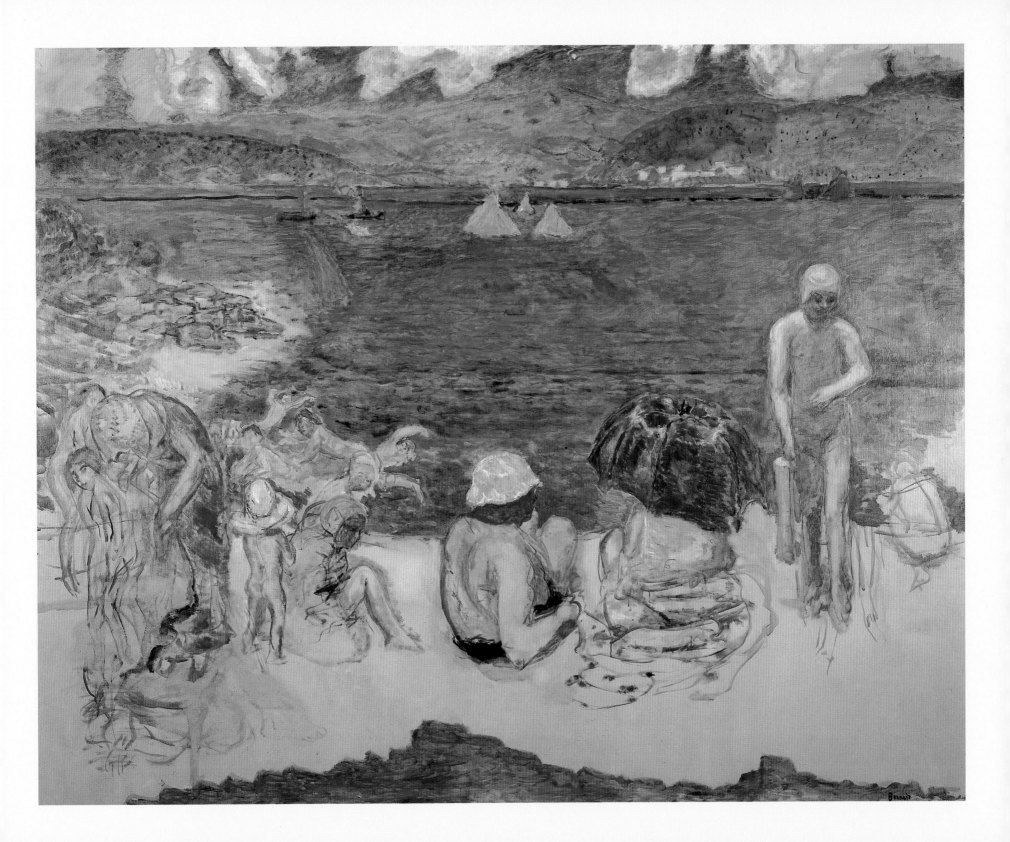

A Photographer Despite Himself

One man's spoliation is another man's paradise. Jacques-Henri Lartigue's photograph of Chou Valton [figure 54], lying in the sun on the Plage de la Garoupe at Antibes in 1932, might be documentary evidence for Louis Bertrand's thesis, were it not so thoroughly permeated with the pleasures of a summer's afternoon. This is the quintessential image of Côte d'Azur sophistication, in which the natural and the mechanical merge as effortlessly as the water of the Mediterranean and the sand on the beach. The blond protagonist, whose bathing suit is hiked up just enough on her still-pale lower buttocks to indicate how

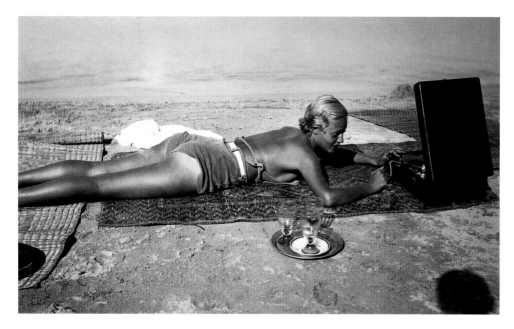

54. Jacques-Henri Lartigue,
*Chou Valton, Plage de la
Garoupe, Cap d'Antibes*, 1932.
Association des Amis
de Jacques-Henri Lartigue

deeply tanned she is otherwise, blithely reaches over to wind her portable phonograph.[98] A carafe of water, three glasses, and a small plate on a tray tell us that this is a scene not of isolated escapism, but of contemporary sociability: Chou Valton has been attended to by waiters and joined by at least two friends. By impinging on the image with his own shadow, at the lower right, Lartigue alerts us to the thoroughly "performative" quality of Riviera beach life, in which visitors are there both to see and to be seen. Unlike Bertrand, though, Lartigue is not offended by the incursions of tourism and technology; he delights in the incongruity of bathing beauty and phonograph, of phonograph and shoreline. He even makes an equation between the sleek modernity of the little music machine and that of its owner—light is reflected off the arm of the victrola and the dark sheen of its black disk, as it is off her brown arms, legs, back, and golden hair.

What was true for modern appliances at the beach was, for Lartigue, even more so for cars on the Côte d'Azur. "It's like magic, having an automobile down here," he

observed in his diary. "All you need to say is, 'I feel like being in Cannes, I feel like being in Monaco,'. . . and you're off, and you're there."[99] If cars meant vastly increased mobility on the coast, enabling painters, among others, to seek out new vistas and to change their lodgings with relative ease, for photographers the automobile allowed for an almost inexhaustible supply of motifs. The introduction of the two machines—car and camera—is inextricably linked to coastal life: automobiles provided access to places where great pictures could be taken, and the taking of pictures encouraged the ever-increasing use of the automobile. As much as anything, the Riviera's renown was a product of the camera. Professional postcard photographers supplied glamorized views of the coast, to be sent around the world by tourists; and amateur tourist photographers, armed with improved easy-to-use cameras, took pictures of their own—felt *compelled* to take pictures —wherever they went. A frenzy of picture-making—scopophilia *à outrance*—overtook coastal life.[100]

Lartigue considered himself one of these amateur photographers (his ambition was to be a painter), even if he must have been aware that his pictures were much better than those of the typical tourist. Beautiful women, the landscape of the Riviera, and cars— small and racy, or large and "bourgeois" (as he termed them), and usually convertibles with the top down—are Lartigue's favorite subjects, in his photographs as well as in his diaries. "Every day a big convertible takes me to Cap d'Antibes. It's always with Pauline, with her little dog perched behind my back," he records in Cannes on March 27, 1932. Four days later: "Pauline Rowe is English and her car is always as well shined as her shoes. Jean and Michel have left by plane for a few days in Paris. Here's the sun and it's a perpetual feast for my eyes." And on April 12, at three-thirty in the morning, waiting for a woman friend with whom he is going to Monte Carlo to see the early arrival of the drivers for the auto races, he notes: "Lolo Burki . . . glimmer of headlights, it's her in her little Bugatti."[101]

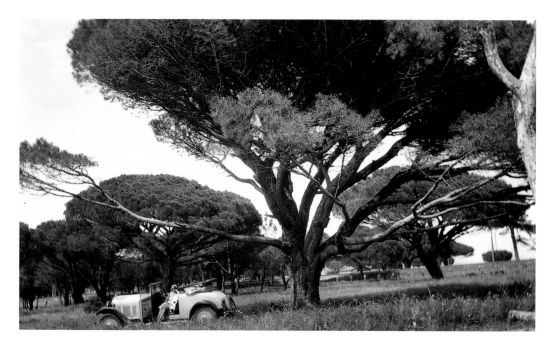

55. Jacques-Henri Lartigue, *Renée in My Talbot Automobile, St.-Tropez*, 1930. Association des Amis de Jacques-Henri Lartigue

OPPOSITE
56. Jacques-Henri Lartigue, *Robert Sabbag in His Cadillac with Huguette Paris, Arlette Rebuffel, and Florette, Cannes,* 1953. Association des Amis de Jacques-Henri Lartigue

Depending on his relationship to the site, to the woman or women in question, and to the automobile, Lartigue's pictures can be dreamily romantic or subtly ironic. When he photographs Renée Perle, one of his great loves, at St.-Tropez in 1930 [figure 55], she is seated in one of his favorite cars, "*mon automobile Talbot*," as the picture's label tells us. Posed beneath huge umbrella pines, his twin companions seem protected by the ancient windswept trees. Whether it is their majestic beauty, or the allure of his girlfriend, or the handsome lines of his roadster, that have inspired the picture, we cannot say; all three conspire to make this a memorable modern idyll. The effect is altogether different when, in 1953, with the town of Old Antibes in the background [figure 56], he poses his beloved second wife, Florette, alongside two other beauties—Huguette Paris and Arlette Rebuffel—sitting, like movie stars, on the seats of the shiny Cadillac convertible belonging to Robert Sabbag (who turns to grin mischievously back at us from the driver's seat). What results is not the classically composed image of a glorious, fleeting afternoon, but something closer to a snapshot, appropriate for a picture of postwar, Americanized glamour on the Côte d'Azur, in which more is better, and bigger is best.

Such was Lartigue's sympathy for his cars that at times they have a life all their own. We sense this anthropomorphism in the diaries. "Seven o'clock in the morning," he wrote, while at Cap d'Ail in 1927, "Sacha sleeps. Yvonne sleeps. Bibi is awake but hardly. The car, packed with luggage, waits for us in the garden." Almost five years earlier, also at Cap

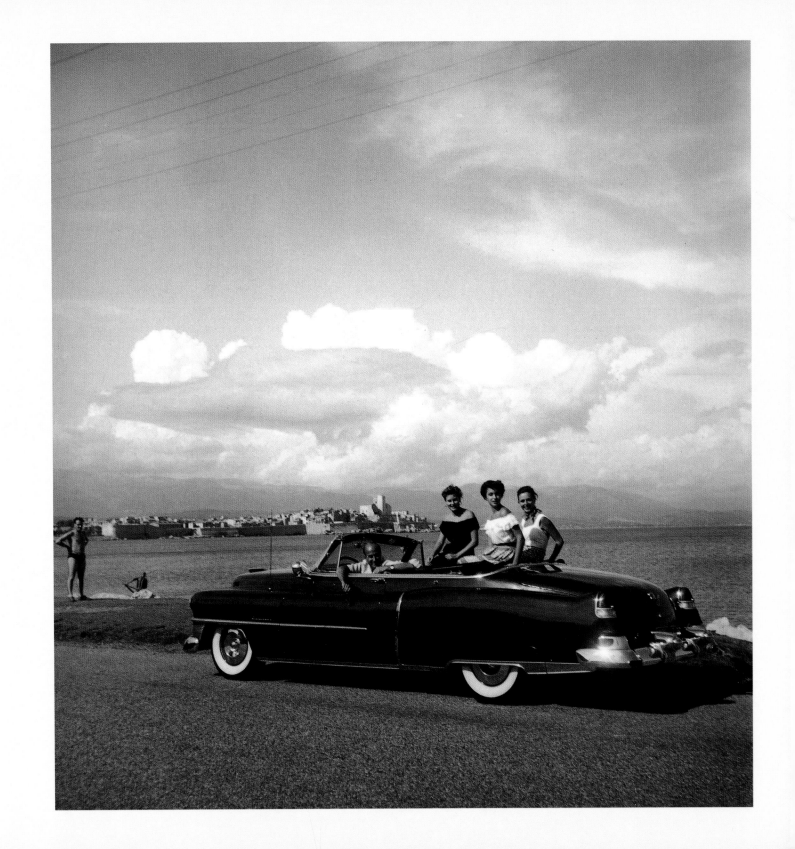

d'Ail, he had noted: "Below the hotel, a big rented Rochet-Schneider. It sleeps in the garden until it is time to take us, on certain evenings before dinner, the three kilometers to Monte-Carlo, to the casino of the Sporting [Club]."[102]

Two great, elegiac photographs of 1927 are really portraits of an automobile, his Hispano-Suiza; although we can deduce that Lartigue has left Bibi, his first wife, in the car and has jumped out to take the two pictures, her presence is so insignificant that the car itself becomes the protagonist. One of the photographs [figure 57] is a panoramic view taken across from the Îles d'Hyères or the Îles de Lérins, near Cannes, to judge from the island on the horizon at upper right. Viewed from above, Lartigue's roadster is so positioned that it could be a foreground figure in a landscape by Pieter Brueghel, or a lone Romantic wanderer in a painting by Caspar David Friedrich. Lartigue endows his automobile with a consciousness; it becomes a surrogate for the artist/ spectator, who, from an elevated viewpoint that is at once touristic and existential, gazes out over the gleaming expanse of sea. The other photograph [figure 58]

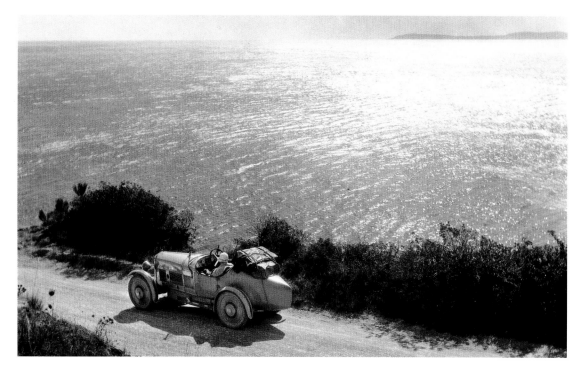

57. Jacques-Henri Lartigue, *Mediterranean*, 1927. Association des Amis de Jacques-Henri Lartigue

is a genre scene in which the walls of what is probably the shoreline road, the Basse Corniche, near the Italian border, enclose the main action in a stagelike setting and block the view of all but a few palms, and of a worker with a wheelbarrow, who can just be

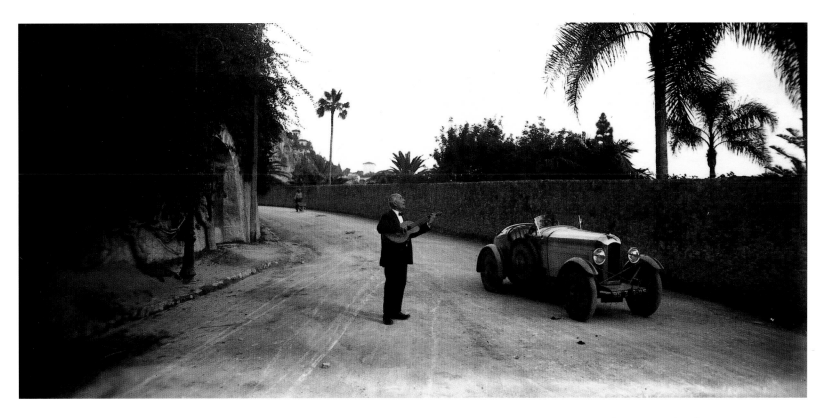

58. Jacques-Henri Lartigue,
*Luigi, Street Singer, at
the Italian Border,* 1927.
Association des Amis
de Jacques-Henri Lartigue

made out in the distance. The caption tells us that the man in the foreground, who strums his guitar to accompany his plangent refrains, is a street singer named Luigi. Although this might have been the first time he was asked to serenade a car, why shouldn't he? We can be certain that Lartigue, who was still quite rich at the time and accustomed to paying for his pleasures, reimbursed the ambulant musician for his exceptional services. And why not sing a love song to an automobile, when the car in question was the photographer's cherished Hispano-Suiza, his magic chariot, that at a moment's notice could whisk him off to Cannes or Monaco, or anywhere else his heart desired?

Hedonism

When Lartigue's money ran out, as did that of so many others after the onset of the Depression, he too started to sing for his supper on the Côte d'Azur. Among his new occupations, which included scouting for movie locations, were organizing and designing parties at the municipal casino in Cannes (which boasted numerous casinos and clubs, for winter and summer, both at the beach and "in town"). For his first gala, at the Salle des Ambassadeurs, in February 1935, Lartigue designed an event called "Fleurs et Papillons" (Flowers and Butterflies), which featured painted bouquets on the walls and hundreds of paper butterflies, attached to a scrim, floating over the room. The next year he organized and designed a "Multicolor" party for the casino.[103] Although we might be taken aback to imagine one of the greatest photographers in the history of the medium cutting out paper butterflies for the amusement of Cannes's chic tourists, we should keep in mind that Lartigue himself had been among those partygoers, and hence was comfortable in that milieu, and moreover, that a notable contemporary artist had already done likewise.

Francis Picabia had been organizing parties in Cannes long before he was hard up for cash, although it was undoubtedly congenial to earn money at the kind of play the Dadaist loved. At his "Gala de l'Enfance," in March 1927 [figure 59], the artist came dressed in drag, as a governess, with his companion, Germaine Everling, and the couturière Nicole Groult (sister of Paul Poiret) costumed as the little girls in his charge. For a "Fête des Cannibales," a charity event Picabia organized at Cannes's Château Madrid in the summer of 1930 [figure 60], he asked the guests, including many of his friends, to come dressed as savages, just as, that same year, he requested real or simulated body decoration for his "Tattooed Night." Ladies were expected to come dressed in blue and white for "A Night at Sea," organized at the Ambassadeurs in March 1931; for Christmas 1932, the theme was "Dialogue dans la Stratosphère," with the American movie diva Jeannette MacDonald as guest of honor, ostensibly representing the silver-screen

59. Nicole Groult, Francis Picabia, and Germaine Everling at the "Gala de l'Enfance," Cannes, 1927

60. "Fête des Cannibales,"
Cannes, 1930

firmament; and for "A Night in Singapore," earlier the same year, Picabia found someone to supply live lions and panthers.

Picabia's life in Cannes was worldly in all the ways in which the life of the high-minded, serious artist was supposed not to be. He built a large house, the Château de Mai (so-called because it was in May that construction began), at Mougins, a suburb of Cannes, equipped with a swimming pool; he bought himself a yacht, and drove his fast and expensive cars, including a Rolls-Royce, along the winding roads of the back country. All the while, he was painting in a variety of conflicting styles that have since made him the prototype of the postmodernist—exemplified by the frankly parodic collage *Promenade des Anglais* mentioned earlier, and a series, known as the *Transparences,* in which several thinly painted neo-Renaissance images are superimposed one upon another. Picabia's Riviera existence was, in almost every sense, extravagant.[104] His transgressive self-indulgence on the coast became legendary, his embrace of hedonism a rebuke to the Romantic myth of artistic self-denial. In Picabia, the sybaritic aspect of resort life had found its artistic embodiment, Dada's principle of imaginative and unfettered play its real-life counterpart. So compelling was the combination of man, art, and place that even unlikely suspects were drawn into the orbit of Picabia's *mondain* activities. Down-to-earth, left-leaning Léger wrote from the coast in 1934: "With Picabia have launched multicolored toenails—the big one yellow, the other blue, etc.—and back decoration—a 'decorated back' contest—you have to pass the time [somehow]—but I'm not a Cannes type—what a place . . . !"[105]

Someone who was a "Cannes type" was the Dutch painter and former Fauve Kees van Dongen. He first came to Cannes in the early 1920s, and soon became the aristocratic resort's reigning "artist in residence."[106] Van Dongen painted prodigiously and was a

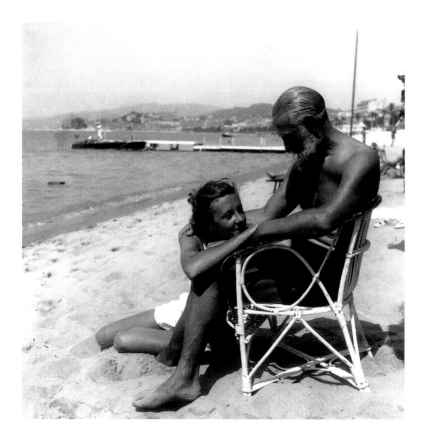

61. Kees van Dongen and young woman on the beach at Cannes, c. 1930

much-sought-after guest at countless social functions (he was also a good friend of Lartigue's). His *Self-Portrait as King Neptune*, of 1922 [figure 62], may be a record of a costume he wore to a masquerade at Cannes. The forty-five-year-old artist, who always looked older than his years in real life but who seems to have shaved a few years off his age in this idealized fashioning, pushes himself up to the picture plane. The cruise ship anchored in the harbor behind him provides the painting with its breadth, and lets us know, as if with a wink, that whatever watery depths this deity presides over are tailored strictly to a first-class clientele of pleasure-loving mortals. Holding a decorated spear in his right hand, van Dongen sits in majesty (although the faulty perspectival foreshortening makes it look as if he were standing). He wears a grass skirt with seashell belt, eight necklaces—four strings of beads and four chains with hanging pendants—a pair of earrings, and a hat with raffia cascading down the back, topped by the sort of dolphin you might find on the stone fountain of a town square in France; another dolphin is sketchily indicated at his lower right. The whole getup partakes of an especially Frenchified notion of adornment, of *parure*, that refuses to sacrifice elegance completely in the service of disguise.

Despite the unabashed superficiality of the painting's conceit, there is something that strikes deep in van Dongen's portrayal of himself on the Côte d'Azur, as well as in Picabia's "cannibal" party and his "Gala de l'Enfance"—the desire for regression. This note was sounded in 1905, when the Fauve painter Albert Marquet, excited by the

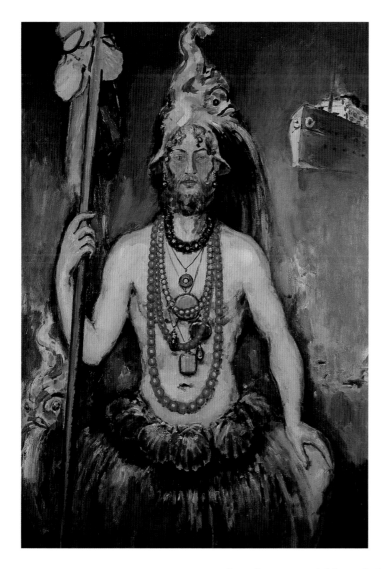

62. Kees van Dongen,
Self-Portrait as King Neptune,
1922. Oil on canvas.
Collections MNAM/CCI,
Centre Georges Pompidou, Paris

simple pleasures he discovered at St.-Tropez, wrote to a friend: "In these French tropics, we become tropical people."[107] The possibility of throwing off the restraints of civilization and regressing to the presumed innocence of children, or of "tropical people," was central to the coast's allure. Somerset Maugham, as we have seen, installed one of Gauguin's painted windows in his study at Cap Ferrat, and the violet-and-yellow combination prevalent in paintings made on the Riviera was a favorite of France's most celebrated seeker of primitive exoticism. But in a far more general way, Gauguin's shade presided over art-and-life on the coast. It was he, for better and worse, who had acted out the great modern search for ecstatic, unbridled pleasure (or perhaps who transformed that quest from an exclusively aristocratic to a middle-class pursuit—isn't that why it is essential to his story that we know he was a stockbroker, or "bank clerk," as the popular version goes?). It was Gauguin who had escaped to an exotic, distant place, and who had evaded the confines of the Paris art world (or attempted to: he could not break free of his financial dependence on the capital); it was he who went in search of artistic renewal and authenticity (although he took himself to a French colony that had already corrupted native life); it was owing to him that, forever after, the idea of the truly free, fulfilled artistic life would require palm trees, a deep blue sea, and an endless supply of sexual partners. Paul Gauguin, or rather his myth, embodied nearly everything—art, beauty, escape, and sex—that would encourage France's southeast coast to be reimagined as

LEFT

63. Jules Pascin with friends
(Lucy Krogh at right) at the
Lespinasse villa, St.-Tropez, 1925

RIGHT

64. Jules Pascin and two
friends at the Lespinasse villa,
St.-Tropez, 1925

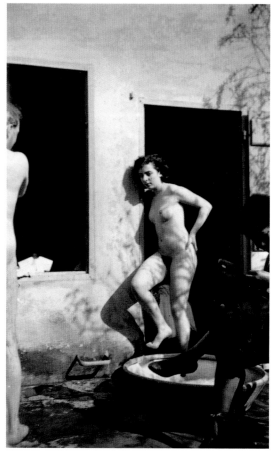

a home-grown version of the South Pacific. And without the potency of that myth, in
both its contradictions and the ways in which it spoke to real desire, it is unlikely that
the Côte d'Azur would have assumed the particular cultural shape it did.

Pleasure, play, sex, make-believe, regression: all of this, if not more easily pursued
on the Riviera than in Paris, seemed more appropriate there. When the painter Jules
Pascin went to St.-Tropez in February 1925, accompanied by a group of friends, they
stayed in the house of an American, Herbert Lespinasse.[108] Photographs taken there by

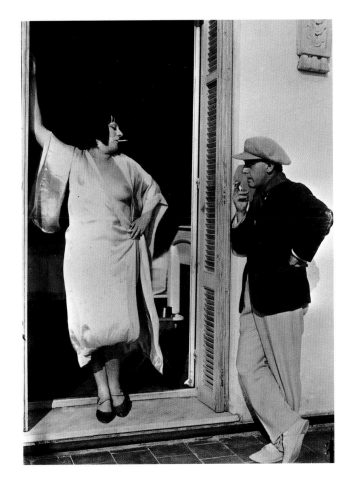

65. Man Ray and Kiki de Montparnasse at Villefranche, 1925

Thora Dardel [figures 63 and 64], wife of the Swedish painter and scenic designer Nils Dardel, show us a group of tough-acting Parisians sporting the chic coastal *style marin*—white sailor pants and tops for the women, a fisherman's sweater for Pascin— or nothing at all, as in the photograph in which Pascin and a companion, having just bathed in the sea, stand buck naked in the yard outside the villa. That same month, farther east down the coast at Villefranche, another group from Montparnasse was visiting: Per Krogh, the husband of Lucy Krogh, a lover of Pascin's who was with him in St.-Tropez, with *his* lover, Thérèse Maure, who went by the name "Treize," and Alice Prin, known familiarly as "Kiki de Montparnasse," and her lover, the American artist Man Ray. The latter two performed a little low-life vignette for the camera [figure 65]: on a hotel terrace, Kiki, with one breast exposed, provocatively plays the prostitute to Man Ray's interested client.[109]

The exquisite little port of Villefranche was, in fact, filled with real prostitutes. Possessed of the deepest natural harbor on the Riviera, it was a navy town reserved for foreign fleets. Jean Cocteau is usually credited with the avant-garde's "discovery" of Villefranche, which, like the two other navy towns on the coast, Marseilles and Toulon, was also a gay mecca. Cocteau frequented all three ports of call. His anonymously published homosexual novel of 1928, *Le Livre Blanc*, is set in Toulon, to which "men in love with masculine beauty come from all corners of the globe to admire the sailors, who walk by idly, alone or in groups, respond to glances with a smile and never refuse an offer of love. Some nocturnal salt transforms the most brutal jailbird, the roughest Breton, the most savage Corsican," Cocteau writes, sounding like Jean Genet *avant la lettre*, "into

66. Jean Cocteau, *Gala de la Marine*, 1940. Ink on paper. Jack S. Blanton Museum of Art, The University of Texas at Austin, The Severin Wunderman Collection

those tall, flower-decked girls with low décolletés and loose limbs who like dancing and lead their partners, without the slightest embarrassment, into the shady hotels by the port."[110] Although Cocteau refrained from attaching his name to this novel about unnamable love, he was more than happy to sign prominently a poster design for a navy celebration planned for Marseilles in 1940 [figure 66]. Here, though, the sex is almost entirely sublimated: with the sun peeking through from beneath a banderole, on which are inscribed the words "Gala de la Marine," the profile of a young sailor strains upward, toward the skirted cables of what we recognize as one of the twin pylons of the Pont Transbordeur, as if he were a male Danaë, awash in a shower of gold from on high.

The social calendar of the Côte d'Azur was filled with such galas, public celebrations organized by the various towns and their chambers of commerce. Many of these were ancient festivities of local origin, enlarged and made more elaborate for the tourist trade. The biggest and most famous was Nice's Mardi Gras, which artists as diverse as Signac, Picabia, and Lartigue depicted at various times. From the balcony of his room at the Hôtel Méditerranée, Matisse painted at least five versions of the event that took place the day *before* Mardi Gras, the Bataille des Fleurs (or Fête des Fleurs), when local dignitaries and visiting socialites competed for prizes on flower-bedecked floats (an event comparable to Pasadena's Tournament of Roses

67. Man Ray, *Hopes and Optical Illusions,* Antibes, 1938. Ink on paper. Collection Timothy Baum

parade). Henri-Edmond Cross painted *Village Dance in the Var* in 1896, Dufy a picture of Nice's May Day celebration in 1930, and in 1956, for his daughter Rebecca, Orson Welles created a "portfolio of pictures," in ink and gouache, with accompanying texts, illustrating the weeklong Bravades festivities at St.-Tropez.[111] All of these events, many with a folkloric aspect, were supplemented by a continual round of modern *divertissements sportifs*—tennis matches, air shows, car races, horse races, bicycle races [see figure 67].

Villa America

Above and beyond public entertainments, it was in private enclaves—within the walls of villas, and on an occasional yacht—that modern artists most enjoyed themselves, and also managed to produce a good deal of work. We have seen how Signac's La Hune, at St.-Tropez, was a center of activity at the turn of the century; so were Picabia's Château de Mai at Mougins, Kisling's La Baie at Sanary (as well as his various rented houses on the coast), and the villa called Trait d'Union, at Beauvallon, designed by the architect Julien Flegenheimer for the painter Romaine Brooks and the writer Nathalie Barney.[112] Cocteau created murals for the Villa Blanche at Tamaris, near Toulon, in 1932 and at the Villa Croix-Fleurie at Pramousquier in 1937.[113] Dufy painted an elaborate four-paneled mural, with images of palm trees, exotic birds, and butterflies, for the drawing room of the Weisweiller family villa at Antibes, L'Altana,[114] in whose garden Lartigue photographed a scene he had undoubtedly orches-

trated: a lithe young woman cavorts amid the hedges and shaped shrubs, in pursuit of a large bouncing ball [figure 69]. Might we call this Art Deco fantasy "Fleeting Pleasure"? And it was at the Noailles villa at Hyères, where a long list of Parisian celebrities went to relax, that Man Ray, at the viscount's request, filmed *Le Mystère du Château de Dés* in 1929. Its title was partly an homage to Mallarmé's poem "Un Coup de Dés Jamais N'Abolira le Hasard," and partly the result of the fact that Man Ray thought the villa resembled enormous dice (*dés*). The film's subject was "a vacation, but a mysterious and disquieting vacation indeed, for the villa's rooms are ominously empty, and the bathers in the swimming pool are masked and manikinlike."[115]

Mysterious and disquieting—nothing could be further from Man Ray's Surrealist *vie de château* than the exuberant, purposeful life of the Americans Gerald and Sarah

Murphy at Cap d'Antibes.[116] The Villa America, as they named their house, began as a relatively modest chalet (on a very expensive piece of real estate, with an unmatched view of the sea). After remodeling, it boasted a sun porch and a dining terrace, and its interior walls were whitewashed and the floors covered in waxed black tiles. The compound included also two guest houses, a garage, and a painting studio at the bottom of the garden. Life at Villa America was spent as much as possible out of doors, in the ample gardens and at the nearby Plage de la Garoupe. Calisthenics, swimming, and sailing, often in the company of their three children, Baoth, Patrick, and Honoria, were part of the Murphys' routine; there was also much adult entertaining, with their wide circle of American and French friends. This was a New World idea of leisure: energetic yet casual, with a willful flaunting of *haut-bourgeois* formality, and a highly self-conscious embrace of all that might be rendered elegant by virtue of its simplicity.

The Murphys first visited Cap d'Antibes in 1922 as the guests of Linda and Cole Porter, and returned the next summer, staying at the Hôtel du Cap. Their choice of season is noteworthy: at the time, high-society tourists like them arrived on the coast after Christmas and left by Lent. But Gerald Murphy was a painter—a good one—and artists had been coming to the Riviera in the off-season for decades. During the summer of 1923 the Murphys were joined at Cap d'Antibes by Pablo and Olga Picasso, their baby Paulo, and Pablo's mother (Picasso made a lovely drawing of two neoclassical bathers on Hôtel du Cap d'Antibes stationery, now in the collection of the Musée National d'Art Moderne, Paris). When they returned to Paris, Gerald Murphy was suddenly a figure of note in art circles. The premiere of the Ballets Suédois production of *Within the Quota*, for which he had designed the sets and costumes, and Cole Porter had supplied the music, was a huge success.

But Cap d'Antibes, not Paris, was home base for the Murphys. Around 1924, Gerald painted a signboard for their residence, to be displayed on one of the entrance gateposts,

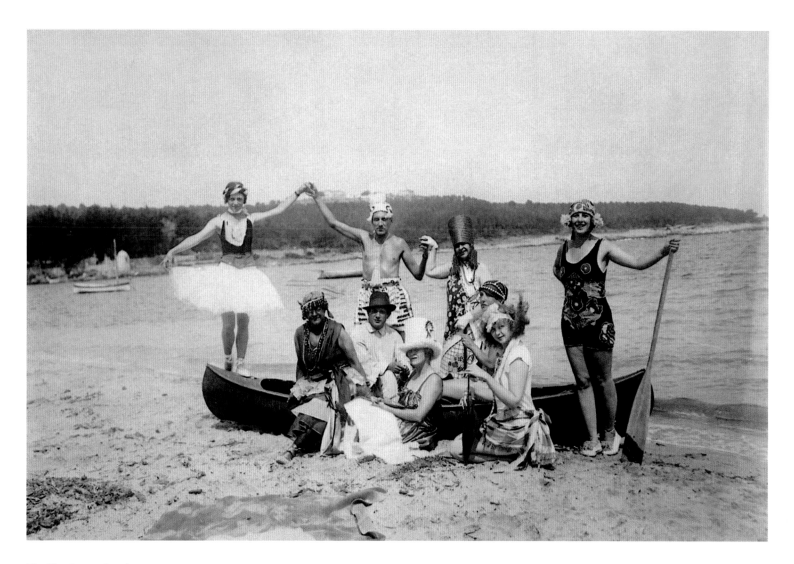

70. Olga Picasso (standing
at left), Pablo Picasso (sitting at
center), and Sara Murphy (with
tall hat, in front of Picasso), Plage
de la Garoupe, Antibes, 1923

behind glass [figure 71]. The words "Villa America," in sans-serif letters, are at the center of an abstracted American flag: red and white horizontal stripes make up the right half of the image; the fragment of a giant gold star, and a vertical row of five smaller stars (presumably meant to signify the five Murphys in residence) on a blue background make up the left half. The effect of the signboard is proudly American and indisputably modernist. The fragmentation of the image is Cubist, as well as cinematic: the enlarged gold star makes one think of a movie close-up. One also feels the influence of modern advertising here, in the way text and image are made interdependent.

71. Gerald Murphy, *Villa America*, Cap d'Antibes, c. 1924. Oil and gold leaf on canvas. Private collection

OPPOSITE

72. Gerald Murphy, *Cocktail*, Cap d'Antibes, 1927. Oil on canvas. Whitney Museum of American Art, New York. Purchase, with funds from Evelyn and Leonard A. Lauder, Thomas H. Lee, and the Modern Painting and Sculpture Committee

A far more complex use of these strategies is apparent in *Cocktail* [figure 72], painted in 1927 in Murphy's garden studio at Villa America. Although its immediate source is a cocktail tray that belonged to Gerald's father, it alludes to an important ritual of the Murphys' life at Cap d'Antibes, the cocktail hour (the playwright Philip Barry said that when Gerald mixed drinks he looked like a priest at mass). Embedded in an abstract grid are the fragments, silhouettes, and cross-sections of the main elements—a gleaming metal cocktail shaker, a corkscrew, a sliced lemon, cocktail glasses, and a box of Cuban cigars, whose cover and tax label look like collaged pieces, but are actually meticulously rendered in paint. The picture's cool grisaille palette is "cut," as Murphy expressed it, with the vivid yellow-green of the lemon and the red of the half-cherry in the glass (colors that are repeated in slightly different shades on the cigar box top). Despite its theme, this is a picture not about intoxication, but about its opposite—the discipline required of those who would lead the good life without succumbing to its anarchic potential. The repeated rhythms of *Cocktail* suggest both the order of ritualized activity and the drumbeat of a military procession: the glasses fall in line behind the primary one and rise in unison, at the upper left; the cigars stand at attention at the painting's center. (Perhaps, as Amanda Vaill

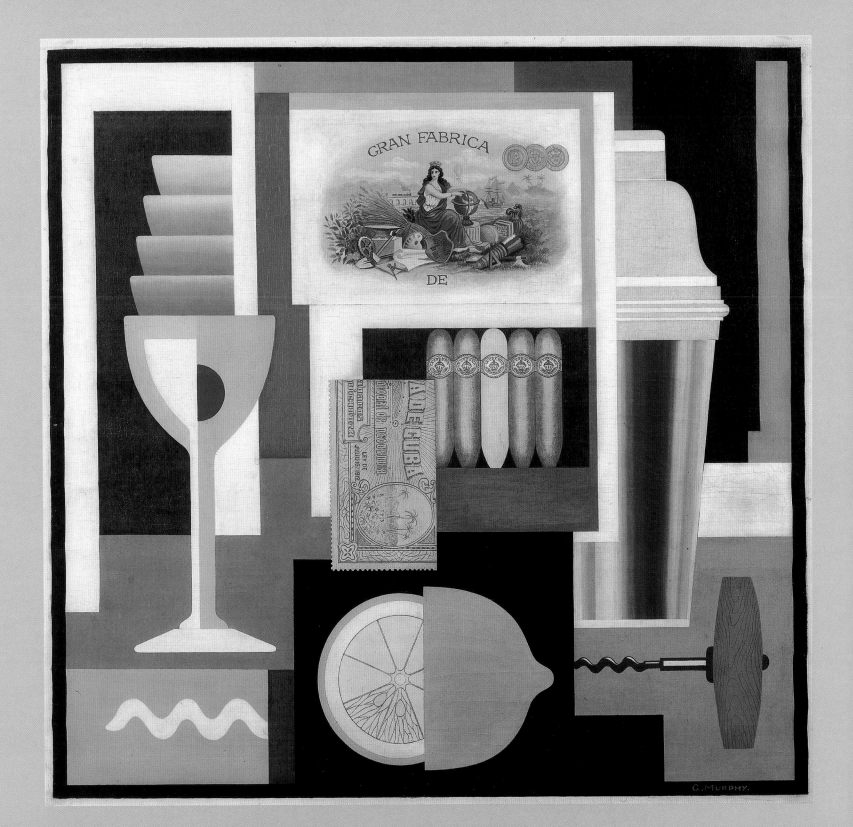

LEFT

73. Fernand Léger, *Sara Murphy on the Weatherbird*, 1934. Watercolor on paper. Collection Estate Honoria Murphy Donnelly

RIGHT

74. Fernand Léger, *Gerald Murphy on the Weatherbird*, 1934. Watercolor on paper. Collection Estate Honoria Murphy Donnelly

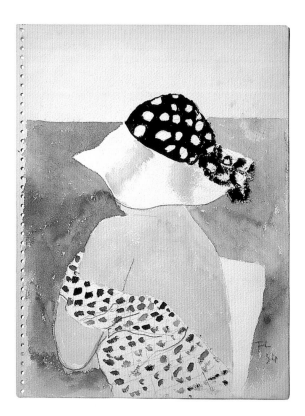 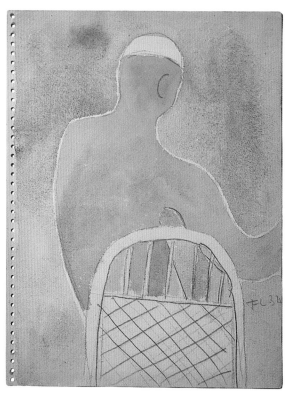

suggests, these two five-membered groups of glasses and cigars are meant to symbolize the well-functioning Murphy family unit.[117])

If there is something familiar about the numerous contrasts around which *Cocktail* is structured—grisaille versus color, curves versus straight lines, modeled forms versus flat ones, abstract elements versus illusionism—that is because it is so indebted to the art of Murphy's good friend, the theoretician of modernist "contrast," Fernand Léger. And it is thanks to the French painter that we catch a glimpse of Sarah and Gerald Murphy on board their schooner *Weatherbird*. Forgoing the abstract scaffolding on which he usually

built his images, Léger executed a pair of quick naturalistic watercolor portraits of his hosts when he sailed with them in the Mediterranean for a week in August 1934 [figures 73 and 74]. Sarah is viewed from behind and to the side; she reveals a great deal of back and shoulder, her polka-dotted dress having slipped down her arm. Her head is covered by a floppy-brimmed hat, around which a scarf, also polka-dotted, has been tied. Gerald, who is separated from us by the back of a chair, is also seen from behind. His upper torso is bare—he looks quite suntanned—and he wears a small cap, probably a fisherman's hat. Léger has refrained from providing us with what we usually expect from portraits, that is, a view from the front, with recognizable facial features. The renderings are nonetheless so concise that we feel not deprived but privileged, given the opportunity to observe a remarkable couple in a candid moment, as a fellow traveler might (or a crew member: Léger's dedication of the book of watercolors he made while on the *Weatherbird*, which included these two portraits, reads: "*À Sara, à Gerald, leur mousse très devoué*," "to Sara, to Gerald, their very devoted cabin boy"[118]). Sarah's voluptuous figure, her relaxed yet provocative body language, and her lively sense of style are all made evident by Léger; Gerald's stiff, slightly self-conscious glamour is conveyed in the precise yet sinuous outline of his pose, and in the jaunty angle of his cap, placed just so, high and forward on his head. Like Gerald's painting *Cocktail*, and like life in general at Villa America, the Murphys in these portraits by Léger embody that peculiarly American combination of the carefree and the calculated.

Fake, Absurd, Amazing, Delicious

It is not altogether surprising that when the Murphys invited Léger to join them on the *Weatherbird*, he accepted. Apart from the fact that the two artists were friends, and that the Murphys had been sending him "numerous 'small checks' over the past year to help him out,"[119] the Frenchman was much happier to be at sea with his American friends than on land at Antibes. Léger, we know, complained bitterly about the noisy traffic on the Promenade des Anglais, and admitted that even as he passed the time amusingly with Picabia, he did not consider himself "a Cannes type." But his indictment of the Riviera was more thoroughgoing. On his way down to the coast to meet the Murphys, Léger sent a postcard of the Old Port and the Pont Transbordeur in Marseilles to his girlfriend: "Maybe these are the same postcards I sent last year? I'll be in Antibes in a few hours— Marseilles is still magnificent and strange—I think I'm a Marseilles kind of guy!" The next day, from Antibes, he wrote again, and at first he sounds like any tourist, exuberant with discovery: "How can I describe for you the view from the Lighthouse—I think it's famous!—one looks out over the entire Côte d'Azur." But no sooner has he enunciated Liégeard's name for the place than he launches into a splenetic outpouring: "Côte d'Azur —it's a ridiculous expression, I recognize as I write it—the word azure—you realize, it's First Communion, it's virginal. . . . Côte Bleue—that was better. . . . It's a desire to trans- form everything into 'cake.' Blue = bread / Azure = cake. . . . I swear that you've got to be ill to accept this medicine-en-Azur—when I think of Marseilles—at the scorching truth of that city. It's not Marseilles-sur-Azur!"[120]

Léger's response to the Riviera is at once visceral and political: he can't stand the artifice, and the artifice immediately brings to mind what, for him, is the modus operandi of decadent capitalism—the sugar-coating of reality, the transforming of the given into make-believe, in contradistinction to the honesty of working-class Marseilles. No wonder, then, that it was while meditating on the names of colors—the distinction between blue and azure, and what they signify—that this artist who favored the use of primary colors

for most of his career had his epiphany. Yet the very artifice that Léger finds as distasteful as medicine—and which, in Proustian fashion, immediately calls forth a worldview—was a magic elixir for Jean Cocteau: "Nice, a fairy-tale city of carnivals," he wrote, "pageantry, battles of flowers, azure, plaster, gold, a city one crosses in a dream and which astounds with its sordid ostentation, its [red-colored] squares, its flower beds, its arches, its trompe l'oeil, and its crowds perching on white chairs to applaud the procession of waves . . . No Italian comic-opera set could more fittingly haunt the waking sleep of poets than this theater of illusions."[121] Henri Matisse would likewise conjure a stage image when he spoke to a friend many years later about his first hotel rooms on the Promenade des Anglais: "Do you remember the light through the shutters? It came from below as if from theater footlights. Everything was fake, absurd, amazing, delicious."[122]

As it could never be for Léger, the artifice of the coast was inspirational for Matisse. He was especially attracted to the decorative effulgence of fin-de-siècle "Orientalism," the best-known example of which was outside his window on the Promenade des Anglais: the Jetée-Promenade.[123] A late-nineteenth-century iron-and-glass structure in "Moorish" style, the Jetée-Promenade [figure 75] was the center of Nice's nightlife for more than half a century. It stretched out into the Baie des Anges on a great pier, complete with cafés, restaurants, game rooms, and a theater, and its distinctive gold-leafed domes and vaulting

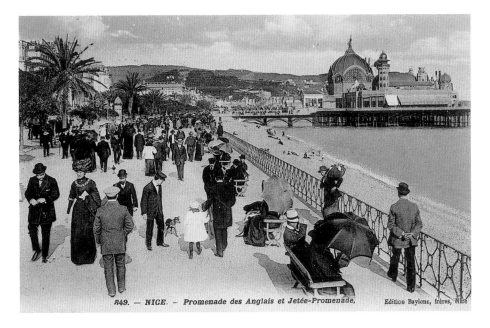

849. — NICE. — *Promenade des Anglais et Jetée-Promenade,* Edition Baylone, frères, Nice

75. The Promenade des Anglais
and the Jetée-Promenade,
Nice, c. 1910

arches are clearly visible in several of Matisse's Fête des Fleurs pictures. This is not to say that he needed the local rendition of Islamic-style decorative arts to remind him of his travels in North Africa earlier in the century; the notion of the real thing was deep within his artistic unconscious, to be summoned at will. Because it was not the authentic he was after in Nice, but the fake—absurd, amazing, and delicious.

76. Henri Matisse, *Reclining Odalisque with Green Sash*, Nice, 1927. Oil on canvas. The Baltimore Museum of Art. The Cone Collection, formed by Dr. Claribel Cone and Miss Etta Cone of Baltimore, Maryland

The seemingly endless suite of odalisques that he painted in Nice in the 1920s [see figure 76] are Matisse's domesticated translations of the Côte d'Azur's fantasy architecture, the resort's carefully calculated stage set for well-heeled self-indulgence. Eliciting distant and not-so-distant memories of French colonial occupation, and culling from a century's worth of highly sexualized Orientalist imagery—by Delacroix, Chassériau, and Ingres, among many others—Matisse's lounging beauties are propaganda for a middle-aged Frenchman's right to privacy. His obviously Caucasian models are scantily attired in harem pants, or wear slave bracelets on their ankles; they lounge in interiors that are a hodgepodge of the French and the Muslim—a North African brazier, a Louis XV table, Islamic fabrics, and remnants of *toile de Jouy*. This is the the imagery of withdrawal, of *retrait*: Nice, then as now, was a well-known retirement community, a place in which, amid a lifetime's worth of bibelots, memory and dream replaced the vigor of the artist's youth. Léger might well yearn for the "scorching truth" of Marseilles, but not Matisse. Although he would be artistically rejuvenated after World War II, for the time being, during what is really his "middle period," Matisse was content

to remain in the shaded confines of his apartment, nourished by the Riviera's inauthenticity, making pictures whose only claim to the real was the reality of his own fantasy life.

As it is for all resorts, the cultivation of fantasy on the Côte d'Azur was good business. But the escape from routine that vacations promise can result in disorientation: rather than offer a secure sense of place, the resort becomes a kind of nonplace. It is hard not to notice how often, and by how many of its visitors, the Riviera is transformed into somewhere else. Matisse, for instance, eventually grew weary of reimagining the south of France as the north of Africa. When, during World War II, he went to live in Vence, in the hills west of Nice, it was not Morocco but the South Seas that came to mind: "As I walk in front of my house and see all the girls, and men and women hurrying towards the market place on their bicycles, I can fancy myself at Tahiti at market time."[124] Tahiti was the name given to one of St.-Tropez's celebrated sandy beaches, just as an immense protuberant waterside cliff near Beaulieu was nicknamed "La Petite Afrique." At Cannes, the superchic shore swimming club was the Palm Beach, and the expensive neighborhood in the hills behind the town center was La Californie. The Americas, North and South, appear fairly often on this fantastic remapping of the Côte d'Azur. When Eileen Gray created a mural for the living room of "E.1027," it was into a marine map of the Caribbean islands that she inserted Baudelaire's title "Invitation au Voyage" (with the additional words "*Vas-y-Totor*," an exhortation to her car), as if the spectacular, real view of the Mediterranean out the window were insufficient cause for dreaming. A certain permeability of site—a release into fantasy or a descent into placelessness, depending on one's point of view—typified the Riviera experience.

Such speculations, even if they had been offered, wouldn't have made the metamorphosis of the coast any easier to tolerate. As any number of observers remarked, artists now had to share some of the blame for the boom in tourism. In Colette's novel *Break of Day*, published in 1932, the action unfolds in an overcrowded St.-Tropez. Having

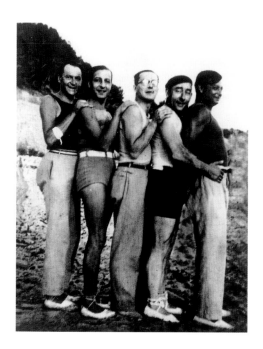

77. (Left to right) André Salmon, Jean Brun, Carlo Rim, Florent Fels, and Moïse Kisling on the beach at Sanary, 1928

bought a house there in 1926, La Treille Muscate (The Muscat Trellis), Colette was familiar with the place, and well aware that the "art crowd" had invaded the formerly secluded fishing port. She has the real-life painter Luc-Albert Moreau report that there is "not a canvas left in town," and for this foreign artists are to blame: "Acres and acres of ruined canvases," he complains, "all daubed by the Americans and the Czechs. I paint on the bottoms of cardboard hat boxes." Lartigue, who had been visiting the Riviera since his earliest days, was depressed by the unreal quality that had overtaken St.-Tropez, for which he thought artists and their hangers-on were in part responsible. "Why be disappointed?" he asked himself rhetorically in his diary in 1927, and then proceeded to give the reasons: "Fishing port posed like a little slug on the water's edge. Walk in town, which is really a village, minuscule streets. Peasant girls, a few fishermen, and townspeople, more or less well known: painters, musicians . . . writers . . . a few real ones among them. They seem like snobs of a new kind to me, with multicolored espadrilles, unwashed sailor's sweaters (or badly washed). . . . Me too, I'm also a snob in my way, and I detest the infatuations of the fashionable crowd."[125] By 1933 his evaluation was even harsher. Now outright fraudulence reigned, and money was the root of the problem: "St.-Tropez was the little violet vendor discovered by the stylish painter. The violet vendor is now a parvenu. She's a fattened-up bourgeois disguised as a violet vendor so that she can continue to please the painter, himself done up like a poor art student to please the violet vendor."[126] Q.E.D.

The Blue Train

Money—cold, hard cash, changing hands—neither disguised in the pseudo-folkloric transactions of locals and tourists, nor hidden behind the walls of private villas, was at the origin of at least one Riviera town: Monte Carlo. From the time that entrepreneur François Blanc was granted a fifty-year concession to establish a gambling casino there in 1863, the principality had flourished. An endless stream of visitors came to play, and mostly lose their money, at its gaming tables. Strangely, it was also Monte Carlo, more than anywhere else on the Côte d'Azur, that became a creative center for the Parisian avant-garde. This was due to Serge Diaghilev, who invited many of its most celebrated members to Monte Carlo to design sets and costumes for his Ballets Russes. In 1920 the impresario formalized an arrangement with the Société des Bains de Mer, which had been in place informally since 1911, for his company to perform regularly at the casino's theater. Thus Monte Carlo rather than Paris became home for the Ballets Russes, the place where the company would recuperate, rehearse, and present many of its most important premieres, until the death of its founder in 1929. After a three-year hiatus, Colonel Wasily de Basil and René Blum (his brother Léon would lead the Popular Front government four years later) revived the company, calling it the Ballets Russes de Monte Carlo. In various permutations—at irregular intervals, with numerous changes of directorship and name—there has been a ballet company in Monte Carlo ever since.[127]

Among those who came to design for the Ballets Russes were a number of the artists who were already frequent visitors to the Riviera: Matisse, who in 1920 collaborated with Igor Stravinsky and Léonide Massine on *Le Chant du Rossignol*; Picasso, who that same year worked with Stravinsky and Massine on *Pulcinella* and the next year returned to design *Cuadro Flamenco*, based on traditional Spanish music and dances; and André Masson, who designed the 1932 production of *Les Présages*, choreographed by Massine to Tchaikovsky's Fifth Symphony. Among other artists who worked for extended periods for the Ballets Russes in Monte Carlo were Joan Miró, Max Ernst, Marie Laurencin, Georges

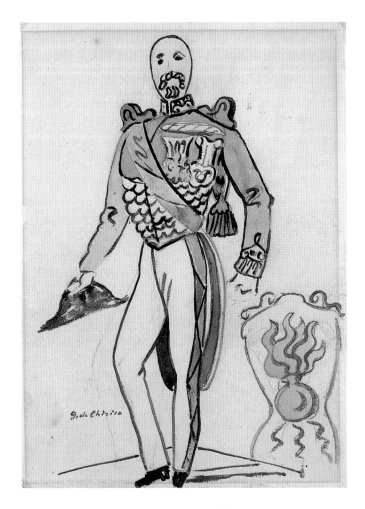

78. Giorgio de Chirico, design for a general's costume for *Le Bal*, 1929. Pencil and watercolor on paper. Wadsworth Atheneum, Hartford, Connecticut

Braque, Natalia Gontcharova (who designed three ballets choreographed by Bronislava Nijinska, Nijinsky's brilliant and prolific sister[128]), Maurice Utrillo, Georges Rouault, Naum Gabo, Nikolas Pevsner, Pavel Tchelitchew, and Giorgio de Chirico, who in 1929 designed the last ballet personally produced by Diaghilev, *Le Bal*, with a story by Boris Kochno, music by Vittorio Rieti, and choreography by the brilliant young George Balanchine.[129] Appropriately for the fancy crowd attending the premieres at the Théâtre de Monte Carlo and frequenting the various galas on the Riviera, its subject was a costume ball. This gave de Chirico free rein in the design of costumes that were meant to be exaggerated rather than realistic, like that of one of the male guests, who was dressed as a general [figure 78], his jacket decorated with oversize epaulettes, a silk sash, and two appliquéd medals.

One Ballets Russes production, in 1924, was an exercise in pure Riviera reflexivity: *Le Train Bleu*. The title referred to the all-first-class Calais-Méditerranée Express (inaugurated on December 8, 1922), which carried its eighty passengers to the south in blue cars, to distinguish them from the brown of the ordinary *wagons-lits*. With choreography by Nijinska, music by Darius Milhaud, costumes by Coco Chanel, an overture curtain by Picasso, and sets by the Cubist sculptor Henri Laurens, whose minimal decor was a scattering of stylized beach cabanas, it featured Jean Cocteau's elliptical libretto about contemporary life on the Côte d'Azur. Although it never appears in the ballet, the Blue Train of the title is the conveyance that evidently has brought south all of the work's archetypal Riviera characters: the Tennis

Champion (based on Suzanne Lenglen, who played regularly at the Tennis Club de Nice), the Golfer (probably a reference to the Duke of Windsor, a habitual visitor on the coast), the Bathing Beauty, and the Handsome Kid. [See figure 79.] The dance historian Lynn Garafola has rightly referred to the work as an example of Diaghilev's taste for "lifestyle modernism," an intentional jettisoning of ballet's tradition-bound stories and style in favor of the particularities of the contemporary scene.[130] But *Le Train Bleu* might also, in a distinctly 1920s way, be thought of as classical—as an attempt to distill a timeless essence from a modern resort that, in a few decades, had passed from undiscovered to overexposed.[131]

79. (Left to right) Léon Wizikovsky, Lydia Sokolova, Bronislava Nijinska, and Anton Dolin in *Le Train Bleu*, c. 1924

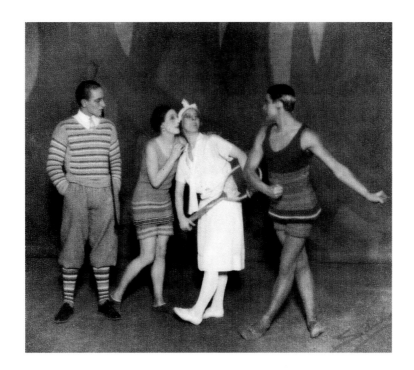

Rien Ne Vas Plus

Not everyone who came to create art in Monte Carlo was happy to be there. Juan Gris wrote to his dealer, Daniel-Henry Kahnweiler, when he first went to collaborate with Diaghilev, in 1921: "I am in a great hurry to get back to Bandol, for I can't stand this sort of Universal Exposition landscape, where one sees nothing but bad architecture, people with idiotic expressions or intriguers."[132] Two years later, when he was back to design the sets and costumes for the Ballets Russes production of *Les Tentations de la Bergère* (*The Temptations of the Shepherdess*), he wrote Kahnweiler: "Monte Carlo is boring as a sanitarium. All one sees are people wandering about aimlessly, not knowing what to do. I hope I don't set foot in the casino; I am disgusted by this atmosphere of gambling."[133] Gris obviously knew himself well, or at least had a healthy respect for the lure of the gaming tables (perhaps he was chastened by the specter of the shepherdess's "temptations" in the ballet he was working on).

Other artists have felt differently. Claude Monet went to gamble at the casino, having crossed over the nearby Italian border, while he was painting at Bordighera, in 1884. The English painter Francis Bacon, a serious gambler, lived on and off in the principality from 1947 to 1950. "I used to think that I heard the croupier calling out the winning number at roulette before the ball had fallen into the socket, and I used to go from table to table," he told an interviewer. "I remember one afternoon . . . I was playing three different tables, and I heard these echoes. . . . I was playing rather small stakes, but at the end of the afternoon chance had been very much on my side and I ended up with about sixteen hundred pounds, which was a lot of money for me then."[134] (Gilles Deleuze has suggested that Bacon's use of the triptych format is related to this incident.[135]) Marcel Duchamp found a way to combine gambling and art in one activity. In 1924 he issued a *Monte Carlo Bond* [figure 80], which was supposed to pay the bearer a twenty-percent annual dividend, to be derived from Duchamp's foolproof system for winning at roulette. Like most such systems, his was a failure, although the few investors who bought his bonds—including the

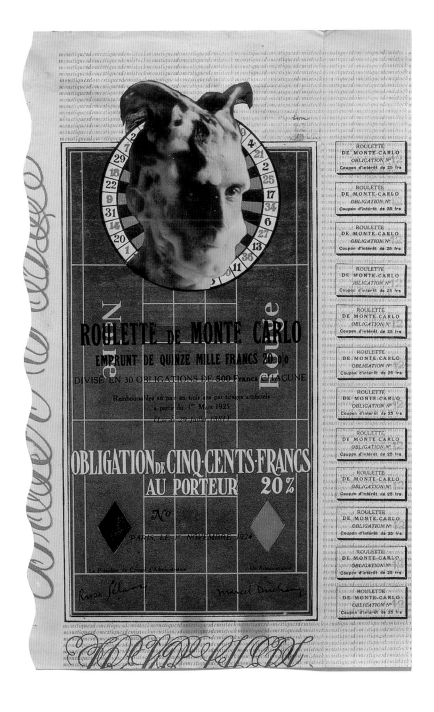

painter Marie Laurencin and the couturier and collector Jacques Doucet—had the pleasure of receiving an official-looking document. It was cosigned by Rrose Sélavy (president of the company) and Marcel Duchamp, and bore a photograph of the artist covered in soapsuds, his shampooed hair styled into a pair of faunlike horns, collaged onto a schematic rendering of a roulette table. The year it was made, the savvy New York literary magazine *The Little Review* encouraged its readers to purchase an example: "Here is a chance to invest in a perfect masterpiece. Marcel's signature alone is worth much more than the 500 francs asked for the shares."[136] Duchamp's bond, as well as the gaming system it reifies, is another instance—akin to Picabia's antics at Cannes—in which the liberating play theorized by Dada meets the real-life libertinism of the Côte d'Azur.

There was, however, a dark side to these ludic obsessions, nowhere more forcefully demonstrated than in the case of Edvard Munch. The Norwegian painter spent two winters, still the stylish season in those days, in and around Nice, in 1891 and 1892. His stays immediately preceded the creation of his masterpiece, *The Scream*, the artistic embodiment of northern Romantic angst, set on

the desolate-looking fjords of Oslo. Like many another northerner, Munch preferred the south. While living on the Riviera, he had the temerity to write a series of "letters" that were published in a newspaper back in freezing Oslo. "While a Siberian cold covers Europe," he informed his hometown readers on January 28, 1891, "here I am in Nice warming myself in the sun before my open window." And on February 11, he told them: "This Riviera is an enchanted land—when the thousand-and-one nights comes to be written in the future, the setting will no longer be India, it will be here. . . . Listen to these names—Menton, Nice, Villefranche, Monte Carlo—isn't there joy in the very words?"[137] A little too much, as it so happens. Ten months later, when Munch was beginning his second sojourn on the Côte d'Azur, an exposé of his travels by a Norwegian journalist, Björnstjerne Björnson, appeared in a competing Oslo newspaper under the title "On the Misuse of State Bourses." Munch, it seems, had been using his government scholarship, intended to underwrite his art studies in Paris, to finance his Riviera trips.[138]

This public humiliation aside, the artist experienced a far greater private humiliation on the coast. As he confided to his diary, the bloom was soon off the words "Monte Carlo." On the way to his first excursion there, he saw a large sign near the Nice train station, warning tourists to stay away from the casino; it included a list of recent suicides caused by losses at Monaco's gaming tables. "It's possible," Munch wrote, "that it discourages a few people from coming here, but for he who has already begun, it will do no good— if once you've penetrated the enchanted castle of Monte Carlo you're already bewitched— and you'll return—you have to." Munch was soon addicted to gambling: "The same thing happened every day—every morning I swore not to go back there—and then the afternoon comes—I have everything ready to get back to work—I'm about to begin—then the idea that I could go back despite everything hits me like a thunderclap—it's no longer a question of reflection—it's only a question of finding out what times the train leaves— I'm suddenly seized by the fever—the minutes are hours—the trip from Nice to Monte

OPPOSITE
81. Edvard Munch, *At the Roulette Table, Monte Carlo*, 1892. Oil on canvas. Munch Museet, Oslo

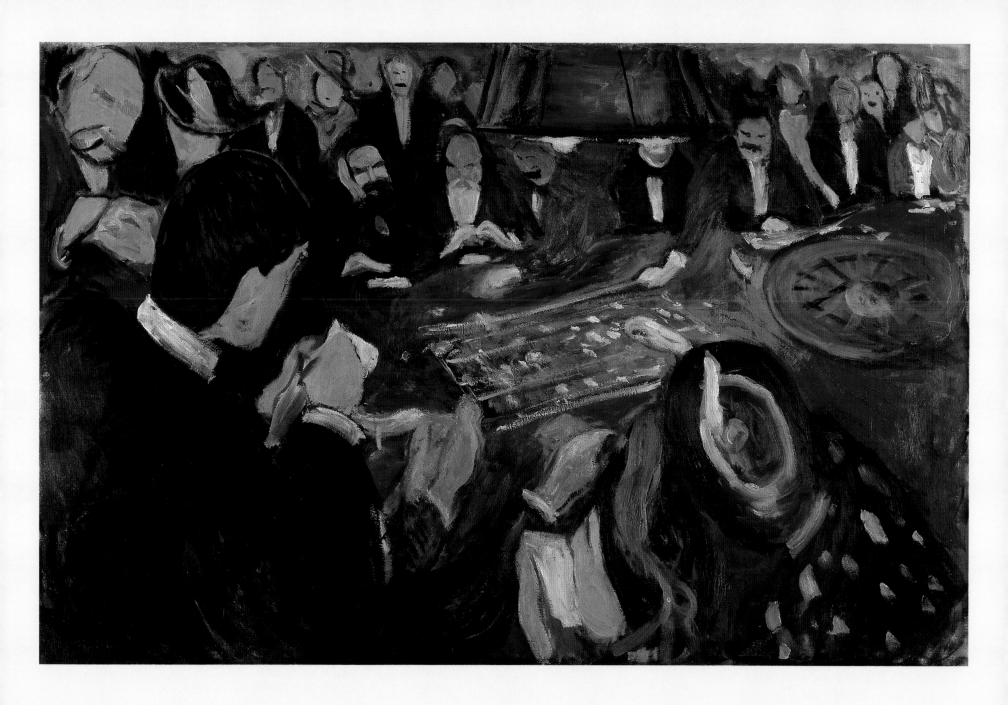

Carlo is an eternity—finally I am mounting the steps that lead to the casino."[139]

At the Roulette Table, of 1892 [figure 81], is Munch's attempt to convey some of the feverish intensity of the irresistible casino, and it is obviously indebted to *The Night Café*, van Gogh's depiction of a room, or rather, of the room's ambience, with its green pool-table protagonist. Munch too focuses attention on a green table, pushed just off center, on the right of the picture. Pressing in from all sides is the Monte Carlo crowd in fancy dress, so unlike the forlorn denizens of van Gogh's provincial gathering spot. Munch's painting represents a specific moment: as the croupier in the upper right sweeps the losing bets away with his rake, losses must be reckoned with, and hope, against the better judgment of the players, starts to reassert itself. It has been suggested that the young man in the extreme foreground, at the left, is a self-portrait, which it may well be; whether he and the man at the upper left edge of the painting are taking notes on the winning numbers, or simply removing more cash from their wallets to buy chips for the next round, is unclear.[140] What is obvious, though, is how completely captivated all the players are by the table itself, aglow in the light from the overhead lamp. "This table is like a living thing," Munch wrote, "whose brain would be the roulette wheel—which has its own way of doing things—lucky man who would know how to analyze this brain."[141]

If, despite its Symbolist pedigree, Munch's painting remains firmly grounded in the naturalist's here and now, Max Beckmann's *Dream of Monte Carlo*, of 1939–1940 [figure 82], is purely allegorical.[142] It was painted during a period when the artist's future seemed to be in the hands of fate. In self-exile from Germany, where his work had been featured in the Nazi-organized Degenerate Art show of 1937, Beckmann found himself on the Riviera in the spring of 1939, and then went on to Paris and Amsterdam. Contained within the outlines of his trademark slashing black lines are ripe, brilliant variations of the Côte d'Azur palette: vermilions, mauves, pinks, deep blues, and cadmium reds, which contrast with the light green of the gaming tables and the touches of yellow in the pair

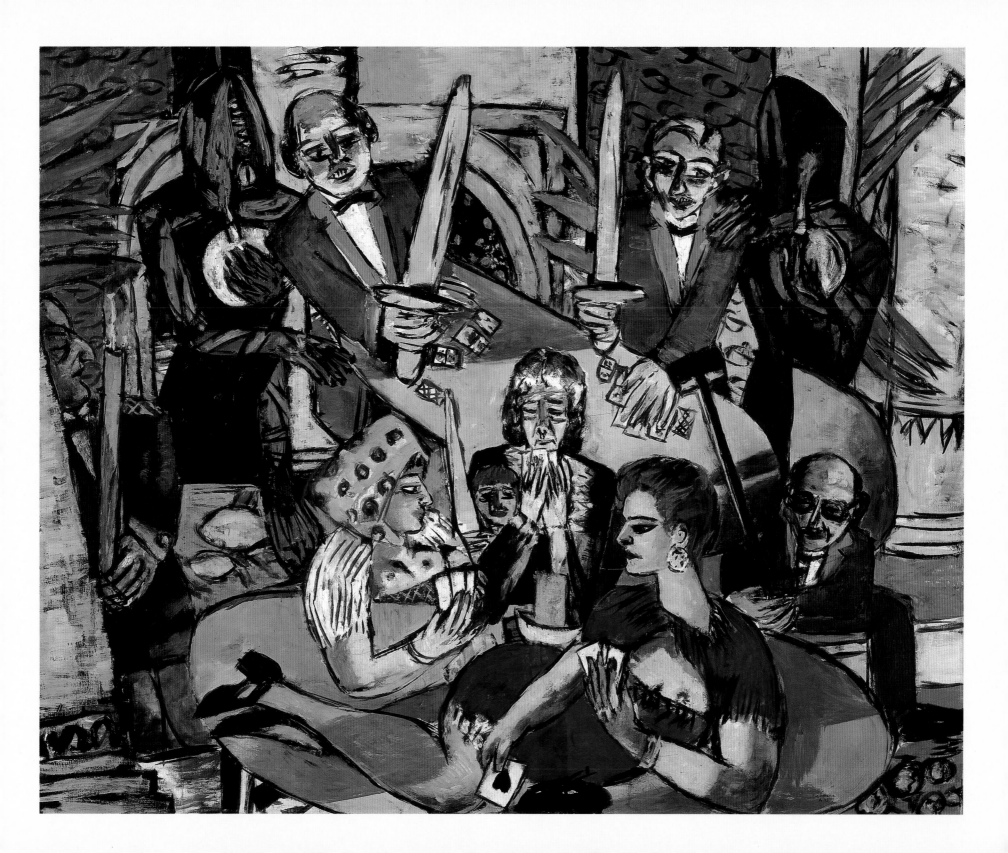

of lemons, the candle's flame, the blond hair of the croupier at upper right. The picture is enigmatic in the way all dreams are, and its iconography is powerfully evocative: In one of the casino's elegant rooms, what appears to be a game of twenty-one is in progress. A seductive redheaded odalisque in the extreme foreground, with the nipple of one partly exposed breast peeking out, holds a black ace of hearts in her outstretched hand. Two women play alongside her: a young one, with both breasts exposed, and an older one, with a small child incongruously nestled in her lap and brandishing a sword. Two croupiers at a second table also hold upright swords, while a third, at the lower right, wields his rake, and another attendant at the left edge holds a long taper. All the male characters are armed, but they seem only quaintly menacing when compared with the two hooded figures bracketing the canvas at upper left and right; these monstrous-looking guardians hold grenades, the fuses ignited. There are of course many possible interpretations of this complex work, but it is perhaps sufficient here to see Beckmann's Monte Carlo dream as a brilliant rendition of the casino's legendary status. This is nothing less than the entrance foyer to hell, where evening clothes, palm fronds, and pink marble columns are the deceptive, decorative foretaste of an ineluctable fate.

A Political Critique of the Riviera

"Surprise . . . meets you every day in your study of Nice," the travel writer Herbert Gibbons claimed in 1931. But the surprise was not necessarily a pleasant one. "The city charms: and it repels. On the Promenade des Anglais sewage greets the eye as well as the nose. Not vicious women and poor little dolls alone, but cruel and weak faces, shifty and vapid faces, self-centered and morose faces, leech faces, pig faces, of well-tailored men—you watch them pass, you remember what you have seen at the tables in nearby Monte Carlo, and the utter depravity of your race frightens you."[143] By now, complaints about the Côte d'Azur are familiar: its noisy overdevelopment and self-conscious exclusivity, its materialism and fraudulence. Although Munch's story suggests that depravity predates these other antibucolic developments, the idea of the Riviera as strange and disturbing, especially in regard to Monte Carlo and Nice, seems to have become a literary trope by the 1930s. Two factors in particular encouraged this: Hitler's ascent to power in 1933, and the Depression. In the first instance, the impact of Germany's new racial laws was a gradual but not insubstantial migration of foreigners to France, mostly German and Austrian Jews, and political dissidents. Some of them settled on the Côte d'Azur.[144] Perhaps this was because it was a place they already knew, or because it offered refugees the illusion that they were merely on vacation; or since the presence of foreigners in resorts is normal, maybe these émigrés felt they could more easily blend into the crowds of this most international of resorts. As far as visual artists were concerned, the Riviera had begun to attract Germans and Austrians before the Nazis took control of the government. In a book about the Côte d'Azur they wrote in 1931, Erika and Klaus Mann, Thomas Mann's children, referred to Sanary as "the summer meeting place of the Paris-Berlin-Schwabing painters' world."[145] These painters included Hans Purrmann and Rudolf Levy, both former students of Matisse, around 1910, and at the turn of the century Walter Bondy, habitué of Paris's Café du Dôme, whose view of a local garage we saw earlier.[146] In the 1930s, writers trooped to Sanary:

Thomas Mann and his brother Heinrich, the popular novelist Lion Feuchtwanger, the art critic Julius Meier-Graefe.[147]

The presence on the coast of so many new faces, of so many displaced people with time on their hands, added a xenophobic twist to the notion of the Riviera's degeneracy (although one suspects that this too had long been part of a widespread French distaste for the coast). To make matters worse, the economic crisis was devastating for a place that had always depended on the free-spending ways of its visitors. Many hotels and restaurants were forced to close, and even the casino at Monte Carlo felt the effects of fewer big spenders in its *salles de jeux*. Although extravagance by no means ceased altogether— there were always people with discretionary funds—after early 1934, when, for instance, a large labor demonstration was held in Nice, it became apparent that the Côte d'Azur was no longer an exception to the rules of economic life that prevailed elsewhere. What troubled the rest of the world now troubled the Riviera too.

This is the local context for the well-known photographic portraits that Lisette Model took on the Promenade des Anglais in the summer of 1934 [figures 83–85]. An Austrian Jewish émigré in Paris, she had gone to visit her family, who had relocated to Nice. Working with both a reflex camera (a Rolleiflex) and a portable Leica, Model found on Nice's celebrated thoroughfare, in the words of Ann Thomas, "a wealth of individual physiognomy and extremes of body shape and size . . . enough to produce a visual epic."[148] For the most part middle-aged or older, Model's typically well-heeled café denizens sit on one variety or other of lounge chair, usually with the same basket-weave paving tiles at their feet (this may be the café of the Hôtel Westminster, a popular daytime spot on the Promenade in the 1930s). Most of her sitters do not smile, and many appear to look back at her with suspicious expressions (and as a result look suspicious themselves). They may have been asking themselves who this young woman taking pictures of them was, and where their images might end up.

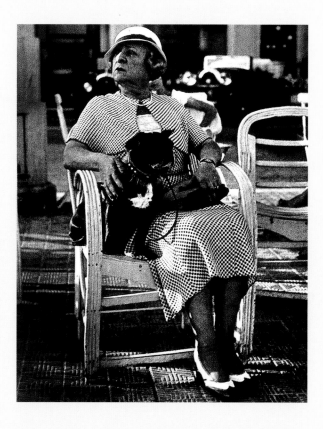

83–85. Lisette Model,
Promenade des Anglais,
Nice, 1934. Gelatin silver
prints. International Center
of Photography, New York

As well they might have, inasmuch as Model's photographs accompanied an article, "Côte d'Azur," by Lise Curel, published the next year in the magazine *Regards*. There, presumably with the photographer's consent, they became evidence for a Marxist indictment of the Riviera tourist, in which the "utter depravity" of Herbert Gibbons's "shifty and vapid faces . . . leech faces, pig faces" reappears as political critique. The analysis is about as far from Cocteau's image of Nice's "crowds perching on white chairs to applaud the procession of waves" as it could possibly be. "The Promenade des Anglais is a zoo," Curel wrote, "to which have come to loll in white armchairs the most hideous specimens of the human animal." She continued: "Boredom, disdain, the most insolent stupidity and sometimes brutality mark these faces. The comfortably-off people who spend most of their time getting dressed, making themselves beautiful, doing their nails, and putting on makeup never manage to hide their decadence, the incommensurable wasteland of middle-class thinking. The middle class is ugly. Sprawling on *chaises longues* under the fairest of skies, before the finest of seas, these people are revealed for what they are: irredeemably old, disgusted, disgusting. This monumental offence, this fat belly masquerading as a man, this fifty-year-old whose body smothers his chair and whose scorn stifles the entire world, owns a delightful villa at Cimiez, set among vast, luxuriant, nearly tropical gardens. His villa is empty eleven months of the year."[149]

Is the intensity of this rhetoric appropriate to the pictures? Not entirely. Although there are certainly photographs that might support Curel's verbal outpouring, not all of them can—some of Model's sitters look even dignified, if not precisely noble, and there is greater variety to the series than those chosen to illustrate the article in *Regards* might suggest. The cool style of Model's Promenade des Anglais pictures asserts their status as documents, and to that extent they seem open to more complex and subtle interpretations. Besides, the existence of other, earlier texts, like that of Gibbons, demonstrates that one need not have had a political ax to grind in order to conceive of the Promenade des

Anglais as a carnival of grotesque humanity. Yet it appears unlikely that Model would have allowed her photographs to be used in a way she deemed wrongheaded. In the end, she finds nothing on the Riviera that Beckmann does not depict with much greater exaggeration at Monte Carlo a few years later.

This is not the only case in which the increasingly charged political atmosphere of the decade affected practitioners on the Côte d'Azur. In 1936, having more or less decamped from "E.1027," and having built for herself a second house on the coast, Tempe à Pailla, at Castellar, near Menton, Eileen Gray turned her attention to the working class. Inspired by the election of Léon Blum's leftist coalition, she started plans for a Centre des Vacances, to be erected at the edge of the sea. "Now that paid holidays are universally recognized," she wrote, "one thinks more and more of facilitating the holiday so necessary to those families and persons whose means are limited."[150] Gray would put her energy into designing lodgings for the masses on the Riviera, instead of private residences for the privileged, of which she was one. The Vacation Center would include an area for transportable cabins, an apartment block for families, garages, a dispensary, a gymnasium, an open-air theater, a combination café-cinema-dancehall, and a large restaurant with a takeout stand. Although, like many such ambitious architectural schemes, it was never built, an elaborate model of Gray's center was exhibited in 1937 in Le Corbusier's Temps Nouveaux pavilion at the Paris International Exposition. In introducing this "remarkably well-thought-out" project to the public, Le Corbusier noted that "as the result of paid holidays, we have seen during the summer of 1937, the country[side] being invaded by those who benefit from it. This is a new event in the life of this country. Innkeepers make long faces because there are small purses, but [others] feel that they must find new ways. One has seen happy people making contact with nature . . . and opening up to a freedom . . . they had not known before."[151]

The Riviera's own working class—the locals who were so drastically underrepresented by modern artists—finally makes a grand if quasi-comic appearance in a major work of art in 1939, in Picasso's *Night Fishing at Antibes* [figure 86].[152] Very large, eleven feet wide by almost seven feet tall, it was painted in the artist's rented apartment in the old fortified port town, and raises to monumental proportions a scene taken from coastal life. In a boat at the picture's center, two fisherman concentrate on their nocturnal labor: luring and spearing fish by the light of an acetylene lamp (indicated by the concentric swirl of yellow and orange above the head of the fisherman at the right). Their exertions, in turn, are the focus of attention for two young women at the right,[153] who observe the expedition from the safe distance of the rusticated wall on which they stand (similar walls, and the Château Grimaldi, whose towers can be glimpsed at the upper left, are among Old Antibes's most striking features). That the women's gazes are specifically touristic in the distracted way of vacationers, whatever salacious subtheme might also be imputed to them, is indicated by the fact that the one at the far right, with a bicycle, watches the scene while sticking out her tongue to lick her twin-scooped ice cream, or sorbet. Indeed, watching fishermen work at night by lamplight seems to have been a long-established diversion for tourists on the Côte d'Azur. A commentator earlier in the century wrote of going out in a boat with the locals at Le Trayas, several miles down the coast from Antibes: "The light penetrates far down into the sea, while the sky above appears to remain quite black"; this accords well with the scene as Picasso has painted it. As does a description of the underwater life revealed: "Bright sea anemones with radiating tentacles, red starfish with outstretched arms, and prickly sea urchins seemed to form the dark spots on a bright carpet. Small fish fled in terror on all sides; the larger ones followed our boat in shoals, as though fascinated by the light."[154] Although the night fishing described here was carried out by the light of wood-burning braziers (acetylene illumination must have been a later contrivance), the method remains otherwise unchanged: "One of the

86. Pablo Picasso, *Night Fishing at Antibes*, 1939. Oil on canvas. The Museum of Modern Art, New York. Mrs. Simon Guggenheim Fund

fishermen stands in the bow of the vessel and looks down into the water. He holds a three-pronged harpoon in his left hand [Picasso's wields a four-pronged spear], fastened by a long cord and ready to be thrown. . . . Suddenly the harpoon shoots through the deep and impales a fish with its barbed prongs. . . . Much skill and practice are required for this kind of fishing. It is necessary to take into account not only the motion of the fish, but also the refraction of light by the water, which misleads the eye as to the real position of the fish." This may explain, at least in part, the almost myopic gaze of Picasso's fisherman at the left, who stares with all his might at the marine life below. We might even say that this is a work about the work of looking, and that the distracted gaze of the young female tourists is offered by Picasso as a foil for the intense concentration of those whose livelihood depends on their ability to look and judge precisely.

This is not to deny the at once more immediate and less tangible resonances of the painting. It is unusual, to say the least, that a major artist has chosen to focus on the local life of the coast. In *Night Fishing at Antibes*, Picasso has raised the curtain on a piece of Grand Guignol, a swashbuckling tale whose plot is derived from working-class life, and whose lead roles are played by those usually relegated to the wings. Is that why Picasso has given us a nocturnal scene—in itself unusual for artists working on the Riviera—as the antithesis of the brilliantly illuminated daytime of the well-to-do tourist? As the coast continued its economic decline, and increasingly desperate foreigners took the place of the diminishing ranks of carefree visitors, the importance of local life— of those who were "rooted," as opposed to the swelling ranks of *déracinés*—increased exponentially.[155] How utterly the landscape is changed from Picasso's earlier arcadias, drenched in sunlight, or even from the small-scale sand-encrusted works that evoked a private world on the beach, near at hand and yet wholly imagined. Now a form of painterly reportage is instantiated: the real inhabitants of the Riviera, those who live and work on the coast full-time, are his actors, just as it is real tourists, not the Grecian

beauties of Picasso's active fantasy life, who are spectators of these nocturnal wage-earners. The work remains, nonetheless, almost palpably mythic. If Apollonian, light-filled scenes of timeless bliss have given way to a specific local event, at a specific time of day, it is in the form of a dark, Dionysian ritual. Christian reference as well has been cited by the work's numerous interpreters—from the miraculous (Peter's Draught of Fishes) to the horrendous (the Massacre of the Innocents).[156] And with good reason: not only does the painting's iconography practically beg to be deciphered, but the tone is ambiguous. There is an antic quality to the distorted physiognomies of the characters, and a cheerful whimsicality to the assortment of fish below and the oversize moths (if that's what they are) that fly near the light overhead. At the same time, the sacrificial event depicted, and the painting's palette, are ominous. While there is a vestige of the "classic" Riviera color complements—the deep lavender of the woman's dress at the right and the fortified castle at the left, the brilliant yellow punctuating the scene at several points—the colors are for the most part rarely seen in depictions of the Riviera, with greens, grays, browns, and especially blacks predominating.

But how could we expect this picture to be other than ambiguous in tone? On the one hand, Picasso was healthy, highly productive, happily entangled with his current mistress, Dora Maar, and back on the Côte d'Azur—a place to which, for twenty years, he had been going for a change of scene from Paris. On the other hand, death, war, and destruction were encroaching from all sides. Personally, there were two deaths: that of his mother, at the beginning of the year, and that of Ambroise Vollard, his old friend and sometimes dealer, who died in Paris just after Picasso had left for Antibes. Politically, things had gone from bad to worse: Barcelona had surrendered to Franco in January, and in March, Madrid fell—the defeat of the Spanish Republicans was complete. Also in March, Hitler had entered Prague, and a month later Italy annexed Albania. While Picasso rushed to complete his large canvas, the Soviets signed a nonaggression pact

with Germany; in response, the French government officially banned the Communist Party and, a few days later, declared general mobilization.[157] The surcharge of feeling with which Picasso has endowed this local Côte d'Azur ritual—the strange mood, both upbeat and forbidding, of *Night Fishing at Antibes*—is entirely appropriate to the historical circumstances of its making, at least for an artist who never held himself above the fray. Its grotesque aspects share a family resemblance to other works made on the coast, by Model and Beckmann. On August 26, the painting completed, Picasso, Dora, and their friend Jaime Sabartès left Antibes for Paris. Eight days later, France and Britain declared war on Germany.

Refuge

If the Riviera had for decades functioned as a place of escape from the rigors of everyday life and a mythic site of wish-fulfillment, in June 1940 it became a refuge in a far more crucial way. In that month France signed an armistice with the victorious German forces, which split France into two sections: the Occupied Zone, encompassing most of the northern part of the country, including Paris and the Channel and Atlantic coastlines, and the Free Zone, or Zone Libre, comprising most of the south from Vichy down, including almost the entire Mediterranean coastline. The Germans agreed to stay out of the Free Zone, allowing the French to (nominally) govern the south themselves. The result was a mass exodus to this region by both French-born Jews (who were now required to wear the yellow star of David in the Occupied Zone) and foreigners, including Jews and other exiles in Parisian residence. These new displaced people swelled the ranks of the already substantial number of émigrés on the Riviera. Many of them fled south without plans, hoping that the situation might change shortly and they could return home, wherever that might be. Others went south on the way elsewhere, with Marseilles as an intended point of departure. In May, in anticipation of the French defeat, 406 boats carrying 135,000 people—desperate Jews, suspected and actual dissidents, and many others who for one reason or another believed they were not safe in a nation occupied by the Nazis— embarked from France's most important Mediterranean harbor.[158]

The Emergency Rescue Committee, an ad hoc organization founded to facilitate the immigration of artists and intellectuals to the United States, set itself up in Marseilles upon the fall of France. Before the office was forced to shut down, in June 1942, the Committee's two main operatives in the "capital of exile" were the American Varian Fry and the Frenchman Daniel Bénédite. Among the more than one thousand people they helped—in securing visas, booking passage, and sustaining themselves while waiting to leave—were numerous artists. Jacques Lipchitz, for instance, whose sculpture *Joie de Vivre* still presided over the Noailles Cubist garden at Hyères, recalled later that he owed

87. Fernand Léger,
study for *Divers*, 1941.
Gouache over pencil on card.
Private collection

his life to Fry: "I did not want to go away from France. It was his clairvoyant letters which helped me finally to do so."[159] Marc Chagall nearly didn't make it. In the spring of 1941, while waiting to leave the country, he and his wife, Bella, were arrested in a roundup of "undesirables" by the French police in Marseilles. When, at Fry's urging, the American consul there threatened to report the news of the well-known artist's detention to the Vichy correspondent of *The New York Times*, the Chagalls were released; they left almost immediately for Spain, and from there went to Portugal, where they embarked for New York. Moïse Kisling, who owned a house in Sanary and rented a painting studio in Marseilles, was denounced as a Jew to the French police, apparently by one of his models, and had to make a quick getaway through the Pyrenees.[160] Of course, Jewish artists were not the only ones fleeing. Léger, who had taken an active role in Popular Front cultural activities, and who, after all, considered himself "a Marseilles kind of guy," also left France for the extent of the occupation. He sailed for New York from Marseilles, and while waiting to embark, he glimpsed a group of dock workers diving into the harbor for relaxation. It was this sight, amplified by the democratic vision of hundreds of divers he observed later in a New York City public swimming pool, that inspired the series of *Divers* on which he worked over the next several years.[161] [See figure 87.]

The waiting period in Marseilles proved fertile in at least two other cases, and both involved local houses. At a time when accommodations were virtually impossible to

88. Front row, left to right: Helena Lam, Jacqueline Lamba, Lamba's sister; back row: second from left: Jacques Hérold; third from left, Wilfredo Lam; fourth from left, Oscar Domínguez; sixth from left, André Breton. Villa Air Bel, Marseilles, c. 1940–1941. Photograph by André Gomes

come by, Daniel Bénédite's wife, Theo, and Mary Jane Gold, an American coworker of Fry's, managed to find an elegant six-bedroom house for rent, set in a wooded park in the suburb of La Pomme. Air Bel, as it was named, was home to the Bénédites and a few others, including for several months André Breton, his wife Jacqueline Lamba, and their daughter Aube, while they waited to leave for New York.

On Sundays they received many friends, most of whom were also hoping to depart, numerous Surrealists among them: André Masson, the Romanians Victor Brauner and Jacques Hérold, Oscar Domínguez from the Canary Islands, the Cuban Wilfredo Lam, the Germans Hans Bellmer, Wols, and Max Ernst, who was there with his wife, Peggy Guggenheim.

To keep themselves busy, and undoubtedly to keep their spirits buoyant under duress, the friends organized artistic games and projects: they made *cadavres exquis* (folded-paper drawings on which several artists worked in succession), devised collective collages, and held at least one outdoor art exhibition. Their most remarkable endeavor was an updated deck of Tarot-like cards, the *Jeu de Marseille* [figure 89]. Under Breton's direction, the four suits of the usual deck were replaced by four themes, each with its own symbol: a flame for love, a black star for the dream, a bloody wheel for revolution, and a key for knowledge. As a neorevolutionary gesture, the king and queen were replaced by a "genius" and a

89. Cards from the *Jeu de Marseille*, Marseilles, 1940. Designed by (left to right) Max Ernst, Jacques Hérold, and André Masson. Reproductions, André Dimanche edition, 1983

"siren" (apparently no one told Citoyen Breton that eliminating the old royal power structure might leave the old sexual hierarchy intact), and the joker became a "wise man." Political, philosophical, and literary figures were featured on the face cards, all designed by the artists gathered at Air Bel: Paracelsus by Breton, Hegel by Brauner, Pancho Villa by Ernst, the Marquis de Sade by Hérold, Novalis and Baudelaire by Masson, and the "dream figures," Freud, Lautréamont, and Alice (in Wonderland), divided between Domínguez and Lam. As Martica Sawin has said, this refashioned deck "memorializes that tense and uncertain interval" when, "poised in a void," the Surrealists found themselves in the hands of fate.[162] With the *Dream of Monte Carlo*, on which Beckmann was then at work, the *Jeu de Marseille* brackets the experience of the Côte d'Azur during wartime in a game of chance.

Although Masson and his wife, Rose (a Jew, and therefore in peril), were visitors to Air Bel, they were staying across town, as guests of Countess Lily Pastré, heir to the

Noilly Prat vermouth fortune, and an avowed Gaullist. The Massons were put up in the hunting lodge of the Château de Montredon, Pastré's splendid 250-acre estate, not far from Pointe Rouge, the Marseilles suburb where Grosz had vacationed more than a decade earlier. Pastré was a cousin of the viscountess de Noailles, and life at Montredon was as sybaritic as that at Hyères, even under the dire conditions in which many of her forty-odd long-term guests found themselves. Twenty-five domestics watched after an assortment of visitors, who were all served breakfast in bed, and a snack at eleven; gathered for lunch, and tea at five in the afternoon; and had drinks at eight—an unlimited supply of the house brew, of course—followed by dinner, and then usually games or a concert. Lily Pastré's real love was music, and it was to musicians that her wartime organization, Pour Que l'Esprit Vive (That the Spirit May Live), was dedicated. Her guests at Montredon included Pablo Casals, Darius Milhaud, Francis Poulenc, and Countess Ira Belline, niece of Igor Stravinsky.[163]

A memorable event of the war years *chez Pastré* was a production of *A Midsummer Night's Dream*, with music specially composed for the occasion by Jacques Ibert. It was performed in the middle of the summer on the grounds of the estate [figure 90], with the audience moving around with the action, which was directed by Jean Wall. The choreography was by Ferdinand Marionneau and Boris Kochno (who had worked at Monte Carlo with Diaghilev); the costumes were designed by Christian Bérard; and Manuel Rosenthal conducted the orchestra, which was said to be made up mostly of Jewish musicians (who, by Vichy law, were forbidden to perform in public). Kochno left this reminiscence: "The performance of 'A Midsummer Night's Dream' took place on July 27, 1942, in perfect weather, under a sky strewn with stars. Knowing that there would be a full moon, I lit the play in such a way that it would begin in the glare of the spotlights, which were gradually turned down, and finish at midnight bathed in moonlight. To show the audience the way down the valley at the back of the grounds, all along the paths we placed strings

90. Liliane Valois and Georges Jongejans in *A Midsummer Night's Dream*, on the grounds of the Pastré estate, Montredon, 1942. Photograph by Victor H. Grandpierre

of tiny light bulbs in the grass, which looked like a procession of glow worms. . . . When the spectators left Montredon they spoke of it with wonder."[164]

This oneiric interlude is eerily appropriate for a coastline that for so long had been a dream space. So is the name of the house in Vence—Le Rêve (The Dream)—to which Matisse moved in 1943, fearing that Nice would be bombed if there were an Allied invasion. But these anecdotal anomalies are only the most obvious signs of the deeper and more pervasive contradiction between a mythic vacation spot and the sordid reality of World War II. The German painter Wols (pseudonym of Alfred Otto Wolfgang Schulze) had been living in France when war was declared in 1939, and he was promptly interned as an enemy alien. Released upon the signing of the armistice with the Germans, he went to live with his French wife in Cassis. There, in a poem, he enunciated this contradiction as a *modus vivendi*, or a spiritual escape hatch, whereby he could turn from the facts of war toward the abstraction of his imagination, induced by contemplating nature:

> *At Cassis, the pebbles, fish,*
> *rocks under a magnifying glass*
> *the salt of the sea and the sky*
> *made me forget about human pretensions*
> *invited me to turn my back*
> *on the chaos of our goings-on*
> *showed me eternity*
> *in the little harbor waves,*
> *which repeat themselves*
> *without repeating themselves.*[165]

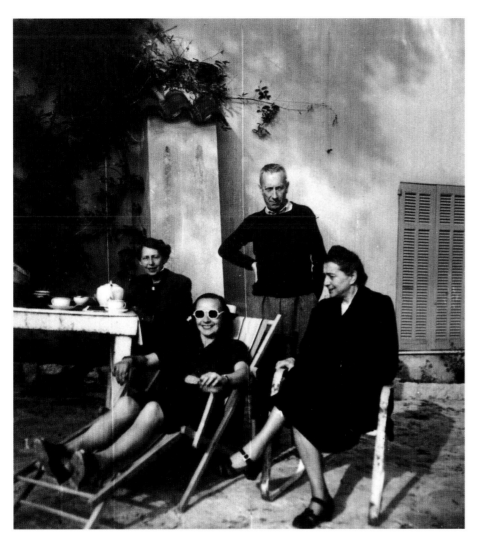

91. (Left to right)
Sophie Täuber-Arp,
Nelly van Doesburg, Jean Arp,
and Sonia Delaunay
at Château Folie, Grasse, 1942

Like many others, Wols found himself in a paradisiacal, bucolic setting at a moment when it was least expected. The snapshot of Sophie Täuber-Arp, Jean Arp, Nelly van Doesburg, and Sonia Delaunay, relaxing on the terrace of the Château Folie in Grasse [figure 91], would not lead one to believe that two of the subjects were in hiding when this picture was taken. Sonia and Robert Delaunay had left Paris at the outbreak of war in 1939. After four months' hiatus in the Auvergne, they moved south, to Mougins, near where two couples with whom they were friendly— Sophie Täuber and Jean Arp, and Susi Gerson and Alberto Magnelli—happened to be staying. The three couples met up in Cannes, where they saw one another frequently.[166] In October 1941, Robert Delaunay, who had been ill for some time, succumbed to cancer; the Arps, who had since moved to the Château Folie,

invited Sonia to stay with them. Magnelli and Gerson, now married, were living nearby, at her parent's villa, La Ferrage. "In the years of unreal darkness, 1941 and 1942," Jean Arp wrote several years later, "the reality of beauty was the sole consolation of our little circle in Grasse. Sonia Delaunay, Sophie Täuber, Susi [and] Alberto Magnelli, and I were part

of this circle."[167] The "unreal darkness" that Arp mentions, of which we have no inkling in the sunny holiday snapshot, was not just the general darkness of the German occupation, but the shadow cast by the risk to the three wives—Sophie Täuber, Susi Gerson, and Sonia Terk—because of their Jewish origins. The three were in imminent danger of being arrested when the photograph was taken, soon after Sonia Delaunay's arrival in late 1941. Susi Gerson had *already* been arrested, in June 1940, and sent to a detention camp at Gurs, in the Pyrenees, from which Alberto Magnelli had succeeded in freeing her. He had also applied to Varian Fry for emigration to the United States, but to no avail.[168]

Even in extremis the group managed to keep itself buoyant. Like the Surrealists at Air Bel, the abstract artists in Grasse collaborated on a project: Jean Arp, Sonia Delaunay, Alberto Magnelli, and Sophie Täuber worked variously on ten preliminary gouaches, in preparation for a series of lithographs.[169] [See figure 92.] Although with some effort one can usually distinguish the hand of each artist, the overall unity of the series is impressive. Mostly untethered forms float in the undifferentiated blank spaces of the lithographic sheets, and geometric and organic elements are used in unexpected combinations. Reminiscent of the Russian Constructivists with their painterly utopias (especially works by Lissitsky and Malevich), the refugees at Grasse imagined for themselves a constellation of better, freer worlds. Arp said that beauty was the only consolation for the terrible circumstances in which they found themselves; we might add that only by means of companionship, and collective endeavor, did the "little circle" manage to make its way to the beautiful in the first place. This was all for the best, since things soon got much worse. In November 1942, the Germans broke the terms of the armistice with the French and moved into what had been the Free Zone, including the Côte d'Azur (although their Italian allies were given nominal control of its eastern end, from Nice to the border). The Arps promptly returned to Switzerland, where Sophie was asphyxiated, so it is said, by a faulty gas jet in their apartment; Susi Gerson went into hiding with her mother, farther

92. Sheets from the Grasse collaborative lithographic print suite, published by Les Nourritures Terrestres, 1950. Designed by (left to right) Jean Arp, Sonia Delaunay, and Alberto Magnelli; Jean Arp and Sophie Täuber-Arp; Jean Arp and Sonia Delaunay. Private collection

93. Charlotte Salomon.
Life or Theatre (No. 558),
1942. Gouache on paper.
Collection Jewish Historical
Museum, Amsterdam

in the back country, leaving Alberto Magnelli in Grasse; and Sonia Delaunay remained there as well, keeping a low profile and staying clear of possible informers. With the exception of Sophie Täuber, they all survived.

Others did not, including Charlotte Salomon. The young German artist, who was Jewish, fled in 1939 from Berlin to Villefranche, where her grandparents had taken shelter with an American woman. Salomon and her grandfather were arrested and interned for a period, like Susi Gerson, at Gurs. Upon their release, Salomon moved to a small hotel at Cap Ferrat, where she began creating an epic "play with music," titled *Life? Or Theatre?* It consisted of hundreds of small gouaches, with accompanying text, and cues to a collage of musical pieces (which she apparently hummed while she worked). The final image, numbered 558 [figure 93], is a self-portrait in which the artist, wearing a bathing suit and seated on a rock at the water's edge, her back imprinted with the words *"Leben oder Theater"* (life or theater) paints on a transparent canvas. Her artistic sojourn in Cap Ferrat would be brief: in September 1943, Salomon was arrested and sent to SS headquarters in Nice, and then deported to Auschwitz, where she was killed almost immediately.[170] At the same moment —this was hunting season for Nazis—the same fate befell Madame Weisweiller, the Jewish owner of L'Altana, the Antibes villa for which Dufy had painted murals and in whose garden Lartigue had photographed a young woman in pursuit of a bouncing ball. But that was yesterday. Now the Nazis appropriated L'Altana, arrested Madame Weisweiller

and sent her, via the Drancy detention camp outside Paris, to her death at Auschwitz.[171] The Noailles villa at Hyères was also appropriated, but by the Italians, who used it as a military hospital; generally less ferocious than the Germans, they left the owners unharmed (they were probably unaware that the viscountess was half Jewish[172]).

At least one artist who was living on the coast, Francis Picabia, suffered not at the hands of the Vichy police or the Nazis during the occupation, but as a suspected collaborator at the time of the liberation. In March 1941, several months after the anti-Semitic Vichy laws went into effect, Picabia had published a pro-Pétain article.[173] Although there is no evidence that Picabia did more than express a vile opinion—no small matter at a time when such opinions could help legitimize collaboration and discourage resistance—this was enough to earn him detention at Cannes, from September 1944 to January 1945. Upon release, he and his companion, Olga Mohler, returned immediately to Paris, their years of high life on the Côte d'Azur definitively ended.[174]

Work and Joy: A New Beginning

The occupation and subsequent liberation took their toll on the Riviera. Both Marseilles and Toulon, the two great commercial and military ports, suffered substantial damage near their harbors, and entire neighborhoods had to be rebuilt. Two celebrated monuments on either side of the coast—Marseilles's Pont Transbordeur and Nice's Jetée-Promenade—were destroyed by the Germans in 1944 (the former in August, to impede any Allied invasion; the latter the previous March, to provide iron and steel for the Fatherland's depleted munitions industry). But there was also, at least for the first five years or so after

94. Henri Matisse, *Nice: Travail & Joie* (poster), 1949. Lithograph on paper. The John O'Donnell and Steven Wozencraft Collection, New York

RIGHT
95. Moïse Kisling. *Soap Factory*, Marseilles, 1949–1950. Oil on canvas. Collection Jean Kisling, Paris

the war, the toll exacted of pleasure itself, as is evident in a poster Matisse made in 1949 for the city of Nice and in a picture painted by Kisling in 1949–1950. [See figures 94 and 95.] Alongside a variation of one of his many window paintings (this one made in Vence, during wartime), Matisse inscribes the words *"Nice: Travail & Joie"*—work and joy. Kisling, who had returned to the coast from his exile in America, paints a picture of workers in a soap factory in Marseilles—the first time, to my knowledge, that the artist had treated such a theme. These were signs of the times. Not only was the left, including for a period the Communist Party, in especially good standing in the postwar years—thanks to antifascist activism and participation in the Resistance—but Riviera hedonism was now tainted by the specter of France's overzealous pursuit of good living, and the collaboration

"Étoile de mer" Cap Martin 15 février 55

Chère amie de Darien Connecticut

Soleil, mistral (vent dur) et solitude,

dans mon cabanon à Cap-Martin

Retour des Indes, surmenage effroyable : Paris!
le médecin m'expédie dans le silence total, seul.
Je suis seul, je dors près de 20 heures par jour.
Les oreilles dorment les cigales. la musique me faisait
mal. Les avant-coureurs de "nervous-break-down"
cher aux Américains

Alors je vous écris pour vous dire bonjour.
La présence de la mer nous est commune
depuis déjà à South Newark (est-ce juste?)
L'été dernier je me suis monté (moi-même avec
un dessinateur) une baraque de chantier de 2 m x 4 m

les rochers

J'y travaille heureux comme un prince, - (pas si ce...)
la liberté (donc plus heureux qu'un prince)

96. Le Corbusier, letter to Marguerite Tjader-Harris, "Étoile de Mer," February 15, 1955. Pen and black ink on wove paper. Collection Centre Canadien d'Architecture / Canadian Centre for Architecture, Montréal

with the occupier that had, for some, assured its perpetuation. A new, democratic emphasis on work and the working classes characterized many postwar artistic efforts on the Côte d'Azur.

Le Corbusier, for instance, won the commission for a large middle-class housing block in Marseilles. Erected between 1947 and 1952, his Unité d'Habitation, as it was called, incorporated numerous innovations, including prefabrication, an independent structural frame, built-in sun louvers, and "facilities for communal services."[175] He also made plans for two small-scale vacation communities at Roquebrune–Cap Martin, alongside the property where Eileen Gray and Jean Badovici's "E.1027" stood.[176] One of these, which had the backing of an American, Marguerite Tjader-Harris, was to have been a collection of bungalows modeled on his one-room Cabanon—the vacation module he had built for himself and his wife on the site [see figure 97]—and on his recently completed one-room atelier not far away. "About our 'cabins' on the rock, we must not be in a hurry to try to sell them," he admonished Tjader-Harris, apparently worried that an American backer would find it difficult to resist making a buck: "We must choose the owners who should consider themselves privileged and show their good intentions. . . . But this rock must not be a Yankee colony."[177] Nonetheless, he was excited about the project and sent her a series of glamorous picture postcards of the Côte d'Azur, on which he noted the location of their dream colony. "Dear Friend of Darien, Connecticut," he wrote, "I have again checked the plans. I have

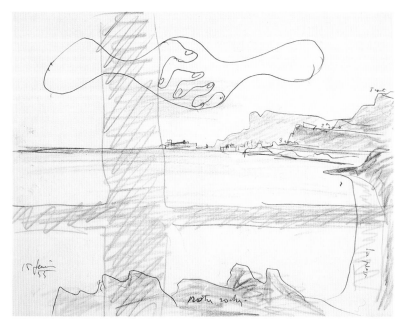

told you that this affair is exceptional, but it requires the presence, the action, the perseverance of an animal of my species. Years of preparation, of refinement of detail— Now everything is in order. I want this to be a little masterpiece, on this rock, beaten by the waves."[178] It was never built. Nor was the vacation colony designed by André Bruyère in collaboration with Fernand Léger, to be erected at Biot, near Antibes. [See figure 98.] Underwritten by a Brazilian businessman and politician, Assis Chateaubriand, the Village Polychrome was meant as a "habitable painting"—with brilliantly colored walls and surfaces conceived by Léger—comprising ten large houses "for friends," a museum with a major sculpture by Léger, a café-bar-restaurant, and dormitories for two hundred students.[179]

At least one egalitarian effort did come to full realization on the Côte d'Azur in the postwar period, however: Picasso's ceramics oeuvre. It began in July 1946. While passing the summer with Françoise Gilot at Golfe-Juan, a small down-at-the-heels former shipping port between Cannes and Antibes, Picasso paid a visit to nearby Vallauris, a town whose inhabitants, thanks to the abundance of clay in the area, had been manufacturing ceramic cooking vessels since Roman days. Vallauris and Golfe-Juan had fallen on hard

99. Pablo Picasso, *Femme*,
1954. White earthenware.
The John O'Donnell Collection,
New York

times, as metal cookware gradually replaced tradi-
tional ceramic pots. By the 1930s initiatives sought to
revive the local industry, the most notable of which
was Georges and Suzanne Ramié's Atelier Madoura,
an old factory refitted for work by modern ceramicists.
It was here that Picasso stopped on his first visit to
Vallauris and modeled a few pieces by hand. When he
returned the next summer, he set to work in earnest,
and within a year had created more than a thousand
ceramic objects.[180]

Over the next two decades—with particular
intensity until 1953, then sporadically until 1969—
Picasso produced thousands of ceramic works, both
unique pieces and objects produced in multiples, all
authorized Madoura editions. [See figure 99.] This
oeuvre is almost entirely figurative: men and women,
animals, mythical creatures, foodstuffs, a few
cityscapes, and an occasional *jeu d'esprit*—as in the
faux-classical shards of black-figure vases of 1950.
Mixed in with Cubist and Surrealist stylizations are a
potpourri of historical references: antique, rococo,
Spanish, Mozarabic, pre-Columbian, and of course,
Provençal. Although Gilot warned Picasso that his
multiples might create confusion with the unique
pieces, the artist felt otherwise, that "it was an amus-
ing idea that anyone might buy them, use them,

100. Françoise Gilot, Pablo
Picasso, and his nephew
Fin Vilato on the beach at
Golfe-Juan, 1948. Photograph
by Robert Capa

and maybe hang them on the wall like a souvenir."[181] Picasso had sensed the moment
with his usual acuity: "anyone" had indeed arrived on the Côte d'Azur, in the form of
the postwar tourist. Now the middle class (lodged in new commercial hotels) and even the
working class (staying in campgrounds and *auberges de jeunesse* and similar hostels) had
joined the traditional Riviera elite. What's more, air travel made the south of France more
accessible from Buenos Aires, Los Angeles, and Beirut, just as advertising, publicity,
and the movies (think of the Technicolor treatment in *On the Riviera*, with Danny Kaye,
and Alfred Hitchcock's *To Catch a Thief*) conspired to make France's southeast coast
more familiar, and more alluring than ever. The tourist boom of the 1950s brought an end-
less stream of visitors to Vallauris, and especially to the Atelier Madoura, where, as late
as the 1960s, one could purchase a Picasso vase or plate for under twenty dollars.

 It was not just these new consumers on the Riviera whom Picasso had in mind when
collaborating with the Ramiés; it was also the producers. Now a member of the French
Communist Party, the artist soon understood that his efforts might be of enormous benefit
to the working men and women of Vallauris. Although it would be an overstatement to
say that Picasso single-handedly revived the local economy, had it not been for the
extraordinary success of his ceramics, the area would probably not have experienced the
intense renewal it did. Not only did Madoura flourish, but so did many other local
manufacturers, for whom numerous artists produced ceramic work, including Cocteau,
Chagall, Léger, and Amedée Ozenfant.[182] Picasso had finally made real the utopian dream
of the Côte d'Azur adumbrated a half-century earlier in Signac's *Au Temps d'Harmonie*:
a place where nature and humankind, work and leisure might be joined in blissful synthe-
sis. This, combined with the model of Gauguin—whose flight from urban culture toward
a palm-shaded paradise took the form of an anti-elitist embrace of local craft as an adjunct
to the high art of painting—meant that Picasso had subtly altered the terms of modern
artistic escape. Now while he played on the Riviera, the artist could also *work* for the

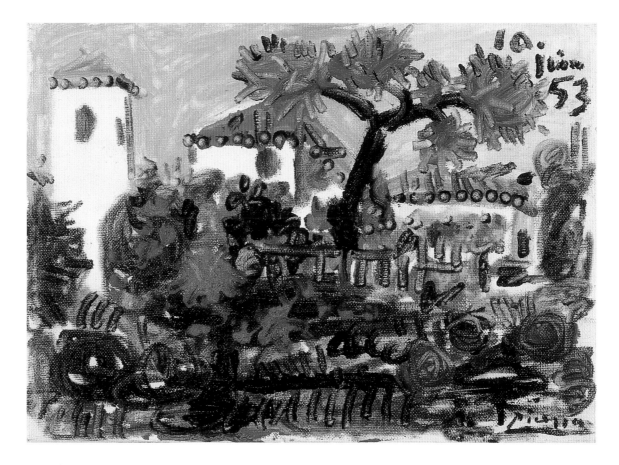

101. Pablo Picasso, *Garden in Vallauris*, 1953. Oil on canvas. The Solomon R. Guggenheim Museum, New York. Thannhauser Collection, Gift, Justin K. Thannhauser, 1978

benefit of others. Predictably, Vallauris was very grateful to Picasso. When, in 1950, he donated a bronze sculpture, *Man with a Lamb*, to stand in the market square, this gratitude was made official.[183] The Communist Party leader Laurent Casanova unveiled the statue, and the Communist mayor made Picasso an honorary citizen of Vallauris— of which he was already a resident, and where he painted many views of La Galloise, his house and garden. [See figure 101.] One writer in the local press commented, "Picasso is not only a great artist, he is also a man with a heart."[184]

Modernism *in Aeternum*

"To visit the Midi has become a fashionable requisite for anyone interested in today's art," wrote Alexander Liberman after the war. "The names Picasso, Braque, Chagall, Léger, and Matisse are heard from the lips of countless tourists disporting themselves on the promenades and the beaches. The evocation of these prestigious names confers a stamp of cultural approval upon the lazy, carefree holiday life of the Riviera. A tourist may feel that he has participated in a creative adventure merely by swimming next to Picasso or Chagall. In the Midi the artists have become the nobles of the land. Their wishes are respected, their activities reported; they are a new royalty."[185] If less than a century earlier it was Queen Victoria, King Léopold of Belgium, and the long-deposed Empress Eugénie who provided the coast with tone, it was now artists who offered tourists the reassurance that they were in the right place, at precisely the right moment. The grand old men of modern art were no longer outsiders, but living monuments, flesh-and-blood attractions whose allure helped revive Riviera tourism. In a way Paris could never be—it was the center of too many other worlds, and it lacked the visible contour of nature—France's southeast coast had become the royal domain of the aging avant-garde. This was fair enough: these artists, among many others, had created the myth of the French Riviera; now they would be the protagonists of their own story.

As befit royalty, Picasso made a grand gesture on the coast. In the summer of 1946, Romuald Dor de la Souchère, director of the small archaeological museum housed in the Château Grimaldi, by the water in Antibes—the castle that had provided background interest for *Night Fishing*—invited Picasso to use a large attic space as a studio. The artist worked like a demon there for several months, producing what has come to be called the *Antipolis Suite* (the title alludes to the town's ancient Greek name): pictures of the nymphs, fauns, centaurs, and satyrs Picasso had long fantasized as the Riviera's indigenous population. To the director's surprise, Picasso decided to make the museum a gift of almost his entire output from the studio—twenty-five paintings

and forty-four drawings—with the stipulation that the works remain in situ. Three years later, the museum was reinaugurated as the Musée Picasso, not only the first museum devoted to his art, but purportedly the first museum in the world devoted to the work of a living artist.

Despite the fact that Picasso was newly a father—his son Claude was born in 1947 and his daughter Paloma in 1949—he was not getting any younger. He was sixty-six the year he made the Antibes donation, and was obviously beginning to think about his legacy, which he may have felt would be more securely left in the hands of grateful locals than in those of bureaucrats in the capital (where it took more than thirty years to see the inauguration of the Picasso Museum). Other "nobles" of the coast were already in late middle age or past: Léger too was sixty-six, Matisse seventy-eight, Chagall sixty. "Whenever you read about the French writers and painters of the previous generation who are now basking in glory—Cocteau, Picasso, Matisse, etc.—you find that sooner or later they took up residence on the Côte d'Azur," the French critic Maurice LeMaître noted in 1955. Wondering why this was so, he paid a visit to sixty-six-year-old Jean Cocteau at Santo Sospir, the Cap Ferrat villa of his patron Francine Weisweiller (daughter-in-law of the murdered owner of L'Altana). "And looking at him I suddenly understood what it was that brought them all to the Riviera. I grasped the essential reason for this retreat in one word—Age. For the artist, for the man who has fought for twenty years or more to impose a new vision of men and of things on the world, there must come a moment when the body and spirit falter, when the tightrope he must always walk in Paris to stay alive begins to give way, and when it is time to make a pact with the sun, the air and silence so that he can go on living, hoping and above all creating."[186] Whether or not LeMaître's idea qualifies as a general principle—many artists, after all, had come to the coast as young men and women—it is nonetheless true that in the case of Henri Matisse, for one, "age" was a major factor in his greatest postwar Riviera project, the

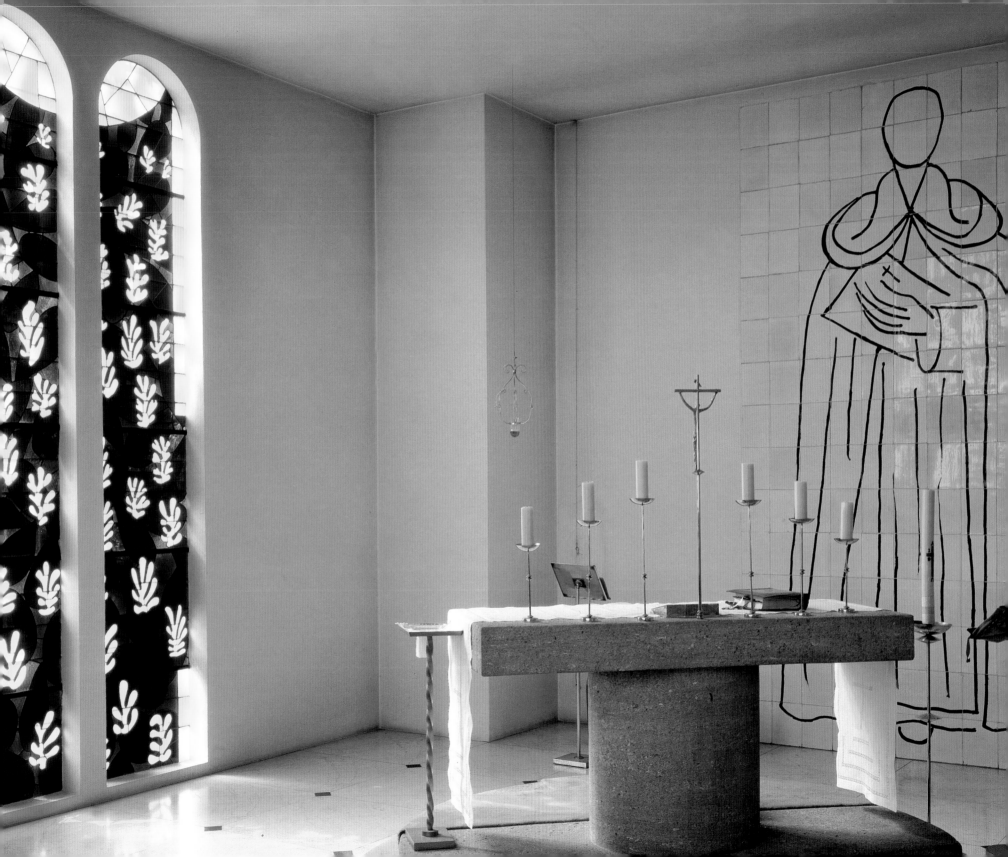

design of the Chapelle du Rosaire, at Vence, which he considered "not a job which I chose but a job for which I was chosen by destiny at the end of my road."[187]

Between 1947 and 1951, Matisse devoted himself almost full-time to the creation of the Chapel of the Rosary. [See figure 102.] Intended for the private worship of the Dominican nuns whose convent was near Matisse's villa in Vence, the chapel owed its initial impulse to one of them, Sister Jacques-Marie. Before taking her vows, as Monique Bourgeois, she had been a nurse; she had watched over the ailing artist when he was recovering from serious abdominal surgery several years earlier. Sister Jacques-Marie told Matisse about the convent's need for a chapel. With the subsequent intervention of a visiting novice priest, Brother Raysiguier, and advice from the architect Auguste Perret and others, Matisse embarked on a design that, when complete, would include ceramic wall drawings and stained-glass windows, an altar, altar cloth, candlesticks, a crucifix, a pierced wooden door for the confessional, and priests's vestments, as well as such details of the exterior as a geometrically patterned ceramic-tile roof and a tall decorated cross.

Although a nonbeliever, Matisse was reared a Catholic. In the letters that passed between him and Sister Jacques-Marie—even those predating his work on the chapel—it is evident that the aging artist was no longer averse to phrasing his private spiritual feelings in traditional terms: "Thank you for praying for me," he wrote in June 1945. "Ask God to give me, in my last years, the illumination of spirit that would put me in contact with Him, that would permit me to complete my long and laborious career in what I have always sought: to show the blind His evident glory, by exclusively earthly nourishment."[188] As Matisse explained, the basic aesthetic idea behind the chapel was to "equilibrate" light and color produced by the stained-glass windows—an abstract tree-of-life motif, in green, blue, and yellow along one wall, and yellow philodendronlike leaves set against blue oval cactus shapes in the apse—with plain white walls and black-and-white drawings on fired ceramic tiles: a large standing figure of Saint Dominic, a Virgin and Child, and

102. Henri Matisse, *Chapelle du Rosaire*, Vence, 1947–1951

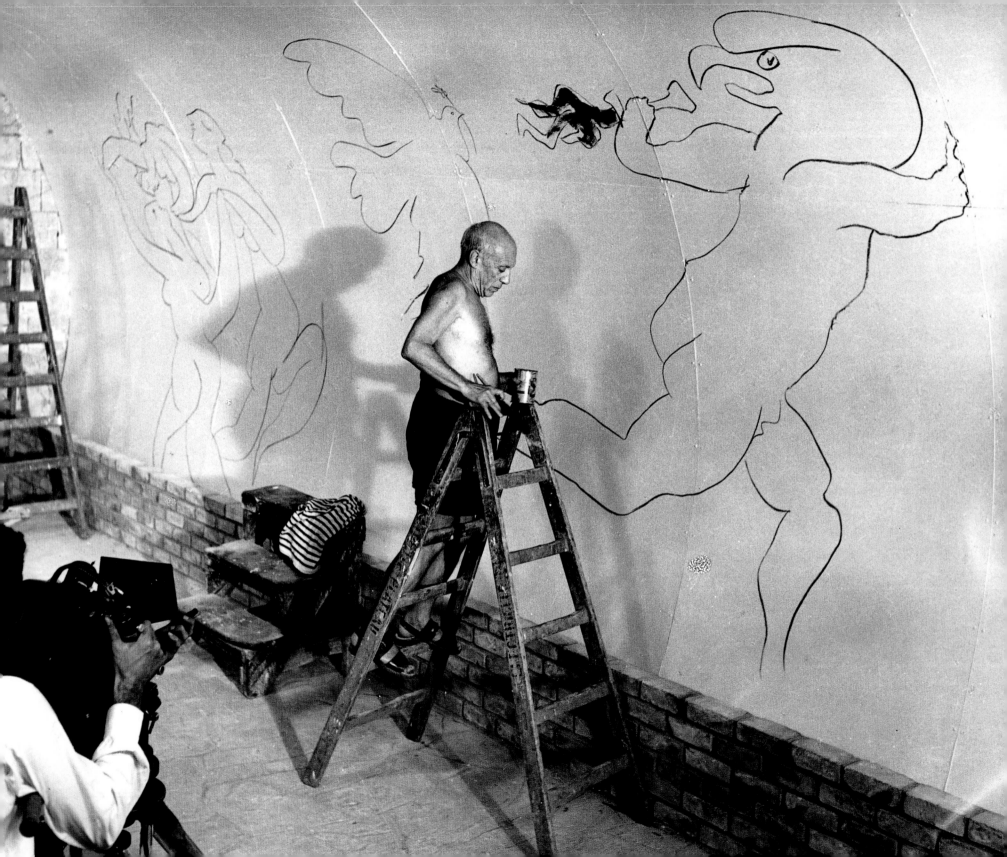

the Stations of the Cross.[189] The effect of this juxtaposition of brilliant, colored, intangible light and down-to-earth, uncolored schematic drawing—what we might think of as the "evident glory" and "earthly nourishment" of which Matisse spoke—is at once ecstatic and austere, entirely fitting for the private chapel of those who have renounced worldly concerns in order to serve God.

Matisse considered the Vence chapel "the culmination of a life's work and the flowering of an enormous, sincere, and difficult effort," and the unquestionably distilled quality of the designs for the chapel—the artist seeing how much he could convey with the most reduced means—could have come only with age. This same quality distinguishes his late paper cut-outs, in which simple shapes and pure, flat color replace the more traditional illusionistic painting techniques of his work done in Nice in the 1920s and early 1930s. "All art worthy of the name is religious," Matisse told an interviewer in 1951. "If it is not religious, it is only a matter of documentary art, anecdotal art . . . which is no longer art."[190] It appears to have taken Matisse decades on the Côte d'Azur to discover the spiritual impulse that lay behind the region's "delicious" artifice, and to rise above anecdote toward abstraction. In his final years on the coast, Matisse shifted his sights from the "luxe" (and the *lux*, in its Latinate form: earthly light) of his first trip to St.-Tropez to the luminosity (*lumen:* divine light) of his Chapel of the Rosary.[191]

Before long there were two other chapels designed by artists on the Riviera. In 1950, at the Picasso celebration in Vallauris, Laurent Casanova invited the artist to decorate a deconsecrated chapel in the château that borders the market square. Although it was not inaugurated until 1959, Picasso's work on the Temple of Peace was completed in 1952. [See figure 103.] With two large painted panels on either side of a windowless, barrel-vaulted space, Picasso's Vallauris chapel is intended not for prayer but for sociopolitical edification: its "war" and "peace" images are closely in line with the anti-American, pro-Soviet cold war rhetoric of the French Communist Party.[192] Also in 1950, Jean Cocteau

103. Picasso working on early sketches for the Temple of Peace, Vallauris, 1952. Photograph by André Villers

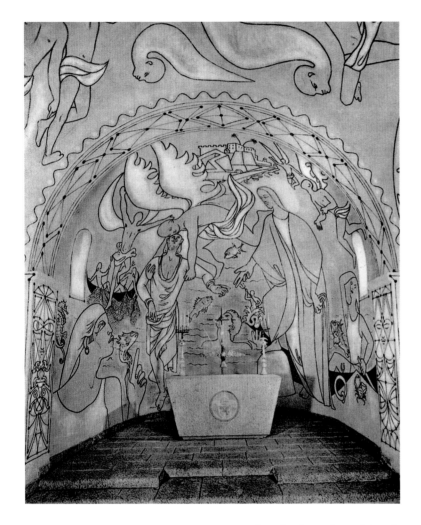

104. Jean Cocteau, *Chapelle Saint-Pierre*, Villefranche, completed 1957

began plans for the decoration of a tiny deconsecrated chapel at the water's edge in Villefranche. Rededicated in 1957 as the Chapelle Saint-Pierre, Cocteau's sanctuary featured scenes from the life of Saint Peter, fisherman turned apostle, juxtaposed to scenes of local life. [See figure 104.] Like Matisse, Cocteau took complete aesthetic control of the chapel, designing wall paintings, stained-glass windows, the altar, the crucifix, and even a pair of candelabra that incorporate the multipronged spears used for night fishing on the coast. But in comparison with the stripped-down abstraction at Vence, the Villefranche chapel is a riot of quasi-Surrealist, neo-Baroque decoration.[193]

Three artists, three chapels: competition was evidently heated among the "new royalty" to leave their mark on the coast and prepare for the perpetuation of their individual glory. Cocteau said of his Villefranche chapel: "I wanted to crown my achievement like a pharaoh painting his sarcophagus."[194] There is a sense in which all three of these chapels *are* royal tombs—in each case, God (in Picasso's chapel, Communism) has had to share his glory with a gifted mortal. Not to be outdone was Marc Chagall, who had moved to the coast—first to Cap Ferrat, then to St.-Jeannet, and finally to St.-Paul-de-Vence—after his return from wartime exile in America. Although they would come many years later, he created two mosaic panels that are perhaps his finest work of the postwar period: *The Finding of Moses* [figure 105] for the baptistery of Vence cathedral, and *The Angels' Meal* for the Chapelle Sainte-Roseline at Les Arcs-sur-Argens.[195] We should keep in mind that all of these projects were undertaken in the aftermath of

World War II, a period of (among other things) mourning. Expressions of grief, regret, guilt, and atonement were widespread in every area of public discourse, from the philosophical to the religious. This included the revival of sacred art, under the direction of Father A. M. Couturier, who, since the late 1930s, had been militating for modern artists to collaborate in the creation of ecclesiastical work.[196] Indeed, Father Couturier had gone to Vence to consult with Matisse as he worked on the Chapel of the Rosary.

The irony that this sacred modern art was being installed in the most *mondain* of places should not escape us. Is there as well an element of repentance, or more straightforward, of thanks being offered, for the pleasure these artists had experienced on the coast for so many years? Admittedly, public manifestations of artistic modernism on the Côte d'Azur were not all religious in nature. As he was completing his work on the Villefranche chapel and in the years immediately afterward, Cocteau created numerous other decorated ensembles on the coast, including two secular wedding chapels, for the town halls of St.-Jean-Cap-Ferrat and Menton, and an amphitheater [figure 106]

for a student retreat at Cap d'Ail.[197] Chagall created a mosaic for the law school of the University of Nice; Braque created a mosaic and Léger a large ceramic wall piece for the Colombe d'Or inn, which artists and their friends had frequented in St.-Paul-de-Vence since the 1930s;[198] and Braque, Léger, Chagall, and Miró made work in ceramic or mosaic for the Fondation Maeght, also in St.-Paul, inaugurated in 1964, the first museum of modern art built in France since the Musée National d'Art Moderne in Paris in 1934. This postwar on-site modernism has roots in the past: Picasso's desire to leave a permanent mark on the Riviera goes back to 1927, according to Christian Zervos, who reported that the artist had made drawings for a series of monumental Surrealist sculptures for Cannes, "to be distributed along the Promenade de la Croisette. Since then, he has continued to persevere in his desire to create a monument."[199] And there was something of this ambition—to leave a mark on the landscape, if only briefly—also in Brancusi's Crocodile Temple on the beach at St.-Raphaël.

Now, though, there was to be nothing temporary in the Riviera's celebration of its modernist past. A series of monographic museums joined Antibes's Musée Picasso: in 1960, at Biot, the Musée National Fernand Léger was opened, five years after the death of the artist who referred to the coast as "medicine-en-Azur"; in the Cimiez neighborhood of Nice, close to where Matisse had lived for many years (and near where he is buried), the Musée Matisse opened in 1963, nine years after his death; the tiny Musée Cocteau opened in Menton in 1967, four years after the artist died; and in 1973, while the artist was still alive and well, an institution with an exceptionally ungraceful name, the Musée National Message Biblique Marc Chagall, was inaugurated in Nice. The Côte d'Azur—the vast pleasure zone of France's southeastern coast—had become the Elysian Fields of modernism.

Local Heroes, New Myths

If, in the years after World War II, the French Riviera was linked in the public's mind with the older generation of great modernists, it nonetheless remained a place to which younger artists found themselves drawn. The English painter Graham Sutherland first went to the Côte d'Azur in 1947, when he had the good fortune to meet Picasso and Matisse. He made a portrait of Somerset Maugham, a longtime coastal resident, at his Villa Mauresque at Cap Ferrat, and in 1955 bought himself a house, the Villa Blanche, in Menton.[200] Nicolas de Staël, the Russian-born Belgian abstract painter, who had made several trips to the coast in the early 1950s, moved to Antibes in September 1954. He rented a house at the water's edge, on the ramparts of the Old Town, near the Picasso Museum, which he visited often, and where Romuald Dor de la Souchère made his acquaintance. In March of the next year, a few months before an exhibition of his own recent work was to open at the museum, de Staël committed suicide, throwing himself from the window of his house.[201]

Several years before, in 1949, the young American artist Ellsworth Kelly had gone to visit a friend in Sanary; he subsequently lived in the small fishing port, from November 1951 until late 1952. Like so many artists before him, Kelly came under the spell of the intense luminosity of the Riviera. He produced a number of brightly colored works based on a strict rectilinear grid system, including a painting titled after the small port town [figure 107]. It was in the south that Kelly's ideas about wall-scale painting seem to have coalesced. In December 1949 he saw the newly inaugurated Musée Picasso at Antibes; three years later he visited Le Corbusier's Unité d'Habitation, still under construction in Marseilles, where he was impressed by the architect's use of primary colors on the balconies, but which he found still too "decorative" for his taste. Kelly wrote in a letter shortly afterward: "The future artist must work directly with society. I believe that the days of the 'easel' painting are fading, and that the future will be something more than just 'personality paintings' for walls of apartments and museums. The future art must go

108. Jean Dubuffet, *The Beach at Cassis*, 1944. Ink on paper. Collection Richard L. Feigen

OPPOSITE
107. Ellsworth Kelly, *Sanary*, 1952. Oil on wood. Private collection

to the wall itself."[202] Brilliant color, socially relevant art, and large-scale wall painting: the view of late modernism as it was being refined on the coast in the postwar years would inform Kelly's work ever after.

Almost the exact opposite reaction to the south was engendered in the work of the perennial contrarian Jean Dubuffet. After he went to live in Vence, in 1955, the "striking colors" of his previous paintings, done in Paris, were, as he himself explained, replaced by "what might be called natural colors, rather light but stony, earthy, sandy (whites, grays, ochres, gold shades bistre)."[203] It was as if Dubuffet were intentionally ignoring the dazzling light, and the vista of sky and sea on the coast, that had so captivated visiting artists since the time of Monet. What interested him was what he saw when he looked down at his feet, the "pieces of ground planted with growing things, tufts of grass, lowly weeds that look like stars, such as . . . thistles or dandelions, coming up between little stones in what appears to be the ground on the edge of badly kept roads, or barren mountain soil like the soil around Vence."[204] The work he made during almost two decades in Vence partakes of the landscape in the literal, indexical way of work by Masson, Picasso, and Kandinsky decades earlier—he incorporated sand, leaves, and even butterfly wings into his paintings. Dubuffet, who had worked in Cassis during the war [see figure 108], returned to the Riviera only because a physician recommended the climate for his wife's pulmonary problems. Once there, the artist joined the small but vocal group, Soutine and Léger notably, who disliked the place. "How boring it is here!" he told the writer Jean Paulhan in 1956. "After being here for a year I am still waiting for

109. Martial Raysse, *Tree*,
1960. Mixed media.
Musée d'Art Moderne et d'Art
Contemporain, Nice

the slightest sign of invitation or an advance from anyone. Oh, how little sense of welcome or inducement there is on the Côte d'Azur!"[205] And to another friend, at around the same time: "The region is full of obtuse, ill-tempered people whose company is not exceedingly agreeable, and is dotted with ridiculous villas, not to mention palm trees and mimosa. Besides which, it's cold here. . . . The great sun, which presides over the place often enough, does admittedly infuse the spirit, at least in fine weather, with a meretricious little inebriation."[206]

Dubuffet was the prototypical "colonial" artist on the Riviera: the outsider, from Paris or elsewhere, whose opinion (whether pro or con) had little to do with the reality of regional life. Yet something was transpiring on the coast at precisely the moment that Dubuffet was complaining about the natives: three local boys were coming of age as the first indigenous avant-garde in the Riviera's history. Since Yves Klein, Arman (Fernandez), and Martial Raysse were all Niçois (although Klein had grown up also in Paris, and in Cagnes-sur-Mer), they are sometimes collectively referred to as the "École de Nice," and more generally as exemplars of *nouveau réalisme*. They had a powerful sense of their own local identity, from early on: "We've had enough of it, we of the École de Nice—for ten years we've nourished Paris and even New York, but there's a limit to family obligations," Klein said in 1960. "Let them do what they like . . . we look to the west, where we see Los Angeles rather than New York . . . and then Tokyo. . . . I envision a new axis for art, Nice, Los Angeles, Tokyo."[207] A bit like the young provincial New York artists during World War II who suddenly found themselves in the company of Mondrian, Breton, Léger, and Ernst, these aspirants on the Côte d'Azur had the good luck to come of age with Picasso, Matisse, Cocteau, and Chagall as neighbors. The young Azuréens thus had both a strong sense of modernist "privilege" and a demystified sense of artistic celebrity—an ideal combination for subsequent self-assertion.

Like Rauschenberg and Pop artists in the United States, the artists of the École de

110. Arman, *Animal Furtif/ Furtive Animal*, 1962. Accumulation of hairbrushes in wood box. Collection Corice Canton Arman and Arman, New York

111. Yves Klein, *Untitled,* 1956. Pigment in synthetic polymer medium on canvas over wood. Collection Corice Canton Arman and Arman, New York

Nice had interests at the opposite end of the aesthetic spectrum from the esoteric formalism of the Abstract Expressionists: irony, popular culture, consumerism, mass production, and kitsch were embraced. After all, who knows more about popular culture and bad taste than those born, raised, and educated in a resort town? And a resort town with resort life as existed nowhere else, with its unique mix of high and low culture. The iconoclasm of the École de Nice, we might say, is a function as much of its members' reaction to the living icons in their midst as to the mass-culture icons and symbols that surrounded them on the coast—palm trees, plastic beach balls, Brigitte Bardot. For one of his first neo-Dada acts, Yves Klein "signed" the brilliant blue sky of the Riviera, calling it his "first and biggest monochrome," and then chose an ultramarine blue as his personal chromatic attribute, renaming it IKB—International Klein Blue.[208] Martial Raysse gathered plastic refuse on the beach or bought objects at the five-and-dime stores in Nice— bottles of suntan oil, toy boats, soft-drink containers—and fashioned sculpture out of them. Arman, whose father owned a furniture store in the city, burned, mutilated, and otherwise subjected faux-Louis *meubles* to whatever indignities he could contrive, when he wasn't raiding his neighbors' garbage cans and encasing the contents in plexiglass boxes.[209] [See figures 109–111.] "It's important to keep in mind that we are not artists," Raysse said. "We're on vacation, we've never worked in our lives." "And being perpetually on vacation," Arman added, "we have time to eat, destroy, and spit out anything we feel like." But Klein wanted to be sure that they were not misunderstood: "Although we're always on vacation, we of the École de Nice, we're not tourists," he said, enunciating what amounts to a radical perspective on Riviera art-making. "That's the essential point. Tourists on vacation come to where we live, we *inhabit* the land of vacation, which gives us this feeling for doing idiotic things. We have a good time, without thinking of religion, or art, or science."[210] With this spirit of freedom—the sense of play, so key to all resorts—the École de Nice turned the tables on nearly three-quarters of a century of artistic "outside agitators."

112. Eric Fischl, *St.-Tropez*, 1982. Oil on canvas. Private collection

Still, tourists will be tourists on the Riviera, no matter how late in the game they arrive. And why not? Not only does the Côte d'Azur continue to offer its *menu touristique* of standard attractions, but there is now also something oddly compelling about its very belatedness. We sense this world-weary quality in Eric Fischl's *St.-Tropez*, of 1982 [figure 112], the picture of a beach that was already over-crowded by the 1930s but which, with its rentable orange-and-white-striped mattresses and their matching umbrellas, looks astonishingly well ordered from an American point of view. In the neo-Freudian triangulation that is Fischl's specialty, a cobbled-together "family romance" is enacted by three main characters: the white "bather" with rhinestone sunglasses in the foreground, pushed right up to the picture plane, about to squirt suntan lotion we know not where; the prepubescent girl at the left, who seems to shake water from her ears; and the tall black man at the right, arms akimbo, wearing a violet-colored sarong. Of course, we have no reason to believe that there is any necessary connection among the protagonists, other than what we impose on them. Following a picture-making technique learned from Manet and Degas, in which mere contiguity in public space is enough to incite the narrative-hungry appetite of the spectator, Fischl complicates—in a very contemporary way—the *volupté* of the classic Riviera beach scene, with implications both sexual and racial.

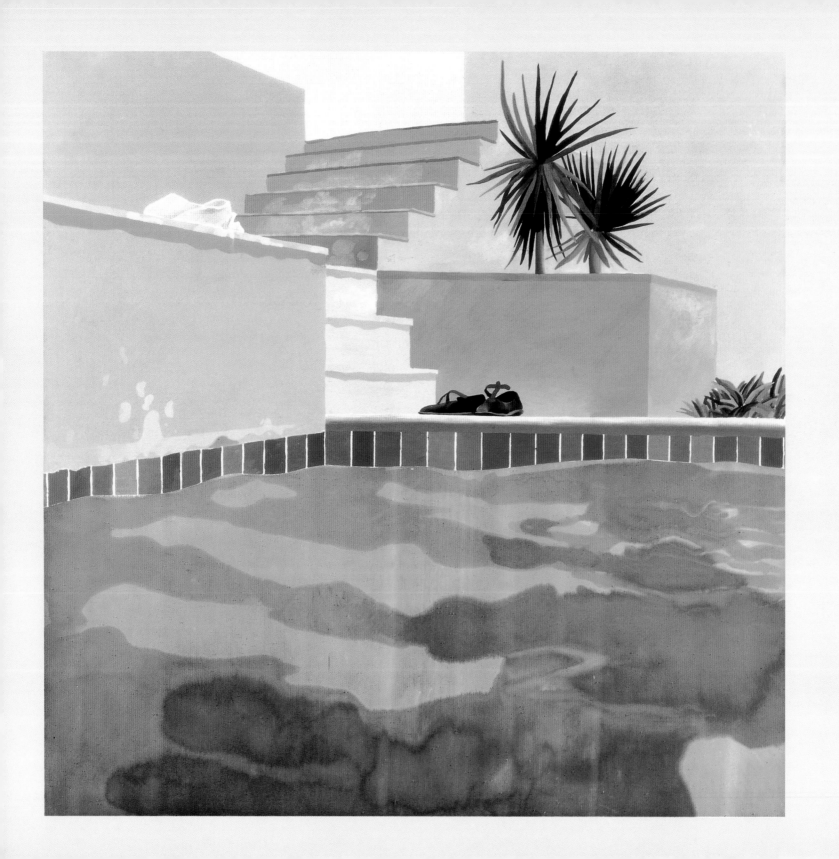

113. David Hockney, *Pool and Steps, Le Nid du Duc*, 1971. Acrylic and detergent on canvas. Private collection

It is the absence of actors that is key to both the *luxe* and the *calme*, as well as the poignancy, of David Hockney's 1971 *Pool and Steps, Le Nid du Duc* [figure 113]. The vantage point is from across a swimming pool (that of the director Tony Richardson's house near St.-Tropez), whose aquamarine depths—rendered in acrylic paint mixed with water and detergent, stained into the weave of the canvas—take up half the painting. On the far side of the pool, above the demarcation line of terra-cotta tiles, the strict geometry of the steps carries the eye upward, toward the paired "heads" of two palms, those ever-reliable symbols of resort life. All is well in this realm of brilliant morning light and blue water, although the brown leather sandals left by the side of the pool introduce an elegiac note.[211] Standing in, as it were, for an owner who must not be far off, but whose presence can only be imagined, their mute attendance spiritualizes our private poolside epiphany of life's manifest joys.

In Jennifer Bartlett's *In the Garden #105* [figure 114], a work done in Conté crayon and oil pastel on paper, the doubled image of an empty swimming pool—a more naturalistically rendered grisaille version with red-orange floor at left, and a more abstracted image, made of up multiple colored hatch marks at right—has the look of a recurring bad dream. This is one of a vast series (197 drawings in all) begun in January 1980, at a rented villa in Nice. Bartlett had taken the house, and what turned out to be its dreary garden with reflecting pool, site unseen. Out of desperation, she began to draw—to "teach herself" to draw,

114. Jennifer Bartlett, *In the Garden #105*, 1982–1983. Conté crayon and oil pastel on paper. Collection PaineWebber Group, Inc.

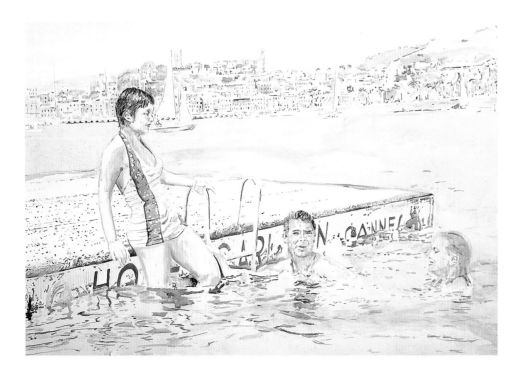

115. Jane Kaplowitz, *To Catch a Thief*, 2000. Acrylic on canvas. Collection of the artist

OPPOSITE

116. Faith Ringgold, *Matisse's Chapel (The French Collection, Part I, #6)*, 1991. Acrylic on canvas with fabric border. Private collection

as she put it—in as many modes as she could master. Inspired in part by a visit to Matisse's Chapel of the Rosary at Vence, she challenged herself not only to juxtapose and reconcile, as he had there, conflicting modes of representation, but to create a series of mural installations based on the garden drawings.[212]

Faith Ringgold goes one step further in her admiration for Matisse's chapel, into the realm of what, in postmodern parlance, is called "appropriation." [See figure 116.] After visiting the Chapel of the Rosary, she decided to paint a quilt (part of her *French Collection*) in which she gathered the dead members of her family in the one-room sanctuary of the Dominican sisters.[213] Each of her family portraits is precisely delineated—there are her parents, and two generations back of grandparents, in addition to siblings and cousins—as are the details of Matisse's chapel: the brightly colored tree-of-life windows at the left and the philodendron-and-cactus windows at the right, the black-and-white Virgin and Child ceramic panel in the center. Finding in the quilt form a female folkloric equivalent of Matisse's architectural ensemble, Ringgold projects her family into the holy Christian space on the hillside in Vence, and herself into the sacred, exclusive precincts of High Modernism.

For Jane Kaplowitz, it is not modernism's rarefied spaces that a recent painting calls to mind, but a reified Hollywood dream space, specifically the Riviera of Alfred Hitchcock's *To Catch a Thief*. [See figure 115.] Here, in her version of a scene from the 1955 film, Cary Grant, in the center, finds himself between the two women, American and French, who are

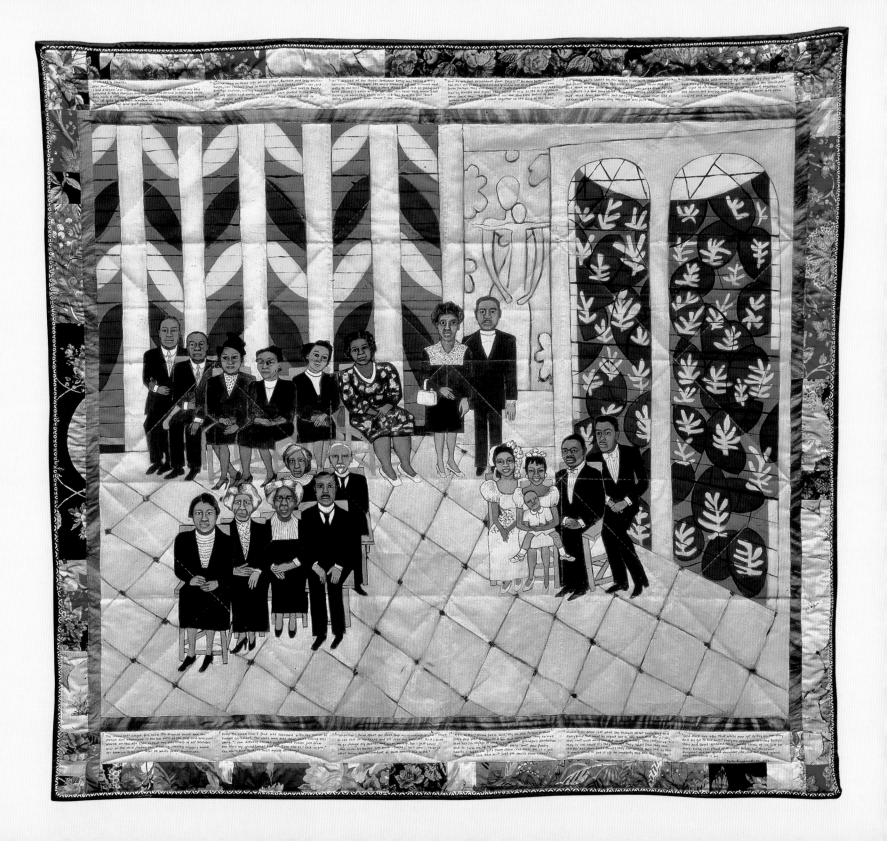

pursuing him: Grace Kelly, in the water, and Brigitte Auber, balanced on the edge of the Hotel Carlton raft (the skyline of Cannes is visible in the distance). Although Cocteau, as he put it, found "nothing stranger than this Côte d'Azur seen in Technicolor by the Americans,"[214] Kaplowitz's picture—with its thin paint application and pale tones—reveals just how common is our collective nostalgia for a place that existed only on celluloid. Based as it is on a film still, itself a peculiar freezing of simulated motion, her painting takes us ever further from the "real" coastline on France's southeastern flank. But this is as it should be: Grace Kelly's real-life marriage to Prince Rainier notwithstanding, there is no Côte d'Azur quite as splendid as the one we have long imagined.

NOTES

117. Donald Sultan, *Five Lemons,
a Pear, and an Egg—April 16, 1986,*
St.-Tropez. Oil, Spackle, and tar on
tile over wood. Collection of the artist

1. *A Life in the Movies: An Autobiography* (London: Heinemann, 1986) and *Million-Dollar Movie* (London: Heinemann, 1992).

2. Sources for the comments of Matisse, Duchamp, and Léger in the display quotations on pp. 19, 20, and 22 are, respectively: "Correspondance Henri Matisse–Charles Camoin," *Revue de l'Art*, 12 (1971), p. 23; Marcel Duchamp to Constantin Brancusi, September 1931 (private collection), in *Brancusi et Duchamp*, exh. cat. (Paris: Centre Georges Pompidou, 2000), p. 46; and Fernand Léger to Simone Herman, in Fernand Léger, *Lettres à Simone*, ed. Christian Dérouet (Paris: Skira and Musée National d'Art Moderne, 1987), p. 84.

3. Mary Blume's *Côte d'Azur: Inventing the French Riviera* (London and New York: Thames & Hudson, 1992) is both the best and most recent cultural history of the Riviera. There is of course a vast literature on the French Riviera as a tourist destination, including myriad guidebooks and memoirs. Although she only occasionally mentions art or artists, Blume's book is the starting point for any serious modern study of the subject.

Two exhibition catalogues during the last decade have taken up the topic of modern art on the Côte d'Azur: *La Côte d'Azur et la Modernité: 1918–1958* (Paris: Réunion des Musées Nationaux, 1997) and Kenneth Wayne, ed., *Impressions of the Riviera: Monet, Renoir, Matisse and Their Contemporaries*, with essays by John House and Kenneth E. Silver

(Portland, ME: Portland Museum of Art, 1998). Robert L. Herbert's pioneering work on nineteenth-century French art, leisure, and tourism provides essential background; see especially *Monet on the Normandy Coast*, (New Haven, CT: Yale University Press, 1994). Also excellent is Joachim Pissarro, *Monet and the Mediterranean*, exh. cat. (Fort Worth: Kimbell Art Museum, 1997). For the Fauve painters on the Riviera, see Judi Freeman, ed., *The Fauve Landscape*, exh. cat. (Los Angeles: Los Angeles County Museum of Art and Abbeville Press, 1990), and especially James D. Herbert, *Fauve Painting: The Making of Cultural Politics* (New Haven, CT, and London: Yale University Press, 1992). Richard Thomson, *Monet to Matisse: Landscape Painting in France, 1874–1914*, exh. cat. (Edinburgh: National Gallery of Scotland, 1994), is a superb synthetic work.

Also useful are Sylvie d'Èze, *La Provence Vue par les Peintres* (Lausanne: Edita, 1987), and *Les Peintres de la Couleur en Provence, 1875–1920*, exh. cat. (Paris: Réunion des Musées Nationaux, 1995), which includes Jean-Paul Monery's essay "1870–1920: Un Midi Surprenant, Attirant, Influent et Créatif, Véritable Lieu Privilégié de l'Avant-garde Picturale." Several other relevant exhibition catalogues are: *Peindre dans la Lumière de la Méditerranée* (Jerusalem: Israel Museum, 1987); *Azur* (Paris: Fondation Cartier, 1993); and *Les Bains de Mer: Une "Aristocratie de la Plage," 1880–1930* (Dinard: Palais des Arts, 1997). As this book is going to press, another work has

appeared in which the Côte d'Azur figures significantly: Françoise Cachin, ed., *Méditerranée de Courbet à Matisse*, exh. cat. (Paris: Grand Palais, 2000).

4. Donald Posner, *Antoine Watteau* (Ithaca, NY: Cornell University Press, 1984), p. 8. See also Posner's article "Watteau Mélancolique: La Formation d'un Mythe," *Bulletin de la Société de l'Histoire de l'Art Français*, 1973/1974, pp. 345–61.

5. Dominique Fourcade, "An Uninterrupted Story," in Jack Cowart and Dominique Fourcade, *Henri Matisse: The Early Years in Nice 1916–1930*, exh. cat. (Washington, DC: National Gallery of Art, 1986), pp. 56–57. See also my review "Matisse's Retour à l'Ordre," *Art in America*, June 1987, pp. 110–23, 167, 169.

6. In fact, keeping the Riviera "pristine" has taken a certain degree of governmental effort. On the entire island of Porquerolles, across from Hyères, as well as in the area known as the Crique de Brouis, near St.-Tropez, for instance, development has been kept in check by the intervention of local and national conservancy organizations.

7. For the Campanian littoral and its resemblance to the Côte d'Azur, see Louis Turner and John Ash, *The Golden Hordes: International Tourism and the Pleasure Periphery* (New York: St. Martin's, 1976), pp. 23–28.

8. Leslie Richardson, *Things Seen on the Riviera: A Description of Its Interesting Peoples and Their Ways and the Charming Scenes of the French and Italian* (New York: E. P. Dutton, 1923), p. 11.

9. For the public-relations aspect of the coast's development, see Elsa Maxwell, *R.S.V.P.: Elsa Maxwell's Own Story* (Boston and Toronto: Little, Brown, 1954).

10. L. R. and D. C. Peattie, *The Happy Kingdom: A Riviera Memoir* (London and Glasgow: Blackie and Son, 1935), p. 2.

11. See *L'Estaque: Naissance du Paysage Moderne, 1870–1910*, exh. cat. (Marseilles: Musée Cantini, 1994).

12. For the contemporary art scene on the coast, see Thomson, *Monet to Matisse*, pp. 65–68.

13. Cited in Blume, *Côte d'Azur*, pp. 42–44.

14. See Jacques Dupont's excellent annotated edition of *Sur l'Eau* (Paris: Gallimard, 1993), as well as Pierre Joannon, *La Riviera de Maupassant* (Nice: Demaistre, 1997).

15. André Derain, from *Lettres à Vlaminck* (1955), in Jean-Louis Andral, "Derain en Plein Midi," in *André Derain: Le Peintre du "Trouble Moderne,"* exh. cat. (Paris: Musée d'Art Moderne de la Ville de Paris, 1994), p. 74.

16. Jean Paulhan, *Braque le Patron* (Paris: Gallimard, 1952), p. 36.

17. Guy de Maupassant, "Petits Voyages: La Charteuse de la Verne," *Gil Blas* (August 26, 1884), cited in Thomson, *Monet to Matisse*, p. 65.

18. René Gimpel, *Journal d'un Collectioneur, Marchand de Tableaux* (Paris, 1963), cited in English in Michael Raeburn, ed., *Renoir*, exh. cat. (London: Hayward Gallery, 1985), p. 277. Also see Georges Dussaule, *Renoir à Cagnes et aux Collettes* (Cagnes: Musée Renoir, 1992).

19. Claude Monet to Alice Hoschedé, Cap d'Antibes, February 1, 1888, in Richard Kendall, ed., *Monet by Himself* (Boston: Bullfinch, 1990), p. 126.

20. Monet to Durand-Ruel, March 1884, in Pissarro, *Monet and the Mediterranean*, p. 38.

21. Monet, April 1888, ibid., p. 45.

22. Monet to Gustave Geffroy, February 11, 1888, ibid., p. 44.

23. Monet to Alice Hoschedé, February 1888, in Charles F. Stuckey, *Claude Monet, 1840–1926*, exh. cat. (Chicago: The Art Institute of Chicago, 1995), p. 216.

24. Eaque, "Claude Monet," *Le Journal des Arts* (July 6, 1888) cited in Pissarro, *Monet and the Mediterranean*, p. 63.

25. Félix Fénéon, *Calendrier* (June 1888), cited in John Rewald, "Theo van Gogh, Goupil, and the Impressionists," *Gazette des Beaux-Arts*, January 1973, p. 23.

26. Françoise Gilot writes: "*Les premiers jours, il parla surtout de la lumière blanche d'Antibes, qui exalte les forms au détriment des couleurs.*" See Gilot and Maurice Fréchuret, *1946, Picasso et Méditerranée Retrouvée* (Antibes: Grégoire Gardette, 1996), p. 19.

27. Nicolas de Staël to Jacques Dubourg, in Jean-Claude Schneider, *Nicolas de Staël: Peintures et Dessins*, exh. cat. (Paris: Hôtel de Ville de Paris, 1994), p. 134.

28. Pierre Bonnard, "Observations sur la Peinture," in Sasha Newman, ed., *Bonnard: The Late Paintings*, exh. cat. (Washington, DC: The Phillips Collection, and Dallas: Dallas Museum of Art, 1984), p. 70.

29. Nicolas de Staël to René Char, Bormes-les-Pins, June 1952, in Schneider, *Nicolas de Staël*, p. 130.

30. Françoise Cachin, "L'Arrivée de Signac à Saint-Tropez," in Jean-Paul Monery and Marina Ferretti-Bocquillon, *Signac et Saint-Tropez, 1892–1913*, exh. cat. (St.-Tropez: Musée de l'Annonciade, 1992), p. 15.

31. For La Hune, and Théo Van Rysselberghe's designs for its interior, see Philippe Thiébaut, "Art Nouveau et Néo-Impressionisme: Les Ateliers

de Signac," *Revue de l'Art*, 92 (1991), pp. 72–78.

32. Louis Vauxcelles, *Gil Blas* (October 17, 1905), cited in Roger Benjamin, "Fauves in the Landscape of Criticism: Metaphor and Scandal at the Salon," in Freeman, *The Fauve Landscape*, p. 248.

33. Paul Signac to Henri-Edmond Cross, in Françoise Cachin, *Paul Signac* (Paris, 1971), cited in Herbert, *Fauve Painting*, p. 140.

34. For Matisse in St.-Tropez and the circumstances surrounding *Luxe, Calme et Volupté*, see Jack Flam, *Matisse: The Man and His Art, 1869–1918* (Ithaca, NY, and London: Cornell University Press, 1986), pp. 109–21.

35. Herbert, *Fauve Painting*, p. 115.

36. Quoted in Jean-Claude Schor, *Nice Pendant la Guerre de 1914–1918*, Travaux et Mémoires, 32 (Aix-en-Provence: Publications des Annales de la Faculté des Lettres, 1964), p. 118, cited in Kenneth Wayne, "Montparnasse Heads South: Archipenko, Modigliani, Matisse and WWI Nice," in Wayne, *Impressions of the Riviera*, p. 27.

37. Robert and Sonia Delaunay, for instance, lived in Spain and Portugal for much of the war, and were criticized upon their return for doing so.

38. Herbert Adams Gibbons, *Riviera Towns* (New York: Robert M. McBride,

1931), p. 115. It is interesting to note that post-Soviet Russians have recently come to the Riviera as big spenders; see Marlise Simons, "New Russians Spread Money on Riviera, but Lack Panache of the Czars," *The New York Times*, July 24, 1999, p. A5.

39. Guillaume Apollinaire, "L'Art Vivant et la Guerre," *Le Petit Messager des Arts et des Industries d'Art* (March 1, 1915), cited in Leo Breunig, ed., *Apollinaire on Art: Essays and Reviews, 1902–1918* (New York: Viking, 1972), p. 440. Although Apollinaire refers to Archipenko's "wife," it is unclear whether the artist was married at this time.

40. Matisse recounted this in 1951 to the publisher Tériade, who owned a villa at Cap Ferrat (for which Matisse created a ceramic mural after World War II); it is cited in French in Dominique Fourcade, ed., *Matisse: Écrits et Propos sur l'Art* (Paris: Hermann, 1972), and in English in Jack Flam, ed., *Matisse on Art* (New York: Phaidon, 1973), p. 134.

41. Lorenz Eitner, "The Open Window and the Storm-Tossed Boat," *The Art Bulletin*, 37, no. 4 (December 1955), p. 286.

42. Henri Matisse, "Radio Interview, First Broadcast, 1942," in Flam, *Matisse on Art*, p. 93.

43. This trip to St.-Raphaël is usually considered Picasso's first to the Riviera; John Richardson makes a convincing case for a surreptitious

amorous visit by Picasso to St.-Tropez in 1916: see "Picasso's Secret Love," *House & Garden*, 159, no. 10 (October 1987), pp. 174–82, 252–54.

44. Yve-Alain Bois does not mention this case of Picasso's borrowing from Matisse, and thus seems mistaken when he says that once Matisse had settled in Nice, "until 1930 or so, he has nothing to communicate to Picasso"; see *Matisse and Picasso* (Paris: Flammarion, 1998), p. 30.

45. David Setford, *Raoul Dufy: Last of the Fauves*, exh. cat. (West Palm Beach, FL: Norton Museum of Art, 1999), p. 10.

46. Carlo Rim, *Le Grenier d'Arlequin* (Paris: DeNoel, 1981), p. 259, cited in Blume, *Côte d'Azur*, p. 109. I am grateful to both Jean and Guy Kisling for their help with my research on the Côte d'Azur; for Moïse Kisling at St.-Tropez and Sanary, see Billy Klüver and Julie Martin, *Kiki's Paris: Artists and Lovers 1900–1930* (New York: Harry N. Abrams, 1989), pp. 78–79, 162–63.

47. George Grosz to Otto Schmalhausen, May 20, 1927, in Hans Hess, *George Grosz* (New Haven, CT, and London: Yale University Press, 1985), p. 148.

48. W. Somerset Maugham, *Strictly Personal* (Garden City, NY: Doubleday, Doran, 1941), p. 156. The original sentence is: "The Riviera isn't only a sunny place for shady people."

49. Maugham describes his study and the window in *Strictly Personal*, p. 150. See also Marla Prather and Charles F. Stuckey, eds., *Gauguin: A Retrospective* (New York: Levin Associates, 1987), p. 379, and Richard Brettell et al., *The Art of Paul Gauguin*, exh. cat. (Washington, DC: National Gallery of Art, 1988), pp. 241–43.

50. Van Rysselberghe archives, cited in Robert L. Herbert, *Neo-Impressionism*, exh. cat. (New York: The Solomon R. Guggenheim Museum, 1968), p. 47. Cross went to Cabasson in 1891, and then built a house at St.-Clair, where he remained until his death in 1910. See Elisabeth Hardouin-Fugier, *Paysages Méditerranéens d'Henri-Edmond Cross*, exh. cat. (St.-Tropez: Musée de l'Annonciade, 1990).

51. See A. Buttara, "Bains de Mer et Bains de Sable à Cannes" (Cannes, 1867), cited in Jacques Borgé and Nicolas Viasnoff, *Archives de la Côte d'Azur* (Paris: Michèle Trinckvel, 1994), pp. 171–77.

52. For Archipenko in Nice, see Kenneth Wayne, "Montparnasse Heads South," in *Impressions of the Riviera*, and Katherine Janszky Michaelsen and Nehama Guralnik, eds., *Alexander Archipenko: A Centennial Tribute*, exh. cat. (Washington, DC: National Gallery of Art, 1986).

53. See my *Esprit de Corps: The Art of the Parisian Avant-Garde and the First World War, 1914–1925* (Princeton, NJ: Princeton University Press, 1989).

54. Pierre Daix, *Picasso* (New York: Praeger, 1965), p. 118.

55. Roland Penrose, *Picasso: His Life and Work* (New York: Schocken, 1962), p. 144. See also William Rubin, *Picasso in the Collection of The Museum of Modern Art* (New York: The Museum of Modern Art, 1972), p. 110.

56. Boris Kochno, *Christian Bérard* (New York: Panache, 1988), pp. 64–65. Bérard made a number of watercolors of Les Goudes, which are reproduced in the book.

57. For Bonnard at Le Cannet, see especially Michel Terrasse, *Bonnard at Le Cannet* (New York: Pantheon, 1988), and James Thrall Soby et al., *Bonnard and His Environment*, exh. cat. (New York: The Museum of Modern Art, 1964). Timothy Hyman's *Bonnard* (London: Thames & Hudson, 1998), although it has no special focus on Le Cannet, is perhaps the best book on the artist.

58. Sasha Newman, "Bonnard 1900–1920," in Newman, *Bonnard*, p. 170.

59. An example of Zadkine's brass *Pomona* is in the collection of the Musée Royal des Beaux-Arts, Antwerp. Maillol's bronze *Pomona* is in the Pushkin Museum, Moscow; there are marble variants in other museums.

60. Jean-Bernard Pouy, "Des Symboles à la Dérive," in Brigitte Ouvry-Vial,

René Louis, and Jean-Bernard Pouy, eds., *Les Vacances: Un Rêve, un Produit, un Miroir* (Paris: Autrement, 1990), pp. 109–10.

61. In the Société Anonyme Collection, Yale University Art Gallery (New Haven, Connecticut), the picture is referred to as both *Midi* and *Promenade des Anglais*. See the note by Lesley Baier in Robert L. Herbert et al., *The Société Anonyme and the Dreier Bequest at Yale University: A Catalogue Raisonné* (New Haven, CT, and London: Yale University Press, 1984), p. 529.

62. See the letter "Sanary le 8 janvier [1927]," in André Masson, *Les Années Surréalistes: Correspondance 1916–1942*, ed. Françoise Levaillant (Paris: La Manufacture, 1990), p. 133.

63. Georges Limbour, "André Masson: Le Dépeceur Universel," *Documents*, 2, no. 5 (Paris, 1930), pp. 286–87. For Masson, see William Rubin and Carolyn Lanchner, *André Masson*, exh. cat. (New York: The Museum of Modern Art, 1976). I am grateful to Guitte Masson, who not only supplied me with the documentary photographs used here, but also provided a detailed itinerary of Masson's peregrinations on the coast.

64. See Frank Whitford, *Kandinsky* (London: Paul Hamlyn, 1967), pl. 30.

65. L. Grote, "Exposition de W. Kandinsky à la Galerie Flechtheim," *Cahiers d'Art*, 6, no. 2 (1931), p. 112.

66. See Christian Dérouet and Vivian Endicott Barnett, *Kandinsky in Paris, 1934–1944*, exh. cat. (New York: The Solomon R. Guggenheim Museum, 1985), pp. 60–64.

67. For "Le Temple de Crocodile," see Sidney Geist, *Brancusi: A Study of the Sculpture* (New York: Grossman, 1968), pp. 91, 94, 194, 209; Edith Balas, "Brancusi, Duchamp, and Dada," *Gazette des Beaux-Arts*, 122, no. 1335 (April 1980), pp. 172–73; and Anna Chave, *Constantin Brancusi: Shifting the Bases of Art* (New Haven, CT, and London: Yale University Press, 1993), pp. 260–61. For the story of Brancusi's "miraculous" rescue, see Pontus Hulten, Natalia Dumitresco, and Alexandre Istrati, *Brancusi* (New York: Harry N. Abrams, 1987), p. 163.

68. For the Villa de Mandrot, see Bruno Reichlin, "'Cette Belle Pierre de Provence'—La Villa de Mandrot," in *Le Corbusier et la Méditerranée*, exh. cat. (Marseilles: Musées de Marseille, 1987). For Hélène de Mandrot, see Antoine Baudin, *Hélène de Mandrot et la Maison des Artistes de La Sarraz* (Lausanne: Payot, 1998); I am grateful to Mary McLeod for this reference and for many years of brilliant conversation about Le Corbusier.

69. For the contemporary art and social context of the Villa de Mandrot, see the chapter "A Crisis of Confidence: From Machinism to the Organic," in Romy Golan, *Modernity and Nostalgia: Art and Politics in France Between the Wars* (New Haven, CT, and London:

Yale University Press, 1995), pp. 61–83. For Le Corbusier's early interest in vernacular architecture, see Francesco Passanti, "The Vernacular, Modernism, and Le Corbusier," *The Journal of the Society of Architectural Historians*, 56, no. 4 (December 1997), pp. 438–51.

70. For the typology of the Riviera villa, see two books by Michel Steve: *L'Architecture Belle Époque à Nice* (Nice: Demaistre, 1995) and *La Métaphore Méditerranéenne: L'Architecture sur la Riviera de 1860 à 1914* (Nice: Demaistre, 1996).

71. Caroline Constant explains: "The name E.1027—a cypher for the authors' intertwined initials [10=J, 2=B, 7=G, thus E.1027 = EJBG]—reflected the collaborative nature of the undertaking. Gray bought the land and spent over two years at the site, taking prime responsibility for both design and construction, while Badovici visited frequently to assist in technical matters." See "E.1027: The Nonheroic Modernism of Eileen Gray," *The Journal of the Society of Architectural Historians*, 53, no. 3 (September 1994), p. 269. Peter Adam, in *Eileen Gray: Architect/Designer* (New York: Harry N. Abrams, 1987), p. 191, also explains the origin of the house's name.

72. I am grateful to my student Erin Hayes for the information I gleaned from her senior seminar report "Modernist Villas on the Riviera," Department of Fine Arts, New York University, December 1995.

73. This area of the coast had apparently been part of Gray's imaginative life for a number of years—and perhaps part of her real life as well; the model room that she designed and displayed at the Salon des Décorateurs in Paris in 1923 was called "Boudoir de Monte Carlo." It is discussed by both Constant and Adam (see note 71).

74. Cited in Cécile Briolle, Agnès Fuzibet, and Gérard Monnier, *Rob. Mallet-Stevens: La Villa Noailles* (Marseilles: Parenthèses, 1990), p. 42.

75. See Jacques Lipchitz with H. H. Arnason, *My Life in Sculpture* (New York: Viking, 1972), pp. 96–99. Lipchitz also created two sculptures for the Mandrot house, *The Song of the Vowels*, for the side facing the plain and the mountains, and *Reclining Woman*, for the garden side.

76. Constant, "E.1027," pp. 275–76. The house also featured a trough for sunbathing; if memory serves me well, there exists a photograph of Le Corbusier sunbathing in it, in the collection of the Fondation Le Corbusier, Paris.

77. Charles de Noailles to Robert Mallet-Stevens, June 23, 1923, in Briolle et al., *Rob. Mallet-Stevens*, p. 21.

78. For Metzinger's *The Harbor (Le Port)*, see Richard R. Brettell, *An Impressionist Legacy: The Collection of Sara Lee Corporation* (New York: Abbeville, 1993),

pp. 98–101, 156. Brettell dates the painting to 1912, but says a date of 1915–1916 is also possible. As for the harbor's identity, he has said more recently that "it seems too small for Marseille," and concludes: "Metzinger's harbor was most likely not an actual harbor, but a represented harbor . . . from images in the mind." See Brettell, *Monet to Moore: The Millennium Gift of Sara Lee Corporation* (New Haven, CT, and London: Yale University Press, 1999), p. 114.

79. Although it deals with photographers, not painters, see Bernard Millet, ed., *Le Pont Transbordeur et la Vision Moderniste*, exh. cat. (Marseilles: Musée Cantini, 1991).

80. The cover of the original German edition of Siegfried Giedion, *Bauen in Frankreich, Bauen in Eisen, Bauen in Eisenbeton* (Berlin, 1927), was a negative print of a photograph Giedion had taken of the Pont Transbordeur. Among other photographers who took pictures of the structure were Herbert Bayer, Tim Gidal, Florence Henri, Germaine Krull, André Papillon, and Roger Parry.

81. Many other artists created images of the Pont Transbordeur, or otherwise included it in their images of the Old Port, among them Charles Camoin, Le Corbusier, André Dunoyer de Segonzac, Moïse Kisling, Oskar Kokoschka, Albert Marquet, and Maurice de Vlaminck.

82. Jeannine Warnod, *Léopold Survage* (Paris: André de Rache, 1983), pp. 51–54. See also *Survage: Les Années Héroiques*, exh. cat. (Troyes: Musée d'Art Moderne, 1993).

83. For Klee on the Riviera, see Uta Gerlach-Laxner and Ellen Schwinzer, eds., *Paul Klee: Reisen in den Süden*, exh. cat. (Hamm: Gustav-Lübcke-Museum, 1997).

84. For Hans Hofmann at St.-Tropez, see Cynthia Goodman, *Hans Hofmann* (Munich: Prestel, 1990), pp. 25–26, 29.

85. Hans Hofmann, "On Space," *Search for the Real, and Other Essays* (Andover, MA: Phillips Academy, Addison Gallery of Art, 1948), p. 72.

86. Helena L. Waters, *The French and Italian Rivieras* (Boston and New York: Houghton Mifflin, 1924), p. v.

87. I gathered this information from the senior seminar report of my student Nathalie Smith, "Renoir's Life in Cagnes," Department of Fine Arts, New York University, December 1995.

88. C. N. Williamson, "Motoring on the Riviera," in E. Reynolds-Ball and C. A. Payton, eds., *Sport on the Rivieras* (London: Reynolds-Ball, 1911), pp. 48–50.

89. Chaim Soutine to Léopold Zborowski, 1923, in *Soutine*, exh. cat. (Paris: Orangerie des Tuileries, 1973), p. 99.

90. Andres Osterlind apparently told this to Jeanne Modigliani, as reported in "Modigliani sans Légende" (1958, 1961), reprinted in *Modigliani*, exh. cat. (Paris: Musée d'Art Moderne de la Ville de Paris, 1981), p. 93.

91. Matisse recounted this to Françoise Gilot, who relates it in *Life with Picasso* (New York: Avon, 1981), p. 251.

92. Williamson, "Motoring on the Riviera," pp. 57–58.

93. Paul Signac to Albert Manguin, October 1905, in Freeman, *Fauve Landscape*, p. 82.

94. For the Courmes portrait and the Emma Goldman gift, see Karole P. B. Vail, *Peggy Guggenheim: A Celebration*, exh. cat. (New York: The Solomon R. Guggenheim Museum, 1998), p. 27. Richard Drinnon, in *Rebel in Paradise: A Biography of Emma Goldman* (Chicago and London: University of Chicago Press, 1961), p. 266, says "some New York friends," including Arthur Ross and Mark Dix, raised the money for the cottage, without mentioning Guggenheim, although one suspects that it was mostly her nearly unlimited funds that paid for Bon Esprit, as the cottage was named.

95. For Walter Bondy, see Kenneth E. Silver and Romy Golan, *The Circle of Montparnasse: Jewish Artists in Paris, 1905–1945*, exh. cat. (New York: Universe Books and The Jewish Museum, 1985).

96. Fernand Léger to Simone Herman, "19 ou 20 août [1933]," in *Lettres à Simone*, p. 81.

97. Louis Bertrand, *La Riviera Que J'Ai Connue* (Paris: Fayard, 1933), pp. 254–55.

98. Actually, the phonograph and records belonged to Lartigue. For the diary entry "Juillet [1932]–Cannes," he writes: *"Plage de la Garoupe. Sur une natte, le phonographe et les disques qui me suivent partout. A côté d'eux, la souple petite Chou sur le sable chaud."* Lartigue, *L'Oeil de la Mémoire, 1932–1985* (Paris: Michel Lafont/Carrère, 1986), pp. 43–44. See also Mary Blume's lovely essay in Martine d'Astier, ed., *Lartigue's Riviera* (Paris and New York: Flammarion, 1997); and for a general overview of Lartigue, see Shelley Rice, "Remembrance of Images Past," *Art in America*, November 1992, pp. 122–29, as well as the volume from which it was adapted: *Jacques-Henri Lartigue: Le Choix du Bonheur* (Paris: Association des Amis de J. H. Lartigue, 1992).

99. Jacques-Henri Lartigue, May 1921, in *Mémoires sans Mémoire* (Paris: Robert Laffont, 1975), p. 371.

100. The Côte d'Azur had another claim to photographic eminence: it became a center of the French film industry, with an important movie studio, La Victorine, located in Nice. It was also on the coast, at La Ciotat in 1895, that the Lumière brothers made their famous short film of a train arriving (from Marseilles) at the local railway station. In the postwar period, with the inauguration of the Festival du Cinéma, Cannes would become an international center for film distribution and promotion.

101. Jacques-Henri Lartigue, Cannes, March 27, March 31, and April 12, 1932, in *L'Oeil*, pp. 29, 30, 32.

102. Lartigue, September 22, 1927, and January 13, 1923, in *L'Émerveillé: Écrits à Mesure, 1923–1931* (Paris: Stock, 1981), pp. 261, 20. "Sacha" refers to the writer, director, and actor Sacha Guitry, and "Yvonne" to his wife, the actress Yvonne Printemps, close friend of Lartigue and Bibi.

103. For Lartigue's parties, see his diaries, as well as Florette Lartigue, *Jacques-Henri Lartigue: La Traversée du Siècle* (Paris: Bordas, 1990), pp. 101–03.

104. I am grateful to Olga Mohler Picabia, who, in Paris in July 1995, spoke with me at length about her life on the Riviera with her late husband; and to the documentation service at the Musée National d'Art Moderne, Centre Georges Pompidou, Paris, for providing me with access to the extensive photographic archive on Picabia. See also *Picabia et la Côte d'Azur*, exh. cat. (Nice: Musée d'Art Moderne et d'Art Contemporain, 1991), and Serge Lemoine, ed., *Francis Picabia: Les Nus et la Méthode*, exh. cat., with additional essays by Arnauld Pierre and Sara Cochran (Grenoble: Musée de Grenoble, 1998).

105. Fernand Léger to Simone Herman, July 8, 1934, in *Lettres à Simone*, p. 123.

106. For van Dongen at Cannes, see *Van Dongen*, exh. cat. (Paris: Musée National d'Art Moderne, 1967), and *Van Dongen, le Peintre: 1877–1968* (Paris: Musée d'Art Moderne de la Ville de Paris, 1990).

107. Albert Marquet to Charles Camoin, in Daniel Giraudy, *Camoin: Sa Vie, Son Oeuvre* (Marseilles: La Savoisienne, 1972), p. 100.

108. For Pascin and his friends in St.-Tropez, see Klüver and Martin, *Kiki's Paris*, pp. 144–45.

109. For Man Ray and Kiki in Villefranche, see ibid., pp. 142–43.

110. Jean Cocteau, *The White Book*, trans. Margaret Crosland (San Francisco: City Lights Books, 1989), p. 43; this was originally published as *Le Livre Blanc* (Paris: Quatres Éditions, 1928). See also Robert Aldrich, *The Seduction of the Mediterranean: Writing, Art, and Homosexual Fantasy* (London and New York: Routledge, 1993), p. 122.

111. See Orson Welles, *Les Bravades: A Portfolio of Pictures Made for Rebecca Welles by Her Father* (New York: Workman, 1996).

112. See also Kenneth Wayne, "Château and Villa Life on the Riviera During the Jazz Age," in Wayne, *Impressions of the Riviera*, pp. 62–71.

113. The Villa Blanche mural, a collaboration with Christian Bérard, is reproduced in Kochno, *Christian Bérard*, p. 42. The Pramousquier mural is mentioned in Pierre Chanel, "A Thousand Flashes of Genius," in Arthur King Peters, ed., *Jean Cocteau and the French Scene* (New York: Abbeville, 1984), p. 117.

114. For the Altana murals, see Dora Perez-Tibi, *Dufy* (New York: Harry N. Abrams, 1989), pp. 224–31.

115. Sandra S. Phillips, "Themes and Variations: Man Ray's Photography in the Twenties and Thirties," in Merry Foresta, ed., *Perpetual Motif: The Art of Man Ray*, exh. cat. (Washington, DC: National Museum of American Art, 1988), p. 200.

116. For the Murphys at Villa America, see Calvin Tomkins, *Living Well Is the Best Revenge* (New York: E. P. Dutton, 1982; orig. 1971); Honoria Murphy Donnelly with Richard N. Billings, *Sara and Gerald: Villa America and After* (New York: Times Books, 1982); and Amanda Vaill, *Everybody Was So Young: Gerald and Sara Murphy, A Lost Generation Love Story* (Boston and New York: Houghton Mifflin, 1998). I am grateful to the late Honoria Murphy Donnelly for sharing with me her reminiscences of her childhood at Villa America and for providing me access to her photographic archive.

117. Vaill, *Everybody*, p. 193.

118. Ibid., p. 251.

119. Ibid.

120. Fernand Léger to Simone Herman, July 20 and 21, 1934, in *Lettres à Simone*, pp. 116, 117.

121. Jean Cocteau, "Nice" (orig. 1935?), in *Souvenir Portraits: Paris in the Belle Époque*, trans. Jesse Browner (New York: Paragon House, 1990), pp. 92–93.

122. Matisse apparently said this to Francis Carco, who published it in *L'Ami des Peintres* (Paris: Gallimard, 1953); it is cited in English in Cowart and Fourcade, *Matisse: The Early Years*, p. 24.

123. For the Jetée-Promenade, see Borgé and Viasnoff, *Archives de la Côte d'Azur*, pp. 8–12, and Guy Junien Moreau, *Le Casino de la Jetée-Promenade: Vies et Morts des Deux Palais* (Nice: Gilletta, 1993).

124. Nicholas Watkins, *Matisse* (New York: Oxford University Press, 1985), p. 203. Matisse had traveled to Tahiti in 1930; see John Klein, "Matisse After Tahiti: The Domestication of Exotic Memory," *Zeitschrift für Kunstgeschichte*, 60, no. 1 (1997), pp. 44–89.

125. Lartigue, Hyères, September 12, 1927, in *L'Émerveillé*, pp. 253–54.

126. Lartigue, August 10, 1933, in *L'Oeil*, p. 86.

127. I am grateful to Robert Johnson and Lynn Garafola, who pointed me in the right direction at the beginning of my research into the Monte Carlo tenure of the Ballets Russes. I am also grateful to the staff of the photo archive of the Bibliothèque de l'Opéra, Paris, for their assistance. Among the books and catalogues I have consulted are *Diaghilev et les Ballets Russes* (Paris: Fayard, 1973); Nancy van Norman Baer, ed., *The Art of Enchantment: Diaghilev's Ballets Russes, 1909–1929*, exh. cat. (San Francisco: The Fine Arts Museums, 1988); Vicente García-Márquez, *The Ballets Russes: Colonel de Basil's Ballets Russes de Monte Carlo 1932–1952* (New York: Alfred A. Knopf, 1990); Kathrine Sorley Walker, *De Basil's Ballets Russes* (New York: Atheneum, 1983); and Jack Anderson, *The One and Only: The Ballet Russe de Monte-Carlo* (London: Dance Books, 1981).

128. For Nijinska's collaboration with Gontcharova, see Nancy van Norman Baer, ed., *Nijinska: A Dancer's Legacy*, exh. cat. (San Francisco: The Fine Arts Museums, 1986), pp. 32–36; and Robert Johnson, "Ritual and Abstraction in Nijinska's *Les Noces*," *Dance Chronicle*, 1987, pp. 147–69. I am grateful to Gibbs Raetz, Nijinska's son-in-law, who allowed me access to the Nijinska Archive, Pacific Palisades, California.

129. For *Le Bal*, see Alexander Shouvaloff, *The Art of the Ballets Russes: The Serge Lifar Collection of Theater Designs, Costumes, and Paintings at the Wadsworth Atheneum, Hartford, Connecticut* (New Haven,

CT, and London: Yale University Press, 1997), pp. 155–71.

130. Lynn Garafola, *Diaghilev's Ballets Russes* (New York and Oxford: Oxford University Press, 1989), pp. 108–10.

131. A work obviously descended from *Le Train Bleu* is the ballet *Beach*, choreographed by Massine for the Ballets Russes de Monte Carlo, in 1933. According to Walker, *De Basil's Ballets Russes* (p. 25), "The working title had been *Dieux au Beach*, and the starting point for the scenario was the temporary transfiguration of the Sea King Nereus and his court into modern bathers on the beach at Monte Carlo. The sets and costumes—typically jolly seaside designs by Raoul Dufy—were based on the latest Riviera fashions." Walker does not mention that Jeanne Lanvin was supposed to have collaborated with Dufy on the costumes for *Beach*. The connection between this ballet and one called *Palm Beach*, also designed by Dufy, is unclear. Perez-Tibi (*Dufy*, p. 313) relates that "*Palm Beach* was a *plein-air* ballet in three scenes . . . interpreted by Léonide Massine. Organized by the Comte de Beaumont, it was presented at the Théâtre des Champs-Élysées. This ballet, whose action takes place in Monte Carlo, was performed at the Royal Opera House at Covent Garden in 1936."

132. Juan Gris to Daniel-Henry Kahnweiler, in Kahnweiler, *Juan Gris: His Life and Work* (New York: Harry N. Abrams, 1969), p. 38. For Gris's collaborations with Diaghilev,

see Karin von Maur, "Music and Theater in the Work of Juan Gris," in Christopher Green, ed., *Juan Gris*, exh. cat. (London: Whitechapel Art Gallery, 1992), pp. 267–304.

133. Gris to Kahnweiler, October 20, 1923, in Kahnweiler, *Juan Gris*, p. 50.

134. *Francis Bacon Interviewed by David Sylvester* (New York: Pantheon, 1975), p. 51.

135. Gilles Deleuze, *Francis Bacon: Logique de la Sensation*, cited in Mark Hutchinson, "Firing at the Nervous System," *Times Literary Supplement*, no. 4870 (August 2, 1996), p. 18.

136. *The Little Review*, 10, no. 2, (Fall/Winter, 1924–1925), p. 18. For the *Monte Carlo Bond*, see also Michel Sanouillet and Elmer Peterson, *The Essential Writings of Marcel Duchamp: Marchand du Sel* (London: Thames & Hudson, 1975), pp. 186–88. David Joselit has recently offered a Freudian/Marxian interpretation: "In the spins of the roulette wheel and the production of dividends, Duchamp's *Monte Carlo Bond* projects a field of capitalist deterritorialization only to collapse or reterritorialize it within the repressive family formation of Oedipus." See *Infinite Regress: Marcel Duchamp 1910–1941* (Cambridge, MA, and London: The MIT Press, 1998), p. 105.

137. Cited in *Munch et la France*, exh. cat. (Paris: Musée d'Orsay, and Oslo: Munch Museet, 1992), p. 352.

138. This is recounted in Arne Eggum, "Importance des Deux Séjours de Munch en France, en 1891–2," ibid., pp. 105–47. The exposé was published on Munch's birthday, December 12, 1891.

139. *Munch et la France*, p. 356.

140. Suggested by Eggum, ibid., p. 138.

141. *Munch et la France*, p. 357.

142. For *Dream of Monte Carlo*, see Friedholm W. Fischer, *Max Beckmann*, trans. P. S. Falla (London: Phaidon, 1973), pp. 59–65.

143. Herbert Gibbons, *Riviera Towns*, pp. 115–16.

144. For German emigration to France, see Jacques Grandjonc and Klaus Voigt, eds., *Émigrés Français en Allemagne, Émigrés Allemands en France 1865–1945*, exh. cat. (Paris: Institute Goethe, 1983).

145. Erika and Klaus Mann, *Das Buch von der Riviera* (Berlin: Silver und Goldstein, 1989; orig. 1931), p. 39.

146. For the Dôme group, see Silver and Golan, *Circle of Montparnasse*, and Annette Gautherie-Kampka, *Les Allemands du Dôme: La Colonie Allemande de Montparnasse dans les Années 1903–1914* (Bern: Contacts, 1995). Many other artists, including

Kisling, were in Sanary: Jean Puy, Othon Friesz, Valentine Prax, Edmond Céria, and Édouard Pignon, all French. For them, see Sylvie d'Èze, *La Provence Vue par les Peintres*, and Hélène Parmelin, *Une Passion pour Sanary* (Aix-en-Provence: Edisud, 1980). Also in Sanary at this time were the American painter Eugene Ullman and his French-born son, also a painter, Paul, who was killed during World War II; see Gaston Poulain, "Anniversaire de Paul Ullman," *Arts*, April 12, 1946.

147. Régis Guyotat, "Sanary, Havre des Écrivains Allemands d'Avant-Guerre," *Le Monde*, March 31, 1995.

148. Ann Thomas, *Lisette Model*, exh. cat. (Ottawa: National Gallery of Canada, 1990), p. 46.

149. Lise Curel, "Côte d'Azur," *Regards*, 4, no. 59 (February 1935), cited ibid., p. 50. Ann Thomas's apparent discovery of the hitherto unsuspected original publication of Model's photographs gives for the first time a political dimension to her work that the photographer herself never revealed.

150. Cited in Adam, *Eileen Gray*, p. 299. My discussion of the Vacation Center comes from Adam's, pp. 296–308.

151. Le Corbusier, *Des Canons, des Munitions? Merci! Des Logis . . . S.V.P.* (1938), cited and translated ibid., p. 303.

152. *Night Fishing at Antibes* has been the subject of much commentary. Basic firsthand accounts are to be found in Penrose, *Picasso: His Life and Work,* and Jaime Sabartès, *Picasso: An Intimate Portrait* (New York: Prentice-Hall, 1948). See as well Lawrence Steefel, "Body Imagery in Picasso's *Night Fishing at Antibes,*" *Art Journal,* 25, no. 4 (Summer 1966), pp. 356–63, 376; Albert Boime, "Picasso's *Night Fishing at Antibes:* One More Try," *Journal of Aesthetics and Art Criticism,* 29, no. 2 (Winter 1970), pp. 223–26; William Rubin, *Picasso in the Collection of The Museum of Modern Art,* pp. 156–57, 332–33; and Kirk Varnedoe, in Kirk Varnedoe and Pepe Karmel, eds., *Picasso: Masterworks from The Museum of Modern Art* (New York: The Museum of Modern Art, 1997), p. 114.

153. Including Dora Maar herself, people have suggested that the identities of the two women are Maar at the extreme right, and Jacqueline Lamba, wife of André Breton, next to her; others (including Burgard, see note 156) have suggested Marie-Thérèse Walter and Olga Koklova Picasso (either or both) as the basis for the figures.

154. Eduard Strasburger, *Rambles on the Riviera* (New York: Charles Scribner's Sons, and London: T. Fisher Unwin, 1906), pp. 201–02.

155. Romy Golan has argued for the picture as a "peasant" alternative to machine-age cosmopolitanism, in *Modernity and Nostalgia: Art and Politics in France Between the Wars* (New Haven, CT, and London: Yale University Press, 1995), pp. 133–35. The previous summer, at Mougins, Picasso painted a series of folkloric-looking figures wearing straw hats, some of whose body parts have the patterns of woven straw; the nearby town of Golfe-Juan was a center of traditional basket-weaving.

156. See, for instance, Timothy Anglin Burgard, "Picasso's *Night Fishing at Antibes*: Autobiography, Apocalypse, and the Spanish Civil War," *The Art Bulletin,* 68, no. 4 (December 1986), pp. 657–72.

157. See Steven A. Nash, ed., *Picasso and the War Years, 1937–1945,* exh. cat. (San Francisco: The Fine Arts Museums, and London and New York: Thames & Hudson, 1998).

158. Martica Sawin, *Surrealism in Exile and the Beginning of the New York School* (Cambridge, MA, and London: The MIT Press, 1995), p. 115. Much of my information on wartime Marseilles is from Sawin; Bernard Noël, *Marseille-New York: Une Liaison Surréaliste* (Marseilles: André Dimanche, 1985); and Germain Viatte, ed., *La Planète Affolée: Surréalisme, Dispersion et Influences, 1938–1947,* exh. cat. (Marseilles: Musées de Marseille and Flammarion, 1986).

159. Jacques Lipchitz, Varian Fry Papers, Butler Library, Columbia University, cited in Sawin, p. 117.

160. Jean Kisling, personal correspondence, May 1994.

161. Peter de Francia, *Fernand Léger* (New Haven, CT, and London: Yale University Press, 1983), p. 134.

162. Sawin, *Surrealism in Exile,* p. 132.

163. Among the guest artists was the Czech painter Rudolf Kundera, who was kind enough to share with me his reminiscences of Montredon during the war, in a conversation at Cassis in 1994. See Aline Gaborit, ed., *Rudolf Kundera* (Marseilles: Éditions de l'Aube, 1991).

164. Kochno, *Bérard,* p. 63.

165. Wols, "At Cassis" (1944), cited in Frances Morris, *Paris Post-War: Art and Existentialism, 1945–55,* exh. cat. (London: Tate Gallery, 1993), p. 181.

166. For Sonia Delaunay, see Sherry Buckberrough, *Sonia Delaunay: A Retrospective,* exh. cat. (Buffalo, NY: Albright-Knox Art Gallery, 1980), pp. 90–91.

167. Jean Arp, "Comfortably Through the Tunnel of Matter" ("Aisément à Travers le Tunnel de la Matière," 1947), in Marcel Jean, ed., *Arp on Arp: Poems, Essays, Memoirs* (New York: Viking, 1972), p. 213.

168. Eric de Chassey, *Alberto Magnelli: "Les Moments de Grasse,"* exh. cat. (Aix-en-Provence: Espace 13, 1998). See also Anne Maisonnier-Lochard, *Les Magnelli de Vallauris,* exh. cat. (Vallauris: Musée de Céramique et d'Art Moderne de Vallauris, 1994).

169. The printing of the suite began in Grasse in 1943, at the Imprimerie Imbert, under André Kalin; work ceased in October of that year and the proofs were destroyed. In 1950, Sonia Delaunay, in possession of a number of the initial gouaches, had the lithographs printed at the presses of Les Nourritures Terrestres, pulled by Jacques Goldschmidt, in an edition of 150. See Claude Laugier, "Le Groupe de Grasse," in *Paris-Paris 1937–1957,* exh. cat. (Paris: Musée National d'Art Moderne, 1992), pp. 142–44, and Marie-Christine Grasse, "Autour du Groupe de Grasse," in *La Côte d'Azur et la Modernité,* pp. 76–77.

170. See *Charlotte Salomon: Life? Or Theatre?,* exh. cat. (Amsterdam: Jewish Historical Museum, 1998), and Grace Glueck, "A Life Cut Short by the Nazis Endures in a Painted 'Opera,'" *The New York Times,* August 25, 2000, p. E33.

171. For the history of the Weisweiller family and the two villas—L'Altana and Santo Sospir—see Carole Weisweiller, *J'Appelais Monsieur Cocteau* (Monaco: Éditions du Rocher, 1996).

172. For the Countess de Noailles, née Marie-Laure Bischoffsheim, see Dominique Marny, *Les Belles de Cocteau* (Paris: Jean-Claude Lattès, 1995).

173. Francis Picabia, "Jeunesse," *L'Opinion* (Cannes, March 1941), repr. in *L'Album d'Olga Mohler* (Turin: Notizie, 1975), p. 125. Olga Mohler Picabia showed me the original in her album, in Paris in 1995.

174. See Yve-Alain Bois, "Francis Picabia: From Dada to Pétain," *October*, 30 (Fall 1984), pp. 121–27. It is unclear whether Picabia was imprisoned, as some including Michel Sanouillet have asserted, or otherwise detained. William Camfield writes: "If he hadn't had a heart attack at this moment, he would have been arrested: he was, so it seems, suspected of collaboration. The facts are as follows: he was secretly put into a hospital and four or five months later, when he was released, the charges against him had been dropped." See "Le 'Réalisme' et les Années de Guerre, 1939–1945," in *Picabia et la Côte d'Azur*, p. 44.

175. A good starting point to the vast literature on the Unité d'Habitation is W. Boesiger, *Le Corbusier: Oeuvre Complète, 1946–1952* (Zurich: Les Éditions d'Architecture, 1970), pp. 189–223, and *Le Corbusier et la Méditerranée* (see note 68). Le Corbusier's interest in Marseilles was of long standing: there are several drawings of 1931 of the harbor, with the Pont Transbordeur clearly indicated, in the collection of the

Fondation Le Corbusier, Paris. He also had plans for the reconstruction of the Old Port neighborhood, after the destruction of the Pont Transbordeur, but local authorities proceeded without him.

176. For Le Corbusier's plans and built architecture at Roquebrune–Cap Martin, see Bruno Chiambretto, *Le Corbusier à Cap-Martin* (Marseilles: Parenthèses, 1987), and Tim Benton, "Historic Houses: Le Corbusier's Cabanon," *Architectural Digest*, December 1987, pp. 146–51, 203.

177. Le Corbusier to Marguerite Tjader-Harris, February 15, 1955, the Centre Canadien d'Architecture/Canadian Centre for Architecture, Montréal.

178. Ibid.

179. The drawings and related documents for the Village Polychrome are in the collection of the the Centre Canadien d'Architecture/Canadian Centre for Architecture, Montréal.

180. The Ramiés, their master potter Jules Agard, and a local chemist taught Picasso the rudiments of his new medium. He never "threw" pots at the wheel himself, leaving the manufacture of his ceramics to Madoura's craftsmen. But in addition to decorating standard shapes, as well as new shapes designed by Suzanne Ramié, Picasso did design many of his own vessels. The basic works on the subject are Georges Ramié, *Picasso's*

Ceramics (New York: Viking, 1976), and Marilyn McCully, ed., *Picasso: Painter and Sculptor in Clay*, exh. cat. (London: Royal Academy of Arts, 1998). See my review of that London exhibition: "Pots, Politics, Paradise," *Art in America*, March 2000, pp. 78–85, 141.

181. This is Marilyn McCully's paraphrase of Gilot's reminiscence, in *Picasso: Painter and Sculptor in Clay*, pp. 38–39.

182. See Anne Lajoix, *L'Age d'Or de Vallauris* (Paris: Les Éditions de l'Amateur, 1995). Léger began to study ceramics with Roland Brice at Biot in 1949; the next year he built himself a ceramics studio there (see de Francia, *Léger*, pp. 231–48). See also Sylvie Forestier and Meret Meyer, *Les Céramiques de Chagall* (Paris: Albin Michel, 1990).

183. For Picasso's *Man with a Lamb*, see Phyllis Tuchman, "Picasso's Sentinel," *Art in America*, February 1998, pp. 87–94, 115.

184. Cited in Penrose, *Picasso: His Life and Work*, p. 332.

185. Alexander Liberman, *Artists in the Studio* (New York: Random House, 1988; orig. 1960), p. 165. For another interesting firsthand observation of artists on the coast in the postwar years, see Rosamund Bernier, *Matisse, Picasso, Miró As I Knew Them* (New York: Knopf, 1991). See as well Jed Perl, "Matisse and Picasso: At the Shores of the Mediterranean," *Paris*

Without End: On French Art Since World War I (San Francisco: North Point, 1988).

186. Maurice LeMaître, "The Artist and the 'Côte,'" *Paris American Kiosk*, 2, no.6 (February 15–March 15, 1955), cited in LeMaitre, *Jean Cocteau et le Lettrisme* (Paris: Centre de Créativité, 1976), pp. 10–13.

187. Henri Matisse, *Chapelle du Rosaire des Dominicaines de Vence* (Paris: Mourlot, 1951). This publication appears to have been produced on the occasion of the chapel's consecration.

188. Henri Matisse to Sister Jacques-Marie, in Soeur Jacques-Marie, *Henri Matisse: La Chapelle de Vence* (Nice: Grégoire Gardette, 1993), pp. 55–56.

189. For the Chapel of the Rosary, see the still superb discussion by Alfred H. Barr, Jr., in *Matisse: His Art and His Public* (New York: The Museum of Modern Art, 1951), pp. 279–88. See also Hanne Finsen and Mikal Wivel, *Matisse: Chapelle du Rosaire des Dominicaines de Vence* (Copenhagen: Ordrupgaard, 1993), and Xavier Girard, *Matisse: La Chapelle du Rosaire* (Nice: Musée Matisse, 1992).

190. Henri Matisse, "Interview with [Georges] Charbonnier" (1951), in Flam, *Matisse on Art*, p. 140.

191. Although he does not discuss Matisse per se, Martin Jay does analyze the *lux/lumen* distinction in

Neoplatonic thought, and its influence on modern French theories of specularity, in *Downcast Eyes: The Denigration of Vision in Twentieth-Century French Thought* (Berkeley, Los Angeles, and London: University of California Press, 1993).

192. For Picasso's postwar work in the context of his Communist politics, and for the design of the Vallauris chapel, see Gertje R. Utley, *Picasso: The Communist Years* (New Haven, CT, and London: Yale University Press, 2000), pp. 154–79.

193. See Jean Cocteau, *La Chapelle Saint-Pierre, Villefranche-sur-Mer* (Beaulieu-sur-Mer: Hassler, 1957).

194. Ted Loos, "The Crown of a Poet," *Art & Antiques*, September 1994, p. 82.

195. See the very helpful guidebook by Barbara F. Freed, *Artists and Their Museums on the Riviera* (New York: Harry N. Abrams, 1998).

196. Marcel Billot, "Le Père Couturier et l'Art Sacré," in *Paris-Paris*, pp. 293–307.

197. For Cocteau's projects on the coast, see Carole Weisweiller, ed., *Les Murs de Jean Cocteau* (Paris: Hermé, 1998). Cocteau executed numerous paintings and mosaics for Santo Sospir, the Weisweiller villa at Cap Ferrat; I am grateful to Isabelle Colin-Dufresne (a.k.a. Ultra Violet) for taking me to see the villa. More generally, for Cocteau's relationship to the Riviera, see Frédéric-Jacques

Temple and Pierre Caizergues, *Jean Cocteau et le Sud (de l'Atlantique à la Méditerranée)* (Avignon: A. Barthélemy, c. 1990), and Hugues de la Touche, *La Riviera de Jean Cocteau: Escale à Menton* (Nice: ROM, 1996).

198. See Martine Buchet, *La Colombe d'Or, Saint Paul de Vence* (Paris: Assouline, 1993).

199. Christian Zervos, "Projets de Picasso pour un Monument," *Cahiers d'Art*, 8–9 (1929), p. 342. See also Werner Spies, *Pablo Picasso on the Path to Sculpture: The Paris and Dinard Sketchbooks of 1928 from the Marina Picasso Collection* (Munich and New York: Prestel, 1995), pp. 6–7.

200. For the portrait of Maugham, see John Hayes, *Portraits by Graham Sutherland*, exh. cat. (London: National Portrait Gallery, 1977).

201. See *Nicolas de Staël à Antibes, Septembre 1954–Mars 1955*, exh. cat. (Antibes: Musée Picasso, 1990).

202. Ellsworth Kelly to Hilla Rebay, November 29 (probably 1952), in Michael Plante, "Things to Cover Walls: Ellsworth Kelly's Paris Paintings and the Tradition of Mural Painting," *American Art*, Spring 1995, p. 43. In an interview with André Verdet in 1952, Matisse said, "I think that one day easel painting will no longer exist because of changing customs. There will be mural painting"; see Flam, *Matisse on Art*, p. 143. The basic reference work for Kelly in

France is *Ellsworth Kelly: The Years in France, 1948–1954*, exh. cat. (Washington, DC: National Gallery of Art, 1992), with essays by Yve-Alain Bois, Jack Cowart, and Alfred Pacquement.

203. Peter Selz, *The Work of Jean Dubuffet* (New York: The Museum of Modern Art, 1962), p. 106.

204. Ibid., p. 109.

205. Jean Dubuffet to Jean Paulhan, February 20, 1956, in Daniel Marchésseau, ed., *Dubuffet*, exh. cat. (Martigny, Switzerland: Fondation Pierre Gianadda, 1993), p. 92.

206. Jean Dubuffet to Jacques Berne, February 5, 1956, in *Chambres pour Dubuffet*, exh. cat. (Vence: Château de Villeneuve, 1995), p. 30. See also the excellent Pierre Chave, ed., *Jean Dubuffet: "La Période de Vence,"* exh. cat. (Vence: Galerie Alphonse Chave, 1995).

207. Yves Klein, in "Klein, Raysse, Arman: Des Nouveaux Réalistes," interview with Sacha Sosnowsky (1960), repr. in *Yves Klein*, exh. cat. (Paris: Musée National d'Art Moderne, Centre Georges Pompidou, 1983), p. 263.

208. Sidra Stich, *Yves Klein*, exh. cat. (Stuttgart: Cantz, 1994), p. 19.

209. For the younger generation and other postwar phenomena, see *Chroniques Niçoises: Genèse d'un Musée*, vol. 1: *1945–1972* (Nice:

Musée d'Art Moderne et d'Art Contemporain, 1991).

210. "Klein, Raysse, Arman," p. 264; emphasis mine.

211. See Marco Livingstone's discussion of the painting in *David Hockney* (New York: Holt, Rinehart & Winston, 1981), p. 147.

212. See Monique Beudert's discussion of this drawing in *The PaineWebber Art Collection* (New York: Rizzoli, 1995), p. 55. For the garden series, and the mural environments that developed from them, see Marge Goldwater, Roberta Smith, and Calvin Tomkins, *Jennifer Bartlett*, exh. cat. (Minneapolis: Walker Art Center, 1985).

213. For Ringgold's *Matisse's Chapel*, see Dan Cameron, ed., *Dancing in the Louvre: Faith Ringgold's French Collection and Other Story Quilts*, exh. cat. (New York: New Museum of Contemporary Art, and Berkeley and London: University of California Press, 1998).

214. Jean Cocteau, April 21 and 22, 1953, *Past Tense: Diaries* (San Diego, New York, and London: Harcourt Brace Jovanovich, 1988), vol. 2, p. 94. Cocteau was referring specifically to Charles Walters's film *Lili*, starring Leslie Caron, Jean-Pierre Aumont, and Mel Ferrer, which he had just seen as a member of the jury at the Cannes Film Festival.

ILLUSTRATION CREDITS

Frontispiece and figure 42.
© Tate, London 2000/Artists Rights
Society (ARS), New York/
VG Bild-Kunst, Bonn
Page 6 and figure 11. Carlton Lake
Collection, Harry Ransom Humanities
Research Center, The University of
Texas at Austin
Page 11. Maps by Paul J. Pugliese
Pages 12, 14. The Museum of Modern
Art, New York, Film Stills Archive
Page 22. © 2000 Artists Rights Society
(ARS), New York/ADAGP, Paris.
Photograph courtesy Bibliothèque
Nationale de France

FIGURES
1. © 1979 The Metropolitan Museum
of Art
2, 21, 23, 24, 26, 46, 53, 73,
74, 87, 109. © 2000 Artists Rights
Society (ARS), New York/
ADAGP, Paris
3. © 2000 The Museum of Modern
Art, New York/Artists Rights Society
(ARS), New York/ADAGP, Paris
5, 43, 45. © 2000 The Metropolitan
Museum of Art
6. © 2000 Artists Rights Society
(ARS), New York/ADAGP, Paris/
Erich Lessing/Art Resource, NY
8, 86. © 2000 The Museum of Modern
Art, New York
10. Courtesy Philadelphia Museum
of Art
12. © 2000 Artists Rights Society
(ARS), New York/ADAGP, Paris.
Photograph by Graydon Wood
13. © 2000 Artists Rights Society (ARS),
New York/ADAGP, Paris/Photothèque
des Musées de la Ville de Paris
15. Photograph courtesy Philip Berman
16. © 2000 Estate of Charles Camoin/

Artists Rights Society (ARS),
New York/ADAGP, Paris. Photograph
by P. S. Azema
17. © 2000 Estate of Alexander
Archipenko/Artists Rights Society
(ARS), New York. Photograph by
Graydon Wood, 1998
19. Photograph © 2001 The Museum
of Modern Art, New York
20, 101. © The Solomon R.
Guggenheim Foundation, New York.
Photographs by David Heald
22. © 2000 Artists Rights Society
(ARS), New York/VG Bild-Kunst,
Bonn. Photograph by Ben Blackwell
25. Courtesy Guitte Masson
28. © 2000 Artists Rights Society
(ARS), New York/ADAGP, Paris/The
Solomon R. Guggenheim Foundation,
New York. Photograph by Carmelo
Guadagno
29. Courtesy The Art Institute
of Chicago
30. Courtesy Sidney Geist
35, 59, 60. © Centre Georges
Pompidou, Paris. Photographs
courtesy Photothèque des Collections
du MNAM/CCI
36. © 2000 Artists Rights Society
(ARS), New York/ADAGP, Paris/
Dallas Museum of Art
37, 52, 75. Photographs of postcards
by Dorothy Zeidman
38. © László Moholy-Nagy Estate/
Artists Rights Society (ARS),
New York/VG Bild-Kunst, Bonn.
Courtesy George Eastman House
40. © Photothèque des Musées de
la Ville de Paris
44. © 2000 Marsden Hartley
Memorial Collection,
Bates College Museum of Art,
Lewiston, Maine

48. Courtesy Geneviève Taillade,
Cambourcy, France
49, 63, 64. Photographs by Thora
Dardel. Courtesy Klüver Martin
Archive
50. © Artists Rights Society (ARS),
New York/ADAGP, Paris/Réunion des
Musées Nationaux/Art Resource, NY
54–58, 69. © Ministère de la Culture–
France/AAJHL
61. Roger-Viollet, Paris/
© Lipnitzki-Viollet
62. © 2000 Artists Rights Society
(ARS), New York/ADAGP, Paris.
Photograph courtesy Photothèque des
Collections du MNAM/CCI
65. Courtesy Klüver Martin Archive
66. Photograph by Rick Hall, Jack S.
Blanton Museum of Art
67. © Man Ray Trust/Artists
Rights Society (ARS), New York/
ADAGP, Paris
68. Courtesy Comité Francis
Picabia, Paris
70. Courtesy John Donnelly
71. © Estate of Honoria Murphy
Donnelly. Courtesy John Donnelly
72. © 2000 Whitney Museum of
American Art, New York.
Photograph by Geoffrey Clements
78. © 2000 Artists Rights Society
(ARS), New York/SAIE, Rome
80. © 2000 The Museum of Modern
Art, New York/Artists Rights Society
(ARS), New York/ADAGP, Paris/Estate
of Marcel Duchamp
81. © 2000 Munch Museet/
The Munch-Ellingsen Group/Artists
Rights Society (ARS), New York
82. © 2000 Artists Rights
Society (ARS), New York/
VG Bild-Kunst, Bonn
83–85. © Estate of Lisette Model

89. © 2000 Artists Rights Society
(ARS), New York/ADAGP, Paris.
Photograph by Dorothy Zeidman
91. Musée-Fondation Arp
92, 99. Photographs by Dorothy
Zeidman
93. © Charlotte Salomon Foundation
94. Courtesy John O'Donnell and
Steven T. Wozencraft. Photograph by
Dorothy Zeidman
95. © 2000 Estate of Moïse Kisling/
Artists Rights Society (ARS),
New York. Courtesy Jean Kisling
100. © 1951 Robert Capa/Magnum
Photos Inc.
102. Courtesy Art Resource, NY
104. Photograph by J. Gasiglia
105. © Marc Chagall Estate/Artists
Rights Society (ARS), New York
113. © David Hockney
116. © 1991 Faith Ringgold
117. © Donald Sultan

All works by Henri Matisse © 2000
Estate of Henri Matisse/Artists Rights
Society (ARS), New York

All works by Pablo Picasso © 2000
Estate of Pablo Picasso/Artists Rights
Society (ARS), New York